Graphic Designer's Digital Printing and Prepress Handbook

ROCKPORT

Graphic Designer's Digital Printing and Prepress Handbook

GLOUCESTER MASSACHUSETTS

ROCKPORT PUBLISHERS

CONSTANCE SIDLES

DESIGNED BY PETER KING & COMPANY

First published in the United States of America
by Rockport Publishers, Inc.
33 Commercial Street
Gloucester, Massachusetts 01930-5089
Telephone: (978) 282-9590
Facsimile: (978) 283-2742
www.rockpub.com

ISBN 1-56496-774-3
10 9 8 7 6 5 4 3 2 1

Cover Design: MATTER
Book Design: Peter King & Company
Technical Illustrations: Brian King

Printed in China.

FOR MY HUSBAND, JOHN.

Contents

Introduction

The World War II Marine veteran walked slowly into the classroom. His back was bent with age, but you could see that once upon a time, he had stood ramrod straight. He had come to the school to be interviewed by a group of sixth-graders who were writing an oral history book about the war. The kids wanted to know what he had done back then.

"I fought in all the big battles of the Pacific," he said.

"Yes, but what was it like?" the kids asked.

The veteran listed the islands he had helped to capture, the campaigns he had fought. The kids kept asking for more details.

"You have to forgive me," the old soldier finally said. "I have tried for sixty years to forget all that. When the war was over, I decided to walk away from it all and never look back. I haven't spoken to anyone about these things before, not ever."

Then he opened the plastic shopping bag he had brought with him and pulled out a book. "This is our brigade book," he said. His lumpish, arthritic hands caressed the olive-drab cover. "The cover is made from our uniforms."

Glued onto the cover was the insignia of his regiment. "Guadalcanal," it read.

Reverently the kids opened the book. Together the young and old heads bent over the pages. "Here is my life, at least for three years," said the veteran. And there it was—the easy stroll up the beach, then the night attacks, the fear, the courage, the love of comrades, the killing. He had come, he said, to open that book and his memories so that the children of the new generation would not forget what he and his fellow soldiers had done.

There has been a lot of talk lately about how the Web is displacing print in the war to capture our attention. "Print is dead," said one industry expert, advising printers to move away from their old-fashioned printing presses and get into Web design. "HTML is the language of the future."

A communications professor from George Washington University agreed. "The vast stream of digital information today is like a great, rushing river," he said. "To survive, all you have to do is to know how and when to jump in, and how and when to get back out again."

People in graphics have a great fear that somehow, as technology revolutionizes communication, we'll be stuck in the past. None of us wants to be a stagnant pool left behind when the river of technology changes course.

And so we leap onto the Internet and get swept away.

You can see this at graphics conferences, where all the hot topics are connected to Web design. When I go to these conferences, frequently I am the only print-production person there. Seven hundred designers and me, a middle-aged production manager.

Q R

This rush to the Net can also be seen in the magazines that serve our industry. Almost every one of them that used to focus on print now devotes at least some space to the Web. Most of the magazines that didn't change their focus from print to Web have gone out of business altogether in the last three years. Design schools teach more and more graphics students the intricacies of the Web and leave out the pains of the press.

Don't get me wrong. I love the Internet. It's the most terrific source of information ever invented. It connects people all over the world. It's current. You can follow Gary Kasparov's every move in the latest chess tournament. You can E-mail Unanu, an atoll out in the middle of the Pacific, where the people have no electricity and no running water, but they do have radiophone connections to the Net. If you need to know why octopuses change color, you can jump on the Web site of your local aquarium and find out. If you're lucky, you can even see a video that catches an octopus in the act. But the Net is not print. And print is not dead.

In fact, the revolution in computers has made print more accessible than ever before. By digitizing text and graphics, we can send print designs shooting all over the world to be printed wherever they're needed or wherever we can get the cheapest deal. Because of digital cameras, digital platemaking and digitally controlled presses, we can take a picture of the winning basket at the NBA championship game after midnight and see it on the front page of *USA Today* before last call. Throughout the entire production process — from the time we cut down a tree to the time that newspaper thumps onto our doorstep — computers make everything faster, better, cheaper. There is more print today than there has ever been in the history of the planet.

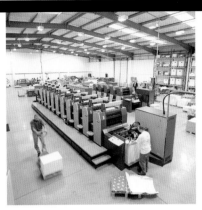

Why? Because print can do what no other medium can do. Sure, the info on a Web site is searchable. But there's more information on one page of the *New York Times* than on ten Internet pages. And when I want to "download" a new data-set from the newspaper, I simply turn the page. No waiting for a new set of pixels to scroll with maddening slowness down the length of my computer screen. I spend a fraction of a second and presto! I'm reading the next page. I can do it anywhere in the house, too, including the kitchen as I make dinner and the bathroom as I brush my teeth. Even more important than mere convenience, there is the reason why we call our business "graphic art": Print is beautiful. It's beautiful to look at and beautiful to touch. The glisten of ink that almost crackles with varnish, the feel of a roughly textured sheet of paper, the weight of a book in your hands, the balance of type and white space as peaceful as a Zen garden—these are ineffable pleasures to our senses. They speak to us in ways that glowing phosphors on a screen simply can't.

It's true that the world is becoming all-digital at a very rapid pace. But that doesn't turn print into the despised stepsister of HTML, grubbing around in the ashes like some pixelated Cinderella. On the contrary, the digitization of design elevates print to new levels: With the power of software programs that can manipulate art down to the tiniest level, we can create things that were never possible before. Check out the pages of any magazine and you'll see layouts made of collages, fades, blends, colors that could never have been designed in any other way.

Digital input devices make it easy to edit
your designs with a few keystrokes.
Digital output devices eliminate makeready.
Together these devices have created a new world:
digitized printing.

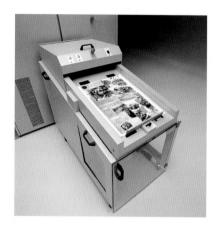

Beyond design, however, an all-digital printing world has given us digitized output devices. These digitized output devices—such as laser, ink-jet, and dye-sublimation printers—do something that no other printing system can do: They create one image at a time, then they reset the printer and create an entirely new image.

This powerful capability is called variable-data output. It allows us to do two things that have never been commercially feasible before: We can print extremely short press runs (as low as one copy) in full color; and we can vary the content of each page as it runs through the printer.

Up to now, color printing has always been a balance between cost and speed. On conventional presses, the only way you can justify the enormous expense of hanging all the color plates, registering them, and bringing the color up to its proper saturation levels is to print large quantities of copies, all the same.

If you wanted extremely small quantities of color printing, you either had to pay much higher prices or create them very slowly, using photographic processes or older technologies such as wood cuts, lithographic stones, or silk screens. Not only was this time-consuming and expensive, it was difficult to edit.

Digital systems have changed all that. Digital input devices make it easy to edit your designs with a few keystrokes. Digital output devices eliminate makeready. Together, these devices have created a new world: digitized printing.

It's a world where you can interface your printed piece with almost anything else that is also digital. This includes database systems that manipulate information such as lists, demographics, spreadsheets, etc.

The result is a new way to customize designs so that each page you print is unique, and its uniqueness is supplied by systems that automate the process. Not only can you create a page of color cheaply, you can tailor it so that one page is directed uniquely toward one recipient.

For many of us, this new world is a scary one. It's highly technical and fast-changing. Just when you think you have a handle on the software involved, a new upgrade — or a whole new application — comes along, and boom! You're back in kindergarten again, not even knowing how to spell your own name.

Ricky Young, a surfer friend of mine, has a way of describing how you can find the courage to face scary situations like this: "If you do nothing," he says, "then nothing happens. If you do something, then something happens."

This book is designed to help you dive in and make something happen. It will give you the information you need to catch this print wave of the future. And, unlike some of Ricky Young's wipeouts, it won't make your brain hurt. I promise.

Chapter 1: Digital Printers

Some years ago, I was asked by a research firm to save every piece of direct mail that I received for one month. They asked me to sort it into three categories: pieces that I opened and acted upon; pieces that I opened but ultimately discarded; and pieces that I didn't even bother to open. They gave me three accordion folders in which to file my mail and told me I could get more folders as needed.

Within a week, I called to ask for another Category 3 folder for mail that I never opened. A week after that, I needed another folder for Category 3, and then another. By the end of the month, I had filled four Category 3 folders. I had put two pieces of mail into my Category 2 folder (looked at but did not buy); and nothing into my Category 1 folder (the category that should have been going, "Ding! Ding! Ding! You have hit the jackpot, Mr. Retailer. I am buying your product").

I carted all the mail down to the Post Office to be sent to the research firm. It weighed 40 pounds. All 40 of those pounds were destined for the dumpster.

Some would see this as a problem. Savvy printers saw it as a solution. In the last two decades, as large printers began to consolidate into even larger printers, they realized that conventional printing would soon become a commodity rather than a craft. Technical advances were smoothing out the differences in quality that used to set one printer apart from another. Printers worried about how they could attract and keep print buyers in a market where customers perceived that all the printers provided about the same level of quality for roughly the same price. The one thing the printers wanted to avoid was a price war, but what else could they do?

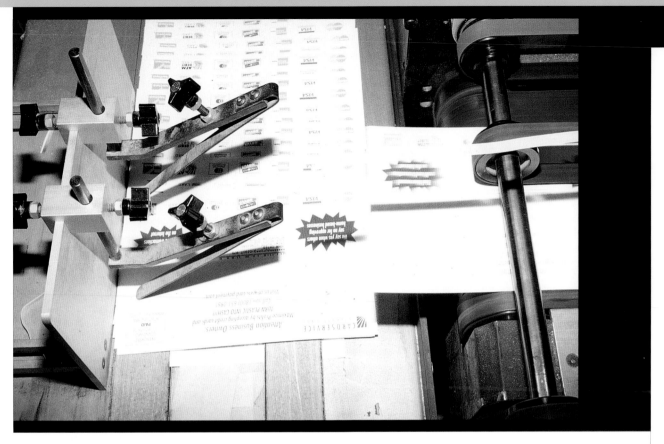

While this trend was developing, another equally powerful trend was shaking corporate America. Customers were demanding to be treated like real people. They were spurred on by urban legends about a retail department store based in Seattle where clerks went out of their way to satisfy customers. Consumers who had been putting up with vendors treating them like no-tip diners in a New York eatery began expecting customized service. They wanted products that were tailored just to them.

A few innovative printers thought they could tie into consumers' desire for individuality and began offering a service they called selective binding. It combined a crude ink-jet printer that could be interfaced with a computer containing a database of names and addresses. As a pre-printed signature ran by the ink-jet station on the bindery, the computer would tell the printer to spew out the subscriber's name and a little message onto a blank space on the page.

The message was usually keyed to an ad that had been printed normally on press. Only the ink-jet-printed name and message changed as each copy of the signature passed by.

(ABOVE LEFT)

Selective binding is a way to marry mass-produced printing (like the above postcard) with individualized messages (such as a mailing address). Although the process combines the speed of conventional printing with the customization of ink-jet technology, the results are visually crude and the amount of customization is limited.

(FACING PAGE)

The fundamental difference between conventional printing and digital printing is the ability to print different images. With conventional printing, you create one plate and print multiple copies, all the same. Different images require new plates. With digital printing, you create one image at a time and print one image at a time. When you want to print another copy, you re-create it all over again and print it again. You can thus alter each new copy any way you want.

The message was sometimes almost comical in the way it tried to appear personal and unique: "Mr. Seidels, we have a great offer for you," said one that came to my house. Never mind the fact that I'm not a mister, nor is my name Seidels.

As the technology improved, however, the system became capable of assembling variable signatures into one book. So Mr. Seidels might get a magazine that included a piece about golf, while my neighbor might get the same magazine but with a piece about kayaking instead of golf.

Selective binding, coupled with ink-jet labeling, did something very important for large-run printers. It transmogrified a mass-production technology into a customized one. High-speed presses work best when they produce vast quantities of the same piece. Selective binding takes all those look-alike signatures and transforms them into personalized messages. So now, instead of getting direct-mail pieces that have nothing to do with your life, you can get offers on items that you might actually want.

Unfortunately, there's a worm in the apple of selective binding. In many ways, it's still a technology of mass production. Printers still have to print thousands of copies at once. Those copies must be either mass-distributed or inventoried. The system cannot truly produce an individualized piece, only a somewhat-customized one.

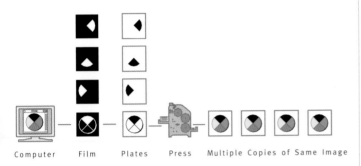

Computer Film Plates Press Multiple Copies of Same Image

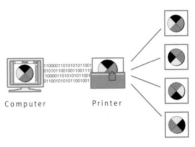

Computer Printer

Multiple Individualized Copies

Digital printing has changed all that. For the first time in history, we have technology that can produce one-of-a-kind designs at commercially acceptable speeds.

Digital printing is fundamentally different from conventional printing. With conventional printing, the technology images one plate at a time. This plate is then used to produce many copies of the same design. By contrast, digital printers image one design at a time. This process is called variable-data printing.

Variable-data printing is the most powerful contribution that an all-digital process can make to your clients. With variable-data printing, you can individualize every single message that you print.

As each page goes through the printing process, a computer tells the printer how to output a given set of bits. Neither the computer nor the printing device cares what the bits look like. They could be the same bits for every copy, or they could be completely different bits for each copy.

Furthermore, because no physical image of the design exists until after each page is output, there is no make-ready needed. In a certain sense, the makeready happens each time the computer outputs a copy, as it tells the output device where to print each separate pixel. With all-digital printing, there are no plates to hang, no colors to balance, no ink fountains to twiddle.

The one-of-a-kind capability of digital printing gives it two powerful advantages:

Customization: You can print press runs that are completely customized to each recipient. The only limitations are the nature and quality of your database, and the slower speed of digital presses.

Short-run Color: You can print extremely short-run full-color jobs at a reasonable price, when you need them. By short-run I mean as few as one copy.

These custom invitations were mailed to people attending seminars on different days. Each recipient received an invitation appropriate to his or her schedule. With conventional printing, the four-color invitations would all be printed at once, and the black-and-white dateline imprinted separately later. With digital printing, each invitation could be printed completely finished, as needed. Last-minute schedule variations could be accommodated on demand.

Customization

One florist in southern California asks his new customers to fill out a short questionnaire when they first buy flowers. On the form are questions such as the name and birth date of a significant other. Sometimes people object to the intrusion, but the florist quickly explains.

"If you'd rather not fill out the form, that's fine," he says. "But if you've ever had trouble remembering your partner's birthday, your anniversary, or any other holiday, then we can help. We keep all this information on a computer that automatically generates a reminder card for all the holidays in your life. Or, if you prefer, you can just place a standing order. We'll take care of sending out flowers on the proper day, and we'll even include a card!"

When people perceive that the florist is really going to make their lives easier (no more last-minute rushes out the door because you "left your briefcase in the car, hah, hah"), they are thrilled to contribute to his vast database.

The florist combines his data management with on-demand printing to generate postcards, letters, special offers, and flyers, all customized to each consumer's needs. When a holiday rolls around, he prints out one-of-a-kind offers that he simply drops in the mail. None of his clients think of his designs as junk mail — they've come to look at these reminders as a kind of free service that saves them time and trouble. The florist even keeps track of clients' kids' ages, so he can send out reminders for *quinceaños* celebrations, confirmations, proms, and graduations.

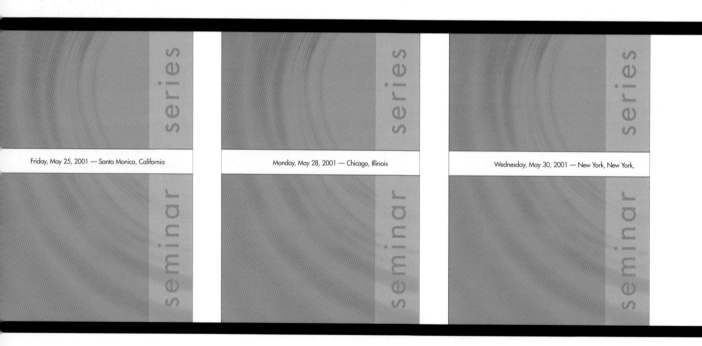

Friday, May 25, 2001 — Santa Monica, California

Monday, May 28, 2001 — Chicago, Illinois

Wednesday, May 30, 2001 — New York, New York,

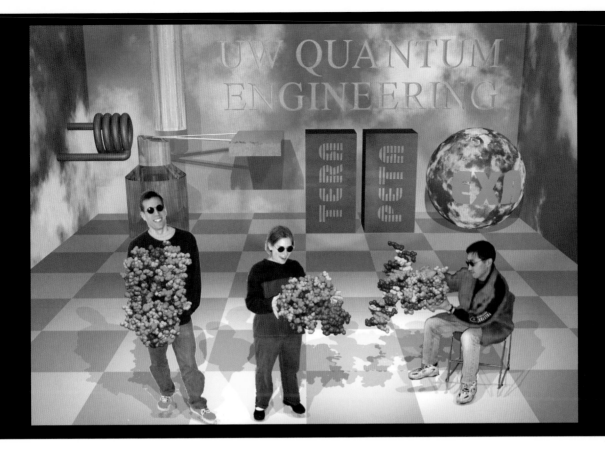

Short-Run Color

Five thousand physicists from the American Physical Society gathered in Seattle recently to view their colleagues' latest, most cutting-edge research. Only a few physicists among the thousands attending had won the right to present their research. Knowing how great this opportunity was—and how critical his colleagues could be—one local physicist decided that he would make a large-format color poster with graphics, instead of the usual bulletin board pinned with pages and pages of boring data. "Even physicists like to look at pictures," he said.

So he worked all week on the project, combining many different software programs, including Adobe Photoshop and PageMaker, a text language called TeX, and Microsoft PowerPoint. He took GIFs off his Web site and ran them through Adobe Acrobat to create PDF files. He captured text from previously published articles and imported it into his new file. He looked for stock photos from a CD to provide a colorful background.

Naturally, he wanted to keep working up to the last minute because he was a physicist, and physicists can always keep improving things just a little bit more. He knew that the large-format ink-jet digital press could output only 1.25 feet (46 cm) every 15 minutes. His poster was going to be 5 feet long, so he needed an hour to print it.

(ABOVE)

This super-sized poster (5 feet by 3 feet/1.5 meter by 1 meter) was printed on a digital ink-jet printer literally seconds before its physicist-designer made his presentation. It depicts a nano-scale imaging device capable of "seeing" the biological molecules held by the physicist's graduate students. No other technology could have produced this color poster in the time needed.

One hour and five minutes before he had to go to the conference, he was ready to print his poster, a 5-foot by 3-foot (1.5-meter by 1-meter) monster that would blow off his colleagues' rumpled socks.

The print operator was waiting, all the equipment primed and ready to go. He loaded up the professor's files, which crashed upon attempting to print the poster. All those different software programs had created an incompatibility. The machine couldn't RIP (raster image process) them all. The printer typed new commands into the computer. Crash. The printer and the professor split up. Each took over a terminal to try different strategies to overcome the RIPing problems.

Now the printing process became not only a race against time for the physicist and the printer, but also a race against each other's expertise. The printer tried one trick, the physicist another. Their fingers flew over their respective keyboards.

"Got it," said the printer, and paper started scrolling through the ink-jet device.

One hour later, the physicist flew out the door and managed to tack up his poster a full 30 seconds before his session began. No problem.

Both the florist and the physicist succeeded because digital printing gave them the power to print a design completely suited to their individual needs. No other form of printing can do that better, because no other form of printing is as flexible and as fast.

Part of the flexibility of digital printing comes from the fact that there are many different output devices on the market. The florist used laser printing to output his cards and brochures. The physicist used ink-jet printing to produce his poster. Both devices are controlled by a computer that outputs pixels, one page at a time. But the output technology differs widely, both in terms of mechanics and capabilities. To make digital printing work for you, you need to know what some of these differences are, and how they might apply to your particular designs. Here is a rundown of the most common devices on the market today and what they can do for you:

Digital direct-to-plate operations like this one receive text, art, and layout files directly from clients (either on disks or via long-distance electronic transmission lines). The data is preflighted and then output on a digitized platemaker. The plates are then hung on conventional presses. Finished printed material can start rolling off the presses within minutes.

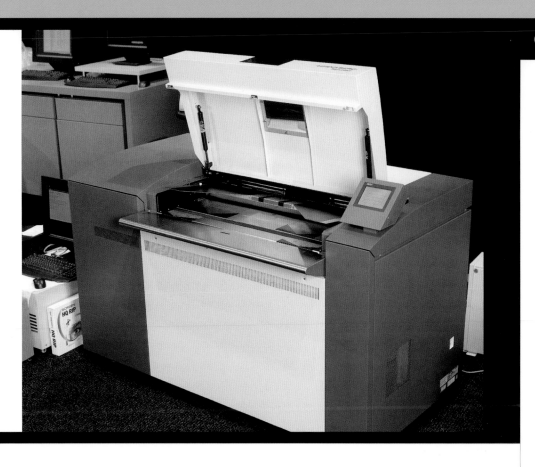

Digital Direct-to-Plate: Conventional Printing with a Digital Twist

Even conventional printing companies recognize the value of digital printers that can output any given set of pixels individually. Many have purchased digital platemaking systems that do essentially the same thing as your desktop laser printer: output one copy at a time, based on digitized prepress data input via computer. The only difference is, instead of outputting individual paper copies, these systems output individual printing plates.

The basic idea of digital direct-to-plate is that you give your file to the printer, ready for printing right away. The printer then RIPs your file directly to the printing plates, with no intermediate film steps. Typically the plates are prepared by a laser ablation process, in which a digitally controlled laser burns away a top silicone layer that repels ink, to reveal an underlying layer that accepts ink.

Once the plates are made, they are then hung or mounted onto conventional offset, flexographic, or gravure presses that mass-produce thousands of paper copies made by the plates. The whole process from starting file to printed page can be as short as 10 minutes, sufficiently fast considering that proofing must be done digitally, on the printer's monitor, immediately before burning the plate.

It is important, therefore, that the color profile of your monitor matches the profile of your printer's monitor, and that the printer's monitor must be well-matched to the ink-and-paper output. To avoid unpleasant color balance surprises, you need to talk to your vendor about calibrating monitor profiles before the final 10 minutes of production.

Digital direct-to-plate printing is the only option that offers you the full quality and speed of offset or gravure printing. This is because digital direct-to-plate is true offset or gravure printing. The only thing digital about it is the method by which the lithographic plates are produced. Thus, while conventional printing has incorporated some aspects of the digitized world, it remains at heart an assembly-line process whose main goal is to produce as many look-alike copies of a design as it can for the lowest possible price.

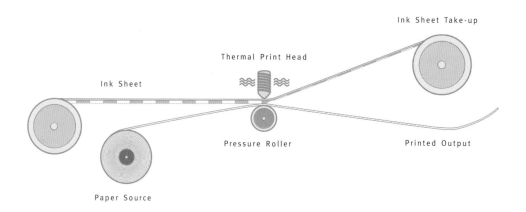

Ink Sheet Take-up

Thermal Print Head

Ink Sheet

Pressure Roller

Printed Output

Paper Source

Scan-Head Printing: Ink-Jet and Dye-Sublimation

If you have a print job that either is short-run or variable-data, digital direct-to-plate is usually not an option. Or perhaps you want to print your piece onto fabric, vinyl, or some other medium that a lithographic press will not accommodate. In this case, you should seriously consider using one of the two kinds of modern scan-head printers: ink-jet and dye-sublimation.

The ancestor of scan-head print technologies is the dot-matrix printer. This machine was hooked up to a computer and used a series of pins mounted in a printing head. As the printing head slid across a piece of paper, the computer would tell the printing head to strike with its pins in certain patterns.

The pins would strike against an ink ribbon and transfer dots to the paper, creating letter shapes. The resulting letters were crude—no fine serifs here, nor any halftones or line art. But the dot-matrix printer was capable of true digital output. As such, it made the boom in desktop systems possible.

Driven by market forces, the basic idea of scanning a print-head over paper has rapidly evolved in stages from dot-matrix printing to thermal-wax printing (heated pins melting waxy dyes) to the two scan-head technologies that dominate digital printing today: ink-jet and dye-sublimation printing.

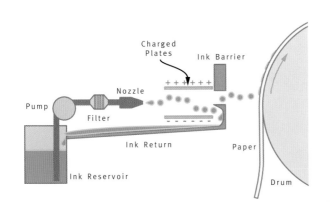

Charged Plates

Ink Barrier

Nozzle

Pump

Filter

Ink Return

Ink Reservoir

Paper

Drum

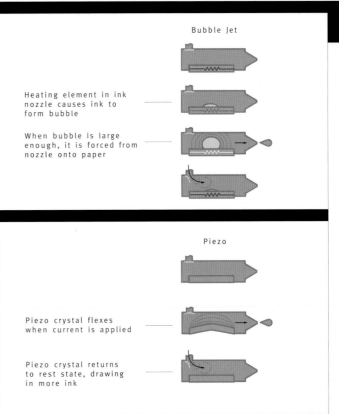

Bubble Jet

Heating element in ink nozzle causes ink to form bubble

When bubble is large enough, it is forced from nozzle onto paper

Piezo

Piezo crystal flexes when current is applied

Piezo crystal returns to rest state, drawing in more ink

INK-JET TECHNOLOGY

With ink-jet printing, the clumsy mechanical impact of dot-matrix devices has been eliminated in favor of electronically controlled jets of ink, which squirt out of nozzles onto paper. There are many different ways that ink-jet companies have invented to squirt out the ink.

For example, the ink streams can be squirted in discrete pulses by various mechanical means (like a water pistol), or the ink can be pushed out by micro-bursts of steam (called "bubble-jet" printing). Alternatively, a continuous stream of drops can be electronically steered onto paper, or steered away from the paper and into a recycling reservoir.

Early ink-jet printers fell far short of the quality of offset-press printing. But in recent years, the technology has improved rapidly, to the point that resolutions equivalent to 1,400 dots per inch (dpi) are attainable by top-of-the-line machines, along with printing speeds of up to 500 feet (152 meters) per minute. However, no ink-jet press presently offers both highest quality and fastest speed; there is always a tradeoff between the two. This is where you need to consult with your vendor—you may have to shop around to find a vendor with the latest and greatest technology.

(ABOVE)

There are many ink-jet technologies on the market. All of them work by forcing droplets of ink onto a substrate (the surface on which printing is done), but they do it in different ways. In one system (above left), charged plates direct liquid ink onto the substrate, which is mounted on a drum. Excess ink not directed onto the substrate falls into a return system and flows back to a reservoir, to be used again. A bubble-jet system (above right, top) uses a heat source to make the ink form a bubble, which is then forced out of the nozzle onto the substrate. A piezo system (above right, bottom) uses electric current to flex a crystal and force ink out.

Color posters like this one are a perfect job for digital printers, including ink-jet and commercial web or sheetfed presses. Such printers can output high-quality color for one-of-a-kind jobs on large-format paper.

The quality of ink and paper is always a major concern with ink-jet printing. Persuading the tiny dots of ink to adhere to paper is not easy, and your vendor may not be able to combine the paper you prefer with the kind of ink you want. Printers are constrained to use inks and papers that are compatible with the ink-jet process.

Furthermore, many ink-jet inks are neither water-proof nor colorfast. Even under indoor fluorescent lights, some inks fade notably within a few months. Put outdoors under strong sunlight, they fade even faster. So if keeping a print colorfast for the long term is important to you, don't just get assurances from your ink-jet printer—get a guarantee.

Ink-jet printing is ideally suited to jobs like poster-making, for several reasons. Modern ink-jet printers can easily print widths of 5 feet (1.5 meters) or even more—it is just a matter of providing longer rails for the ink-jet head to slide upon. And posters are usually short run, so the typically slow speed of ink-jet printing is not a big liability. Finally, the vibrant colors available with modern ink-jet printers look great on posters.

DYE-SUBLIMINATION TECHNOLOGY

Besides ink-jet, the other main scan-head printing type is dye-sublimation. Dye-sublimation technology grew out of thermal-wax printing, in which dots of waxy dye were heated to melting temperature and fused with paper or plastic. Thermal-wax printing was limited in that the resulting printed pieces had a waxy feel combined with appreciable build-up of the dye.

To solve these problems, thermal wax manufacturers raised the operating temperature higher and higher, and developed more and more sophisticated dyes, to the point that the dyes began to be transferred by sublimation rather than by melting.

Sublimation is a technical term that means "the direct transformation from a solid to a gas, with no intervening liquid state." In a modern dye-sublimation printer, a scanning head heats special dyes embedded in a ribbon, which is interposed between the scan head and the paper. As the temperature passes 270 degrees Fahrenheit/ 132 degrees Celsius (which is well above the boiling point of water), the dye vaporizes and transfers to the paper or fabric. There is no intervening liquid state.

(BELOW)
Dye-sublimation printers apply high levels of heat to a roll of transfer dyes. The heat is so great that it forces the solid ink to turn into a gas, which is then bonded to the paper or fabric substrate.

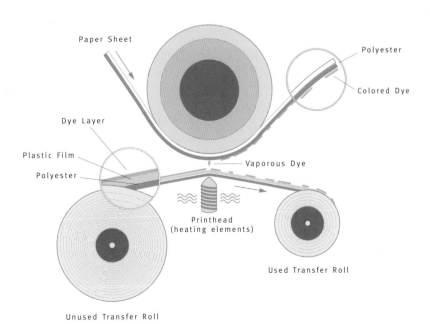

Paper Sheet

Polyester

Colored Dye

Dye Layer

Plastic Film

Polyester

Vaporous Dye

Printhead
(heating elements)

Used Transfer Roll

Unused Transfer Roll

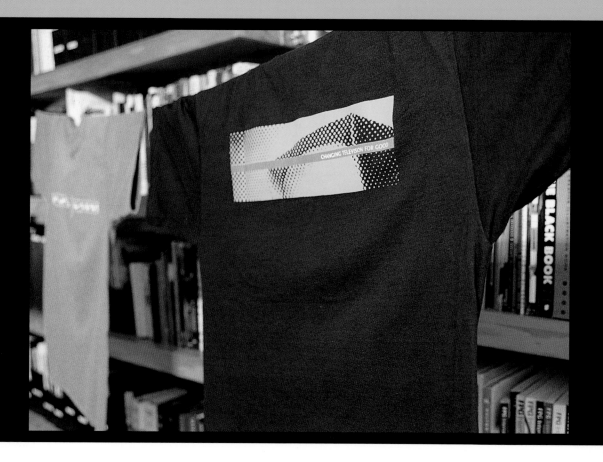

Dye-sublimation printers are especially effective for printing on fabric because the high temperature of the process bonds the dyes directly into the fabric fibers. Because the process is digital, the registration problems inherent in conventional screen printing are nonexistent. The result is high-quality color art that is detailed and color-saturated.

If the paper or fabric contains polyester fibers, and the temperature is hot enough to soften the fibers (350 degrees Fahrenheit/176 degrees Celsius or more), then the dye-fiber bond is completely permanent and cannot be removed by washing or by any ordinary amount of heat. Other advantages are that there is no appreciable mechanical buildup of dye, and the dye colors achieve extraordinary brilliance through their bonding to the transparent fibers.

Dye-sublimation printing has one other big advantage: it is the only kind of commercial printing which can achieve truly continuous tones without resorting to halftone screens. This is accomplished by simply varying the heat applied to each element of the piece; more heat creates a more intense local color. Thus, a top-quality dye-sub print can show the same continuous color intensity as a Kodachrome 35mm slide. Not surprisingly, high-quality photo prints are one of the main uses of dye-sublimation printing.

These advantages of dye-sublimation prints did not escape the notice of ink-jet printer manufacturers. They swiftly realized that ordinary ink-jet printers could be loaded with sublimating dyes. Such dyes could be

printed onto special heat-resistant paper; the resulting paper could then be used to heat-transfer the dyes onto materials such as polyester fabrics.

Building on this idea, they found that consumer items such as coffee mugs can also be coated with a thin layer of polyester robust enough to survive repeated wash cycles. Thus, nowadays there is growing overlap between the use of ink-jet and dye-sublimation technologies.

The main limitation of ink-jet and dye-sublimation technologies is the inherently slow speed of the scan-head. Companies are continuously engineering their way around this obstacle by building larger and larger arrays of ink-jets, combined with faster and faster steering of the jets of inks. Because ink-jet and dye-sublimation technologies are evolving so rapidly, you need to check with your vendors to see how nearly they can meet your needs for speed, resolution, paper quality, color-fastness, and water fastness.

(ABOVE)
Thermal-wax printers apply ink by using heated pins to melt a waxy dye onto paper.

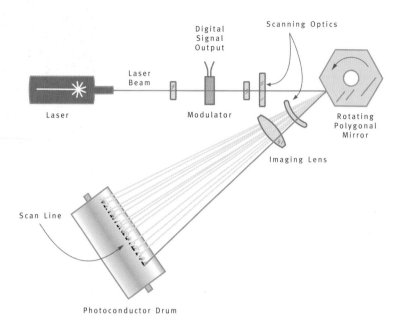

Digital Signal Output

Scanning Optics

Laser Beam

Laser

Modulator

Imaging Lens

Rotating Polygonal Mirror

Scan Line

Photoconductor Drum

Xerography and laser-printing systems work with essentially the same technology: A plate or drum is statically charged, and light shines where ink is to be repelled. Toner particles are then attracted to the charged areas of the plate or drum. These particles are transferred to paper and fused onto the paper surface with heat. Xerography printed its images by projecting an original image onto the drum. Laser printers accomplish the same thing by synthesizing the image digitally.

Xerographic Processes: Laser Printers, Digital Web Presses, Digital Sheetfed Presses

Let's suppose you have a job that truly requires variable-data printing, thus eliminating digital direct-to-plate. Furthermore, it requires more speed or a different ink-paper combination than your local ink-jet vendors can supply. Now it is time to consider xerographic processes.

The idea behind xerography grew out of the oldest idea in printing: Put the ink on a plate, press the paper onto the inked plate. Conventional non-digital printer technologies put the ink variously into hollowed-out areas (gravure or intaglio printing), relief areas (letterpress printing), or greasy areas (lithographic printing).

The trouble is, none of the above methods are suitable for variable-data printing because none of them allow the printing plates to be swiftly erased and re-created. What was needed was a printing plate that could be erased and re-created an indefinite number of times.

Out of this need grew the concept of xerography, which is at heart nothing more than the familiar method of lithographic printing—but with an erasable charge of static electricity instead of grease serving to stick ink to the plate.

The process was invented in 1938 by Chester Carlson and remains basically unaltered to the present day. A specially made drum or plate is sprayed with a uniform electric charge. This can be accomplished in a fraction of a second. Then light is shined upon

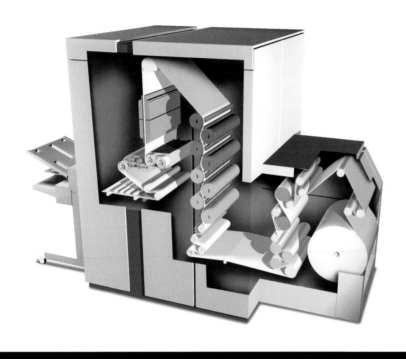

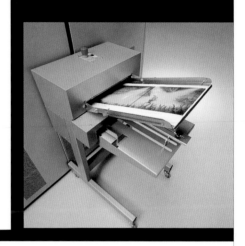

areas of the plate where ink is not desired. This eliminates the charge in all the areas upon which the light shines. Finally, the drum is coated with a "toner" consisting of tiny particles of dye. The toner particles stick only to the parts of the drum that are still statically charged. The drum now holds an image consisting of toner particles; they are transferred to paper and fused there, typically by heat. During the 1950s, the Xerox Corporation's pioneer xerographic machines carried through this process with no digital assistance: An image of a page to be duplicated was projected directly upon a rotating drum, and the resulting copies were produced without alteration. Then, during the 1980s,

Apple Computer produced the LaserWriter, which revolutionized digital printing. The LaserWriter was a consumer-priced xerographic printer in which the electrically charged image was synthesized digitally. Suddenly, any image that could be stored in a computer could be directly transferred to a printed page.

The original LaserWriter had its limitations. It printed only in black-and-white; it achieved a resolution of only 300 dots per inch; and it was not very fast—it could print, at the very most, less than ten pages per minute. In contrast, modern xerographic printers, like those produced by Xeikon and Indigo, can achieve 1,200 dpi or more of resolution, at print speeds of up to 240 feet (73 meters) per minute, using up to seven simultaneous process colors.

(ABOVE LEFT)

A Xeikon printer applies toner using electro-magnets to charge drums that can then transfer the toner to paper. Xeikon printers can print multiple colors on web paper at speeds that approach conventional sheetfed printing. Unlike conventional printing, however, Xeikons can print unique versions of any design.

(ABOVE RIGHT)

Because the Xeikon printer uses web paper, it can print large-format designs such as posters. The size is limited by the width of paper, not the length.

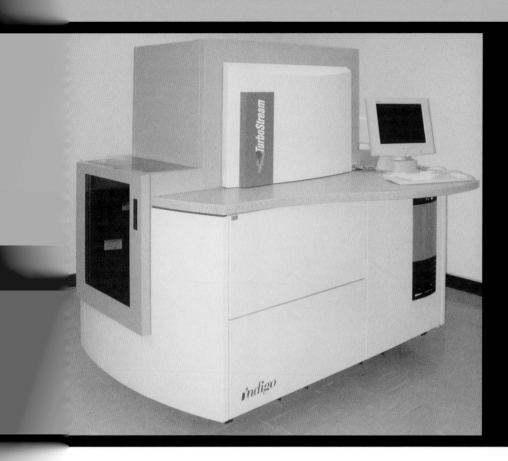

Today's top-end Xeikon and Indigo printers exemplify the two main options in high-end xerographic printing, dry toners (Xeikon) and wet toners (Indigo). The relative merits of the two kinds of toner are vigorously debated, and all the xerographic print technology companies are continuously updating their product lines.

The different companies also employ different strategies for feeding paper through their machines. Some use continuous-roll web paper. So while the width of the printed piece is limited by the width of the machine itself, the length can be almost anything. Other companies use only sheetfed paper, which limits the cutoff size of the final printed piece but also allows for a wider choice of papers.

Xeikon and Indigo occupy a very dynamic niche within the printing industry. At the low end, their digital presses must compete with desktop ink-jet and laser printers, which keep getting faster and can deliver better and better quality. Digital presses are also being squeezed by so-called "enterprise printing" systems. These are basically in-house corporate publishing machines manufactured by business-oriented companies like IBM and Xerox. Originally these enterprise printers were capable of making only xerographic copies. Recently, however, new models can either make copies or print out designs directly from a desktop computer.

At the high end, digital presses must compete with traditional high-volume lithographic print processes. These presses keep getting more efficient with their makeready, so that they become cost-effective at lower and lower quantities of press run. As a result, every year we can expect to see new xerographic print engines of ever-higher quality, color range, and speed.

In day-to-day production, however, only a small fraction of all jobs are printed on state-of-the-art machines. More commonly, your vendors will print your job on machines that they have had for several years and with which they are intimately familiar. It is important to appreciate your vendor's expertise and the stability of his hardware and software. That combination can be far more valuable to you than access to this year's state-of-the-art hardware.

WHAT TO DO?

(FACING PAGE)
This Indigo TurboStream digital printer is a commercial sheet-fed printer that can print six colors (CMYK plus two spot colors) at one pass, at a rate of 2,000 pages per hour. It can completely customize each copy it makes, and it can also print a single full-color copy of a design for an economical price.

(ABOVE)
Digital commercial printers such as Xeikon and Indigo can print short-run, multiple-page, full-color brochures economically because they can treat each signature of the brochure as a customized copy. After the printer prints a page, it erases the image on its printing drum and creates a new one. So each page it prints can be the same as the one before, or completely different.

If you have a short-run or variable-data job that must approach the quality of traditional offset printing, ask to see similar jobs which have been printed by a prospective vendor. Look for designs that are printed on similar paper, with similar inks and in similar quantities. Pay attention also to the color range of the jobs in the printer's portfolio. In a sense, picking out a printer is like selecting a surgeon: You want the guy who has performed thousands of similar operations, not the one who's doing it for the first time.

Once you find a technology and a printer that produce designs similar to yours, you should use the same software and color-matching scheme that the successful jobs used. Particularly if digital printing is a new experience for you, you can't go wrong sticking as closely as possible to a vendor/software/print technology package that has been proven to work well for jobs similar to yours.

For short-run jobs, most printers do not expect you to sign a formal contract. Instead they run the jobs with a simple purchase order-type arrangement. For complicated or long-run jobs, you might want to solicit bids from competing printers. The bidding spec sheet can then serve as the basis for a formal contract. Whether you use a P.O. or a contract, however, the printer needs to know some basic data:

- NAME OF JOB
- CONTACT NAME AND ADDRESS
- DESCRIPTION OF JOB
- QUANTITY
- TRIM SIZE
- BLEED SIZE *(if any)*
- TOTAL PAGE COUNT
- PRINTED ONE SIDE OR TWO
- BINDING METHOD *(if multiple pages)*
- FOLDING *(if necessary)*
- PAPER STOCK
- INK
- FURNISHED MATERIALS *(including all software programs used to assemble the prepress)*
- PROOFS NEEDED, OR FURNISHED?
- VARIABLE DATA REQUIREMENTS
- VARIABLE DATA SOFTWARE PROGRAM(S) USED
- DELIVERY METHOD
- DELIVERY DATE

In this era of digital production, the item "furnished materials" can be complex. Submit a list of the applications you used to create your design, organized around a toolbox idea (for more information on such applications, see the chapter on workflow). Such a list might consist of the following:

- TYPE
 Fonts used (include all font software)
- LAYOUT APPLICATIONS *(usually Adobe Pagemaker or QuarkXPpress)*
- OBJECT-ORIENTED GRAPHICS APPLICATIONS *(such as Adobe Illustrator)*
- BITMAP GRAPHICS APPLICATIONS *(such as Adobe Photoshop)*
- COMPRESSION APPLICATIONS: *JPEG, TIFF, GIF, etc. (also note links between your low-resolution "for position only" artwork and your high-resolution final versions)*
- TRAPPING APPLICATIONS *(such as Adobe Acrobat InProduction)*
- IMPOSITION APPLICATIONS, IF ANY *(note whether you use a simple book-it function in a layout application, or whether you've used a separate plug-in)*
- SEPARATION AND OUTPUT APPLICATIONS *(note how you convert RGB to CMYK or spot color)*

- PDF APPLICATIONS USED TO COMPRESS THE FINAL OUTPUT OR MAKE IT PLATFORM-INDEPENDENT *(software might be Adobe Acrobat or a third-party PDF-creation utility)*
- PREFLIGHT APPLICATIONS *(note the software you used; at least in that application, everything embedded in your design should RIP)*
- WORKFLOW AUTOMATION APPLICATIONS *(some applications can automate corrections found in preflights; note if and when you employ these)*

design company COMMUNICATION DESIGN

REQUEST FOR QUOTE

DIGITAL PRINTING

DATE:

ESTIMATE DUE:

FROM:

PHONE:

FAX:

JOB NAME:

DESCRIPTION:

SCHEDULE	Files in:		Material arrives:	
QUANTITIES	1.	2.	3.	
SIZE	Finished Size:	Flat Size:		# of Pages:
STOCK	Cover:			
	Text:			
	Other:			
INK	Side 1 Cover:	□ Bleeds	Side 1 Text:	□ Bleeds
	Side 2 Cover:	□ Bleeds	Side 2 Text:	□ Bleeds
	Other:			
ARTWORK	□ Electronic Files	□ Live Art	□ FPO Scans	□ Links to Images
SOFTWARE				
FONTS				
PROOFS	□ Loose Proofs	□ Dummy	□ On Actual Stock	□ Press Check
VARIABLE DATA	Description:			
	Software:			
FINISHING	□ Fold	□ Trim	□ Perfect Binding	□ Drill
	□ Score	□ Pad:	□ Plastic Binding	□ # Holes
	□ Perforate	□ Collate	□ Saddle Stich	□ Size Holes
SPECIAL				
SHIPPING				
PACKAGING	□ Shrink Wrap:		□ Band:	
	□ Carton Pack	□ Labeling:		
	Samples:		To:	
	Other:			

Years ago, San Francisco-based designer Dugald Stermer worked for a boss who invited him out to lunch regularly. It was no treat. Stermer's boss held a contest to see who had to pay for the meal. Each day, he would suggest that both men draw a letter of the alphabet in a specific typeface and point size. The one who drew it best ate for free. "He would say, 'Draw me a 144-point Bodoni capital B,' or 'Let's see a 72-point Caslon lower-case M,' and we would sketch it on a napkin," recalled Stermer. Stermer said he paid for a lot of lunches before he learned how to draw type.

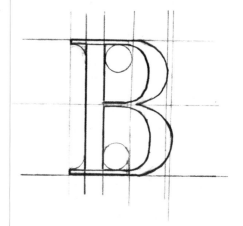

Why was it important for designers to know how to draw type? Back in the days before desktop systems and digital type, if designers wanted to see how a design might look, they had to submit handwritten instructions to their typesetting houses. These specifications (type specs) told the typesetter what typeface and point size to use, as well as the alignment, letter spacing, word spacing, and line spacing. The typesetter would go to his type case and pull open drawers that contained individually cast metal dies, each with one letter on it. The capital letters were stored in the upper half of the case (upper case); the lowercase letters were in the lower half of the case. The typesetter would pull out the dies, letter by letter, and line them up on a plate.

Between the lines, he would insert slugs of lead to create the desired amount of space (leading). Then he would print a proof of the type by inking the surfaces of the dies and pressing a piece of paper on top to transfer the ink to the paper (letterpress).

When he was all done, the typesetter would call for a messenger to run the proof over to the designer. If the designer hated the design, he would have to start all over again from scratch.

(ABOVE)

Setting type for letterpress printing has always been slow and expensive. Each metal character must be placed by hand onto a plate, which is then inked and pressed against paper. For display type such as this, typesetters charge by the letter.

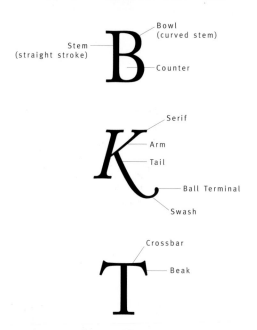

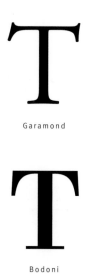

Garamond

Bodoni

Each portion of the letter has a specific name.

Old-fashioned designers who could draw their own type knew intimately the letterforms of the fonts they used and could capitalize on the subtleties of design. Notice the difference in formality between the Bodoni "T" and Garamond "T".

Because letterpress and Linotype designers fashioned totally different fonts for italic and roman typefaces, they could alter design to make each look similar and natural. Notice here how the italic "a" is completely different from the roman "a." Note also how the baseline serifs of the roman letterforms do not appear on the italic version, making the italic letters look more like cursive writing.

Not only was the process slow, it was expensive. Typesetters charged as much as fifty cents per letter for display type. Thus, designers who could sketch their own displays had a real competitive advantage, both in terms of money and time. If this system seems medieval to you, Stermer thought it was great. He says knowing how to draw type forced designers to learn crucial aesthetic lessons, such as the importance of proportion between strokes (straight edges of a letter) and counters (round edges). The very slowness of the process gave designers time to consider the subliminal messages that different type styles can convey, especially through small differences in type design.

A Garamond T and a Bodoni T both have serifs, for example, but look how the Garamond T sticks up above the straight horizontal of the letter, unlike the Bodoni, which is flat.

The downstrokes of the Garamond serifs curve a little, while those of Bodoni have straight edges. The net effect is that Garamond looks more like calligraphy while Bodoni looks more carved. The difference in feel is obvious to anyone who has had to draw them.

Stermer also liked the fact that typefaces were difficult to manufacture. Each letter at each point size had to be carved by hand before the dies could be cast to create a useable alphabet. That meant that a type designer could control all aspects of proportion when it came to changing point sizes. At very large point

Washington

Times Roman

Washington

Times Roman Italic

W

Regular Minion (12pt.)

Regular Minion (scaled to 144pt.)

Display Minion (144pt.)

sizes, for example, a type designer might fatten up thin strokes of a letter so that they were in better proportion with the thick strokes of that letter.

Within a type family, italic and bold faces were all designed and carved separately, giving the type designer enormous control to design faces that carried the feel of the roman face but were subtly modified to look good on their own.

(ABOVE RIGHT)

Notice how much better the scaled "W" is designed compared to the enlarged "W" above it.

(RIGHT)

Letterpress type and Linotype type was manufactured with metal dies (with type either raised or inlaid). Each die was painstakingly carved by hand, so type designers paid a lot of attention to proportion when making different sizes of the same font.

(ABOVE)

Phototype like this revolutionized graphic design. For the first time, typesetting was cheap and fast. An additional benefit was that, because phototype could be letter-fitted photographically, designers could kern letters as tightly as they wished, even to the point of overlap. Letterpress type, by contrast, was carried on a physical die that gave each letter a border so kerning was limited to the size of the metal border around each letter. Printers could physically cut away part of the metallic border to kern letters more tightly, but that was prohibitively expensive.

Of course, Stermer's gain was a type-setter's pain. Acquiring type fonts, with all the point sizes and typeface varia-tions required, was expensive. Heavy, too; the metal letters of a typeface weighed several pounds. You couldn't just download a new font — you had to pay dearly for shipping. Typesetters usually limited themselves to a few faces in a small number of point sizes.

Those limitations spurred the invention of the Linotype machine by Ottmar Merganthaler in 1886. A Linotype machine was a combination of a typewriter-like keyboard and a molten-metal foundry. An operator would type in a line, causing metal dies to line up in a holder. When the line was set, the operator would press a key to cause molten lead to flow into the

dies. The lead solidified quickly, forming a line of type. This system had the advantage of speed, since the operator could type faster than it took to pick out individual letters from cases.

Unfortunately, the printing process was still slow and the resulting printing plates were heavy. Printers began experimenting with thin, photo-reactive plates that could be wrapped around printing cylinders. Because the press cylinders rotated, printers could run a continuous stream or web of paper through the press at high speed.

The idea of producing type and print photographically, coupled with the advent of computers, led to a major advance in typesetting called

```
Cell[BoxData[
    FormBox[
      RowBox[{"\t",
        RowBox[{"\[ScriptCapitalG]", "=",
          RowBox[{
            RowBox[{"\[Chi]", "(", "0", ")"}], "=",
            FractionBox[
              RowBox[{{
                SqrtBox["\[ScriptCapitalR]"], "+", "1"}],
              RowBox[{"1", "-",
                SqrtBox["\[ScriptCapitalR]"]}]}]}]}]}]}],
TraditionalForm]], "Text"]
```

$$\mathcal{G} = \chi(0) = \frac{\sqrt{\mathcal{R}} + 1}{1 - \sqrt{\mathcal{R}}}$$

(LEFT)

Computer typesetting was originally controlled by markup languages such as the one to the left, in which commands for type font, point size, leading, kerning, and layout were all key-stroked separately by hand. Since designers could not see the results until the commands were output, it was easy to make mistakes. One time, I typed in the wrong command for typeface and ended up with twenty galleys all set in Greek characters. One little mistake cost me twenty alteration charges.

phototypesetting. Instead of using metal letters, typesetters bought photo-templates of typefaces that could be mounted in a machine that exposed film to produce letters.

Acquiring new typefaces became much cheaper, and back strain as an occupational hazard for typesetters became a thing of the past.

The only problem was, how would a typesetter tell the computer how to use the right letter at the right point size and in the right typeface? Programmers came up with computer languages that did the job, using codes that could be input with a keyboard. In one system, for example, a $ was used as the symbol that would tell the computer that a directive was

coming. So an operator might type in Gr$p8$l9$y20$u, followed by the text. That would tell the computer to typeset the text in Garamond roman, in a point size of 8 with 9 points of leading at a line length of 20 picas, justified. This kind of language is called a markup language and is still used today by academics who typeset journals and textbooks in a markup language called TeX. It's also used in Web design: HTML stands for hyper-text markup language.

Markup languages give the user enor-mous power to control every aspect of typesetting, but they have two severe drawbacks. They are a pain to learn, and you can't see what you're getting until you output your codes.

These problems were tackled when Microsoft and Apple introduced oper-ating systems for desktop computers that employed the idea of WYSIWYG, what you see is what you get. For the first time, designers could specify typefaces, styles, and point sizes and instantly see what they were getting. Modern digital type was born.

The Advantages of WYSIWYG Digital Type Are Enormous

SPEED

By merely pointing and clicking on a menu, designers can call up a vast array of typefaces, limited only by your computer's memory and your willingness to download more, more, more. If you design something you don't like, you can instantly change it. No more waiting for a messenger to show up with your typesetter's proofs. No more begging your typesetter to please bump someone else's job and do yours first because your client is coming in this afternoon and you really, really need your type.

CONTROL

Having the power to alter virtually every aspect of design, at will, allows designers to do what they do best: see their creativity. In the past, when designers were limited by time and money, they could select very few variations of their designs. When I was a production manager in the old days, for example, I limited my designers to three variations of headline type.

Anything more was simply too expensive. Designers had to hope that one of their choices would look the way they imagined it should. If not (and this was frequent), they either had to convince a penny-pinching production manager to ease up for God's sake, or they had to accept an imperfect design that just didn't look right. Neither prospect was very appealing.

COST

Setting digital type can seem almost free. No one charges you by the letter anymore. Production managers no longer yell at you when you change your mind about your headlines. No one dings you to correct typos. Of course, digital type isn't free. You have to acquire typefaces and page-layout programs. And you have to factor in the cost of your seat-time, as you play around with designs on your monitor. But if you exercise a little self-control and limit your play, digital type is ridiculously cheap, at least in terms of money.

The real price of digital type, however, comes not in coin but in accountability: Who is responsible for quality? In the past, you could literally send out a wadded-up piece of paper with handwritten instructions scrawled all over it, and your supplier had to spin that pile of straw into gold. Now you're the one who has to do it.

To do this well, you have to know a lot more than the principles of good design. You also have to know the principles of typography so that your designs are readable. And you have to know production so that your designs will print.

All this can seem intimidating, especially because software manufacturers like to change their programs often. Just when you feel that you really understand Adobe PageMaker 6.5, for example, along comes Adobe InDesign to put you back into kindergarten.

Digital type is frequently frustrating, too. None of the manuals seem to tell you what you need to know—just try setting a title in boldface followed by leader dots in roman, and you'll see what I mean. The frustration can escalate when you think you've preflighted every possible thing that might go wrong, and then your service bureau calls to say your job won't RIP and what the heck did you embed?

But whenever you feel the urge to open your eighth-story window and fling out your monitor in a magnificent gesture of freedom, remember this. Suppliers want you to succeed. They really do.

The ease of WYSIWYG type allows you to create an image in a matter of minutes using vector-based programs such as Adobe® Illustrator.

Setting type in a curve like this one is almost impossible in markup languages such as HTML. By contrast, WYSIWYG applications such as Adobe Illustrator have the mathematics built in to allow you to drag type and art by using "handle" points. The result is faster and better.

Placing images within asymmetrical outlines is also nearly impossible for markup languages. WYSIWYG applications like QuarkXPress can do it in mere seconds.

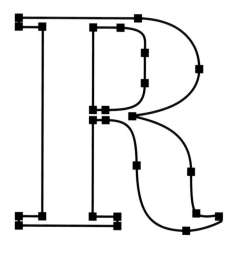

The advantage of object-oriented type is that you can grab onto any of the points defining a letter, and use it to move that portion of the letter around. You can enlarge, reduce, fatten, condense, tilt, or otherwise distort the type without affecting its clarity or resolution.

With that in mind, here are some issues that you need to address in order to make digital type work for you:

Fonts

Back in the days when Microsoft and Adobe were at war with each other, they each assigned programmers to figure out how to tell a computer how to draw type. These programmers devised mathematical equations to draw the curves and straight edges that make up our fonts today. Of course, both companies wanted to keep their mathematically described font outlines to themselves because they were unique. And that was just the problem. Their very uniqueness meant that users could not inter-change fonts. Microsoft's TrueType equations did not compute with Adobe's PostScript Type 1 equations.

From the software companies' point of view, that was not bad. It meant that customers had to buy more of each company's products. But from the user's point of view, it was a pain. Many of us visually oriented users flocked to WYSIWYG precisely because we didn't want to deal with complicated coding or, heaven forbid, the math we thought we'd left behind in high school. We didn't care what the equations were, we just wanted to see typefaces that looked good and didn't cause our computers to freeze up.

OUTPUT DEVICE LANGUAGE

In an attempt to capture their market share, Adobe and Microsoft competed in another area: output device language. Each company tried to convince users to accept either one language or the other as an industry standard.

Unfortunately for Microsoft, Adobe's PostScript programming language hit the street before Microsoft's, and it caught on with the companies who made output devices such as laser printers and imagesetters. The way that PostScript handles type is the same way that illustration programs handle art: with object-oriented curves (as opposed to bitmap images; see page 120). Object-oriented curves are called vector or Bézier curves and are mathematical formulas that can be used to make up straight lines, fixed angles, and complex curved shapes called paths. Using vector curves, you can draw letterforms, diagrams, illustrations, maps, etc.

The way it works is like this: Objects in these software systems are defined by a set of control points that you can input. The points can be manipulated and moved using "handles" that you can attach to the control points (see diagram below). As you move the points around, you can reshape the curves and angles that the points define. As you do so, the computer alters the mathematics of the curves automatically. What you see on your monitor are new shapes that you can change, fill in, rotate, and stretch.

Object-oriented software languages don't care if the objects are letterforms or illustrations. The main difference is that the control points of type fonts are set by the type supplier. You don't have to worry about them, unless you want to alter the type in some way. You can customize PostScript type fonts by grabbing their control points with handles. Then you can stretch it, condense it, fatten it, rotate it, swoosh it, or deform it in any way that you desire.

TrueType

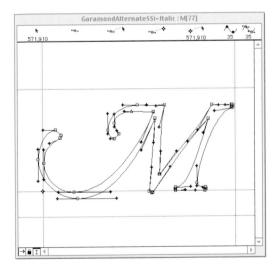

PostScript

(ABOVE)

Both TrueType and PostScript are object-oriented languages, meaning that each letter is defined with a series of mathematically placed points. The problem is that the mathematical formulas for each language are completely different. It's like the difference between Adobe PageMaker and QuarkXPress: Both software applications are layout programs, but their underlying programming is different, and they can't talk to each other.

The overall clarity of the type is not affected in any technical sense (although aesthetically you may end up with type so ugly that no family newspaper would be able to describe it adequately). The reason that clarity remains pure is because the computer makes all your adjustments mathematically. It writes new formulas for each new look.

The most important consequence of this characteristic is that you can resize object-oriented type and art without any loss in quality, whether you make things bigger or smaller. This is the opposite of bitmap resizing (see chapter 5), where pixels are added or subtracted.

Object-oriented designs must be converted into bitmaps, however, so that they can be printed with dots on paper or film. This conversion process is called rasterizing. The machine that performs it is called the Raster Image Processor, or RIP. A RIPing device, such as an imagesetter, converts all imported data (whether in the form of object-oriented type and art or bitmapped layouts and photos) into an output with a given resolution. Once this is done, you can no longer resize your type or art without changing the resolution.

Sometimes the RIPing process causes machines to freeze up. Often this can happen with older imagesetters that can't integrate all the rival font outline languages. One result of the Microsoft/Adobe font wars is the megillah we still wrestle with today. Newer output devices have tried to incorporate software that will read both font outline languages. But the older, PostScript-only devices are still around. That's because people in the print business tend to be conservative. We don't really like to throw anything away, especially anything that continues to work. After all, old letterpresses can still be found churning out flyers. Even woodblock artisans still produce art prints. So it should be no surprise that printers have a hard time believing that an imagesetter that they've owned for only three years and that they're still making loan payments on could be obsolete.

People in the print business tend to be conservative. We don't really like to throw anything away, especially anything that continues to work. After all, old letterpresses can still be found churning out flyers. Even woodblock artisans still produce art prints.

Why should you care about this issue? The fact is, older PostScript-only imagesetters cannot reliably output TrueType. Sometimes they do fine; others times, not. The trouble is, you can't predict when your job will work fine and when it won't output at all.

Because of these factors, there are two things you should check early in the design process: Are your fonts PostScript Type 1 or TrueType? And, can your printer and/or service bureau handle them? In fact, can your printer and/or service bureau handle all of the software programs you have used to create your design? If your print suppliers say they're going to have problems, believe them—and make appropriate changes. You have two choices: either find a supplier who can handle your work, or change your work.

Neither choice is very palatable. Changing suppliers involves establishing new lines of communication, new personnel relationships, new procedures—and new glitches. Start the process early.

Changing your work may be even worse. This is because the typefaces designed by TrueType artists look different from the typefaces designed by Adobe artists. Even a standard typeface such as Times Roman has subtle differences. Some typefaces aren't duplicated at all by the rivals.

This problem came up for me last year when my book designer specified Arial and had to settle for Futura. At first she was very unhappy. Later she became reconciled after working with Futura for awhile. But if I had to put a number on her satisfaction level, I would say the happiest she ever got was about 85 percent. For a production person like me, 85 percent is great. But artists, I've found, are 100 percent-type people. Every few weeks, my designer would kvetch about the type. The book has been out now for seven months, and she still comments on the type now and then. But at least the book did come out. It wouldn't have RIPed at all if we had stuck with the original type specs.

OPENTYPE OUTLINE LANGUAGE

To address these nagging problems, recently Adobe and Microsoft decided to establish détente. They cooperated to create OpenType outline language. Mathematically OpenType attempts to reconcile the differences between the older font outline languages. So a font designed in an OpenType language should work on anybody's system, no matter what.

Of course, that means everyone needs to have upgraded to applications software than can read OpenType and take advantage of its features. That software will come, but you will still need to be careful. Software is not a two-way street. Newer upgrades almost always can handle older software—this is called backward compatibility. But older software cannot read newer upgrades. Once again, you need to check early with your suppliers to make sure that they can handle your fonts.

BOOTLEGGED FONTS

Another pitfall that you must avoid is buying or downloading poorly conceived font outline language. Bootlegged fonts are almost always short on mathematics. In many cases, a bootlegger simply scans someone else's font and then applies simple mathematical equations to describe the gross outlines. The font may look right, and it may even function to some extent. But using it would be like directing a blindfolded mountain climber to cross a narrow ice bridge. "Okay, now you move your right foot 5 inches to the right, and then you take your left foot and move it . . . Ahhhh." Say goodbye to your client.

The main trouble with bootlegged or free fonts is that you don't really know what you're getting. By the time you find out that you have a problem, it's usually late in the production schedule. That's because WYSIWYG is really a bit of a myth. What you see on your monitor is kind of what you get from your output device, but not exactly. Something may look fine on

your monitor but not compute at all in your digital printer's markup language. Or it may not RIP at all on an image-setter. Or it may RIP but come out looking different. If you discover a glitch like this at the last minute, it's usually going to cost you big to fix.

Of course, when you spend a lot of money to buy fonts from a reputable type foundry, you don't really know what you're getting, either. You do know, however, that these companies stand behind their work. For most of us, that's all we really want to know. My advice is, spend the money to buy high-quality fonts. The quality assurance you gain is well worth the price you pay.

If you decide that you simply must save a few bucks by taking the risk of downloading free type fonts, do so early in the production cycle so you have enough time to ask all your suppliers to run tests with them. At least then you'll know what kind of crevice you're going to fall into and maybe you'll even be able to determine how to crawl out again.

Hints for Working with Digital Type

In the old days of photographic type, no one had to worry about whether the edges of a letter would print smoothly. If the photo negative was unscratched, the letters would print cleanly. The process was a physical one: light shined through a negative exposed light-sensitive paper, film, or plate and made a letter with perfectly smooth curves and perfectly straight edges.

Digital type is completely different. Digital type does not exist physically until it is output. It exists as a mathematical formula inside a computer program. When you tell the computer to output digital type, the computer has to think how it can draw a letter onto paper, film, or your monitor screen. The tools it uses to make the drawings are called screen pixels (if output

is on your computer monitor), or dots (if output is on paper or film). Screen pixels are little squares that can be turned on or off at various intensities on your screen; dots can be printed or not printed on paper or film.

The more screen pixels or dots a computer has to work with, the more detail it can show. Think of it this way. Let's say a computer has sixteen screen pixels to work with, four across and four down. How would the computer draw the letter T?

With sixteen screen pixels, the computer can draw any letter with perpendicular or horizontal straight lines. But how can the computer draw a letter with a diagonal, such as N? Even more difficult are letters with curves, such as S. If letters are designed with small details, such as serifs, the computer is completely baffled.

(ABOVE)

When too few screen pixels are used to draw letters, the computer has a tough time making decisions about which screen pixels to turn on and off. Can you guess which letters the computer is trying to draw here?

and the boy dreamed, with the wind in his hair and a song in his heart.

(ABOVE)

Take a look at how difficult it is to read the type in this picture on a monitor. The type is set too small, has too many thin strokes, and is designed with too-fine serifs. When you look at the type through a loupe, you can see how the computer struggles to draw these fine details, but the computer simply has too few screen pixels to work with.

To solve this problem, manufacturers of output devices realized they would need many, many pixels and dots to allow computers to draw details, curves and diagonals. Over time, they settled on widely accepted norms: seventy-two pixels per inch for computer screens; 300 dots per inch for low-quality paper output and up to 1,200 or 2,400 dpi for high-quality paper output (for further discussion of pixels and dots see Chapter 5).

At these high-end levels, most typefaces look smooth, with crisp details and fully rounded curves. Problems can develop, however, when point sizes are very small or when the number of dots per inch falls below 300. The problem is acute with computer-screen type because only seventy-two screen pixels per inch are used. See for yourself. Take a loupe and look at some type on your computer screen.

HINTING

One way that typeface designers have attempted to make digital type more legible is a process called hinting. When a computer draws type, it has to decide which pixels to turn on or off. As an entity with very little brain, a computer uses general equations to make these decisions. A human artist, given the same problem, would exercise artistic judgment when choosing which pixels to use. A human's choices might not always be consistent, mathematically. A computer's choices always are.

Hints are mathematical algorithms that tell a computer how and when to exercise a little more choice about when to use its pixels. The more sophisticated and particular the hints are, the more discretion a computer has to apply itself to pixel problems in different situations. For example, to draw an M at a small point size, a computer might realize that turning on a pixel too far to the left of the center of the diagonal would make the stroke of the letter look bumpy (see below).

But at a large point size, turning on pixels in that same area of the letter M might help make the stroke look smoother.

Programmers can spend a lot of time writing hinting codes. However, the more hints they use, the better the typeface looks. This is one of the main reasons why you should be very careful about downloading bootlegged or free fonts. Such fonts are almost always short on mathematical hints. In many cases, a bootlegger simply scans someone else's font and then applies simple mathematical equations to describe the gross outlines.

(ABOVE)

An outline that hasn't been grid-fitted. Note how poorly the outline corresponds to the pixel pattern and, above all, how awkward the bitmap of the M is.

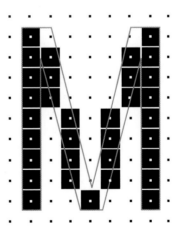

(ABOVE)

The same outline grid-fitted. Now the outline has been adjusted to fit snugly around each pixel, ensuring that the correct pixels are turned on.

Toyota

abode

(ABOVE)

Our Roman alphabet looks great when all the letters in a word have similar shapes, such as these round letters in the word "abode." But look how our eyes struggle with the letter-spacing when diagonal strokes are positioned next to circles, and skinny letters appear next to fat ones (above far right). Kerning individual letter-pairs helps overcome this optical difficulty.

Kerning

There's no doubt that when the early Phoenicians designed the letters of what later became our alphabet, they made a great technical advance in the science of written communication. The designers, however, must have been engineers. Any artist would have come up with a design that aesthetically was easier to work with.

The design works fine when you're using compatibly shaped letters of equal width.

Unfortunately, most of the letter combinations in our language present a concatenation of diagonal lines next to straight ones, curves next to diagonals, square shapes next to diamond shapes, and so on.

Word shapes that have too many uneven amounts of solids and white spaces can be hard to read.

To solve this problem, typeface programmers use kerning. Kerning is the removal of excess white space between pairs of letters to create the optical illusion of even spacing.

During the font wars of the 1980s, type programmers competed against each other to see who could supply fonts with the greatest number of kerned pairs. How many? Consider that the English alphabet has twenty-six letters, each with an uppercase and lowercase.

Yo We To Tr Ta Wo
Tu Tw Ya Te P. Ty Wa
yo we T. Y. TA PA WA

SEATTLE WORKS ON WATER

by the Sixth-Grade Students of Seattle Academy of Arts and Sciences

If you kerned every pair, you would get 2,704 pairs. Now throw in punctuation marks such as ? ! " , etc. Add numerals. Include swashes and ligatures. By the time you're finished, you could end up with more than 5,000 kerned pairs.

At those levels, however, you're also using up a lot of memory. Do you really need that much kerning? Like most things in our business, the answer depends on what you need versus what you can afford. Kerning works best when it's in balance. For most text, type fonts with a couple hundred kerned pairs are fine.

If you need to kern anything beyond the most commonly used pairs, you can use applications software such as Adobe PageMaker to customize pairs. You can do this globally for a font, so that your customized kerning pairs will be used every time you use the font. Or you can customize for just one document. For display type, you can kern each letter individually if you want to take the time.

Kerning for me is a lot like washing windows. You should do it, but if you agonize over every little speck, you'll never have time to do anything else. Focus on what really matters, then move on.

(ABOVE LEFT)

Here are the twenty most common kerning pairs in our alphabet. All well-designed type fonts automatically kern these letter-pairs, as well as many more. Cheap fonts skimp here, and it shows.

(ABOVE RIGHT)

Display type, such as in this title, should be kerned by hand. Here, the designer did not specify the point size of anything in the head. Instead, she asked that each line in the head be justified and very tightly kerned at the largest point size possible. This kind of design specification would have been almost impossible to achieve with metal type; digital type made the whole job possible in just minutes.

JKLM

All typesetting is based on the original version of writing: handwriting. When ancient calligraphers wanted to draw a larger or smaller size of type, they proportioned the thickness of their strokes by eye so that the letterforms stayed in proportion optically. The best typesetting applications pay just as much attention to proportion as did the early calligraphers.

Scaling

In the old days of typesetting, when you wanted to scale type up or down to a different size, you had to carve a new set of letters. The process was slow, but you had total control of it. Nowadays, your computer can apply a mathematical formula and simply make letters bigger or smaller. To turn 9-point type into 36-point, you can just apply a factor of four, right? Wrong. Unfortunately, enlarging or reducing type is more complicated than that.

When you enlarge type evenly, the real proportions of the thin and thick strokes don't change, but they should. If they remain the same, the thin strokes look clunky, the serifs dominate too much, and the thick strokes can look a bit fat or frail. When Michelangelo carved his really big David, he made the statue's hands proportionately bigger. He knew that "correctly" proportioned hands would have looked dinky. Conversely, when you buy down-sized, street-vendor copies of Michelangelo's statue, the hands look huge as baseball mitts.

Times 12-pt.

Times 200% or 24-pt.

Times 300% or 36-pt.

Times 800%

Graphic Design
Caption (6–8pt.)

Graphic Design
Regular (9–13pt.)

Graphic Design
Subhead (14–24pt.)

Graphic Design
Display (25–72pt.)

Metal type designers had the luxury of adjusting the proportions of the different point sizes in a given typeface. They simply carved whatever looked good. Digital type suppliers should do the same thing—it's called optical sizing. But they commonly don't. Recently though, Adobe began offering optical sizing options in some OpenType fonts. The options are generally available as "Opticals" in four size categories: caption (6- to 8-point); regular (9- to 13-point); subhead (14- to 24-point); and display (25- to 72-point).

(ABOVE)

Be careful when you scale up ordinary type— the resulting display type might look clunky. Instead, you should consider ordering a special font just for super-sized type. Notice here how bad Times looks when enlarged 800 percent. A properly designed display typeface would make the crossbar of the "T" more narrow. Similarly, the narrow parts of the round strokes would also be more narrow.

(LEFT)

Note the subtle design differences in these OpenType point sizes: As the point size gets bigger, the thick strokes are made proportionately thinner so that a sense of balance between thick and thin strokes is maintained at all point sizes.

Type Families

A type family is a group of typefaces created with similar design characteristics. The most common members of a family are roman, italic, bold, and small caps. But some typefaces, such as Univers, have huge extended families consisting of variants such as semibold, extra bold, slanted, extended, condensed, etc.

In the old days, type foundries created families by carving new sets of alphabets. Each family was designed to resemble the parent, or roman face. But they also looked good on their own.

Digital type designers can do this, too. But it's expensive. A designer has to draw each letter, uppercase and lowercase, separately. It's a lot easier to program an algorithm that tells your computer to alter a roman letter so it mimics a new family. To make a roman X look bold, simply fatten up all the strokes.

Roman

Bold

UNIVERS

Thin Ultra Condensed	ABCDEFGabcdefg
Light Ultra Condensed	ABCDEFGabcdefg
Ultra Condensed	**ABCDEFGabcdefg**
Condensed Light	ABCDEFGabcdefg
Condensed Light Oblique	*ABCDEFGabcdefg*
Condensed	ABCDEFGabcdefg
Condensed Oblique	*ABCDEFGabcdefg*
Condensed Bold	**ABCDEFGabcdefg**
Condensed Bold Oblique	***ABCDEFGabcdefg***
Light	ABCDEFGabcdefg
Light Oblique	*ABCDEFGabcdefg*
Roman	ABCDEFGabcdefg
Oblique	*ABCDEFGabcdefg*
Bold	**ABCDEFGabcdefg**
Bold Oblique	***ABCDEFGabcdefg***
Black	**ABCDEFGabcdefg**
Extra Black	**ABCDEFGabcdefg**
Black Oblique	***ABCDEFGabcdefg***
Extra Black Oblique	***ABCDEFGabcdefg***
Extended	ABCDEFGabcdefg
Extended Oblique	*ABCDEFGabcdefg*
Bold Extended	**ABCDEFGabcdefg**
Bold Extended Oblique	***ABCDEFGabcdefg***
Black Extended	**ABCDEFGabcdefg**
Extra Black Extended	**ABCDEFGabcdefg**
Black Extended Oblique	***ABCDEFGabcdefg***
Extra Black Extended Oblique	***ABCDEFGabcdefg***

Here is GARAMOND (TrueType)

Here is GARAMOND italic (applied from Style menu in Word)

Here is GARAMOND italic (a separate TrueType font)

Here is GARAMOND bold (applied from Style menu)

Here is GARAMOND bold (a separate TrueType font)

Here is GARAMOND bold italic (applied from Style menu)

Here is GARAMOND bold italic (a separate TrueType font)

Here is GARAMOND semibold (a separate TrueType font)

Here is GARAMOND semibold italic (a separate TrueType font)

This system works remarkably well— until, that is, you compare such faux families to the real thing. Note how a designed italic Garamond (above) looks more natural and elegant than a faked one. The serifs are more elongated, the open counters of the round letters are more compressed, the strokes are a bit thinner. Similarly, note how different a designed bold looks compared to an obese roman (far left). The differences are especially apparent in the x-height of the letters.

Whenever you can, you should buy the designed versions of type families. Your designs will look much better. Bear in mind, however, that to use these designed versions, you have to forego using the Style option for italic or bold in the menu bar. Instead, you must use each family as though it were a different typeface. In reality, they are. Furthermore, you've got to make sure that your applications software supports this use of type families. Some applications, when told to use italic, will confuse the italic of the menu bar with the real italic of an installed font. Don't let that happen to you.

(ABOVE)

You can create bold and italic versions of a roman typeface by using these options in the menu bar, but they won't look as good as the designed versions available for purchase as separate typefaces.

fine fine

The firefly danced in the darkness

(ABOVE TOP)

Ligatures (right) are separate letterforms designed to eliminate the awkwardness that occurs when serifs of one letter collide with elements of an adjoining letter (left).

(ABOVE BOTTOM)

You should exercise care when using ligatures. If a line is loosely spaced, as this one is, ligatures look goofy because the amount of space between each half of the ligature is fixed. So here, for example, the "fi" and "fl" of "firefly" are closely spaced, but every other letter pair is more distantly spaced.

Special Features

Certain typefaces come with special design features that can add a real sense of quality to your designs. When you're out shopping for typefaces, keep some of these in mind:

LIGATURES

In some letter combinations, an element of one character can interfere with elements of neighboring characters.

In the word "fine," for example, the f's crossbar can overlap the i's dot. To avoid this problem, a special character has been designed that elides the two characters and eliminates the dot. Characters that are elided in this way are called ligatures. The most common ligatures are fi, ff, fl, ffi and ffl.

Better-designed typefaces have ligature characters. You should use them whenever typesetting a tightly spaced line. However, if a line is loosely spaced, you should not use ligatures.

1234567890

é ü rᵃ ô

The seminars will be held on July 15, 2010 and July 17, 2010.

OLD-STYLE NUMERALS

Numerals used in body text can overwhelm ordinary characters and give the numbers an emphasis that they don't need. To overcome this problem, type designers sometimes design numerals that have ascenders and descenders just like alphabetic letters. These numerals look natural in text, because they resemble the alphabet. They should not, however, be used in tables. Keep in mind that not all typefaces have this feature, however. More's the pity.

SUBSCRIPTS AND SUPERSCRIPTS

Applications software can turn any number into a subscript or superscript, simply by using ordinary numbers set small. That being said, it's better to find a typeface that has designed subscripts and superscripts. because they look in better proportion.

ACCENTS

If you do a lot of typesetting in languages that have accented letters, find a typeface that contains them as designed features. Keystroking will be easier, type will look better, you'll make fewer typos, and you will avoid the danger of encountering an imagesetter that reads a tilde as a blank rectangle.

(ABOVE LEFT AND BELOW)

Old-style numerals, with ascenders and descenders, look better in text than numerals aligned along the baseline. This is especially true if multiple numerals are set together, such as in dates. Notice how much larger the year 2010 looks compared to the other words in this sentence.

(ABOVE UPPER RIGHT)

Whenever possible, buy type fonts that are designed with separate letterforms for accents, superscripts, and subscripts. The type is better proportioned and is often easier to keystroke.

It's hard to read text with long line lengths. The eye gets lost when it tries to track one line to the next. A good rule of thumb is to never set lines longer (in picas) than twice the size of your type (in points). So 10-point text should never be set in lines longer than 20 picas. Similarly,

lines set
too short
look choppy.
The ideal
line length
measures
the equiv-
alent of
an alphabet
and a half,
when the
alphabet
is set with
normal let-
ter spacing.

Lines with too much leading (spacing) between them

are hard to read. The best leading for typical 10- or

11-point body text is one point larger than the point

size. Larger type, however, should have a point or

two more leading. Display type should be leaded by

hand for best visual effect.

Readability

One last issue about type is really important: readability. In the days when a designer could send a marked up wad of papers to a typesetter and let her worry about quality, readability was left largely in the hands of experts. Now the expert has to be you.

Here are some tips that will improve the readability of your text:

LINE LENGTH

It's hard to read text with long line lengths. The eye gets lost when it tries to track one line to the next. A good rule of thumb is to never set lines longer (in picas) than twice the size of your type (in points). So 10-point text should never be set in lines longer than 20 picas.

Similarly, lines set too short look choppy. The ideal line length measures the equivalent of an alphabet and a half, when the alphabet is set with normal letter spacing.

LEADING

Lines with too much leading (spacing) between them are hard to read. The best leading for typical 10- or 11-point body text is one point larger than the point size. Larger type, however, should have a point or two more leading. Display type should be leaded by hand for best visual effect.

Sometimes, due to word spacing, you can create inadvertent patterns of white space, like rivers. Rivers of white space can be very distracting, because the eye is drawn to them rather than to the meaning of the words. Correct these by revising the text, changing the line length or altering the word spacing in some of the lines.

A widow is a short line in the last line of a paragraph. Widows that are less than one-third the length of a full line should probably be fixed.

An orphan is a widow that is carried to the top of the next column or page. You should always eliminate orphans.

"Mi-nute" and "min-ute" are different words.

RIVERS OF SPACE
Sometimes, due to word spacing, you can create inadvertent patterns of white space, like rivers. Rivers of white space can be very distracting, because the eye is drawn to them rather than to the meaning of the words. Correct these by revising the text, changing the line length or altering the word spacing in some of the lines.

WIDOWS AND ORPHANS
A widow is a short line in the last line of a paragraph. Widows that are less than one-third the length of a full line should probably be fixed. An orphan is a widow that is carried to the top of the next column or page. You should always eliminate orphans.

HYPHENATION
Make sure words are hyphenated correctly. "Mi-nute" and "min-ute" are two different words. Limit the number of lines that end in hyphens. Don't stack up more than two hyphenated lines in a row.

Colored type can be very effective, but only if it doesn't fatigue the reader. Pale grays or pastels are a bad idea because the contrast between the type and the white paper is not strong enough. You need type with a density of at least 30 percent to show up well enough on white paper.

Furthermore, if you print the colored type using a screened-back halftone to create the color, you run the risk of reducing readability even more. That's because the edges of each letter will be broken up into dots, not lines, so the edges will be less distinct.

TEXT SET ALL IN CAPITAL LETTERS IS HARD TO READ. THAT'S BECAUSE PEOPLE READ BY SCANNING QUICKLY OVER ENTIRE CHUNKS OF WORDS. THE SHAPES OF THE UPPERCASE AND LOWERCASE LETTERS HELP READERS IDENTIFY WORDS QUICKLY. READERS CAN'T DO THIS WITH CAPS BECAUSE ALL THE WORDS HAVE BASICALLY THE SAME RECTANGULAR SHAPE.

COLORED TYPE

Colored type can be very effective, but only if it doesn't fatigue the reader. Pale grays or pastels are a bad idea because the contrast between the type and the white paper is not strong enough. You need type with a density of at least 30 percent to show up well enough on white paper.

Furthermore, if you print the colored type using a screened-back halftone to create the color, you run the risk of reducing readability even more. That's because the edges of each letter will be broken up into dots, not lines, so the edges will be less distinct.

CAPS

Text set all in capital letters is hard to read because people read by scanning quickly over entire chunks of words. The shapes of the uppercase and lowercase letters help readers identify words quickly. Readers can't do this with caps because all the words have basically the same rectangular shape.

Grunge type or excessively swooshed type is hard to read for the same reason: The eye cannot easily identify word shapes. Because reading is slowed down, the eye becomes tired. The reader ends up having to read each word separately, the way we did when we were first learning to read. Imagine if you had to read **Moby Dick** by laboriously sounding out each word. You'd never get out of port. You'd never meet the white whale. And you'd miss the whole point.

GRUNGE

Grunge type or excessively swooshed type is hard to read for the same reason: The eye cannot easily identify word shapes. Because reading is slowed down, the eye becomes tired. The reader ends up having to read each word separately, the way we did when we were first learning to read. Imagine if you had to read *Moby Dick* by laboriously sounding out each word. You'd never get out of port. You'd never meet the white whale. And you'd miss the whole point.

Chapter 3: Color Images

If you've ever found yourself toiling in front of a monitor trying to get the last little screen pixel of a photo to look perfect, you know that scanning and software systems today are powerful enough to do almost anything with color. But that power comes with a price—usually hours of seat time that can swallow whole production schedules in a single gulp.

In the days before desktop publishing, pointillist painter Georges Seurat used to paint like that, dot by dot. It took him years to get anything out the door. Neighbors used to hear his wife yell at him, "Georges, are you done yet?"

"Non."

"But Georges..."

"Tais toi (shut up)!" And quiet would descend. But it wouldn't be a happy quiet.

You too can achieve the lasting effects of the master painter, but only if you live in a time capsule. Otherwise, you should make every effort to avoid the need to turn bad art into good. In other words, you should select great originals in the first place.

How can you tell when you've got good originals? The best color originals are the ones that control three factors: composition, sharpness, and color.

This photo has all three of the necessary factors for good reproduction: The composition is appropriate for a photo that has no type on it; the focus is good, so details are sharp; and the colors look saturated because there is a full range of tone from highlight through midtones to deep shadow.

(CENTER)

Notice how good the lighting is on this photo. It brings out perfectly the intricacies of the carving. You can see the details because of the play of light and shadow that highlights the carving. If the lighting were more direct or the photo not in pin-sharp focus, the details would fade into the background.

(RIGHT)

Many outdoor photographers prefer to shoot on cloudy days because they don't have to worry about introducing too much contrast from bright sun and dark shadow. Photos shot in this kind of light can be a little tricky to reproduce, however, because they do lack contrast, so they can come out looking flat. Avoid this by making sure that the photo you select does have a bright highlight somewhere in it, and a dark shadow. Can you find the highlight and shadow in this picture?

Composition

When you evaluate the composition of a photo, don't look just at the artistic merit of the piece. Ask yourself how you plan to use it, and then make sure your photo has the necessary elements to succeed technically. Here are some considerations:

DIRECTION

Is your photo facing the right way? Directional considerations can have great meaning to a designer. Should a model face into the gutter or out? Should the weight of the composition be on the left or right? Luckily, software programs make it quite easy to flop photos. But, if you'll pardon the pun, this capability is a two-edged sword. With it you can create monumental goofs, which once happened to a textbook publisher.

At first glance, the photo above looks eminently floppable. Nobody is famous, the building is almost completely symmetrical, and hieroglyphs can be read from left to right or right to left. Why not flop? The reason is that this building is the Temple of Hatshepsut, and this view shows the place where terrorists slaughtered a group of tourists some years ago. While the building is not as famous as the White House, it's well enough known worldwide to merit a ban against flopping.

BEFORE YOU FLOP ANY COMPOSITIONS, THINK VERY CAREFULLY ABOUT WHETHER ANYONE WILL NOTICE.

- CHECK ESPECIALLY FOR PRINTED TEXT IN THE PICTURE.

- BE CAREFUL WITH FOREIGN SCRIPTS THAT MAY LOOK DECORATIVE BUT REALLY DO SAY SOMETHING.

- LOOK FOR SUBJECTS THAT HAVE AN INHERENT DIRECTION. *Americans place their right hands, not their left, over their hearts when saying the pledge of allegiance, for example. The British drive on the left side of the road, etc.*

- AVOID FLOPPING ANYONE OR ANYTHING FAMOUS THAT HAS RIGHT- OR LEFT-HANDEDNESS.

The publisher was making a presentation to a school board some years ago, during a competitive bid for a new history book. He was bragging about how the authors had gone to great lengths to use original sources, even in the illustrations. As an example, he opened his book to a section on ancient Egypt and showed the board how the designer had used a real illustration from a papyrus in the British Museum. Unfortunately, the hapless publisher failed to realize that one of the board members was a former Egyptologist. She pointed out that the illustration had been flopped.

The publisher's response was that so few people would notice the flop that it wouldn't matter. Even more unfortunately for the publisher, however, another board member was an African-American who had been fighting for equality all his life. When he heard that an African picture had been flopped and that "it didn't matter," he went ballistic. End of sale.

(ABOVE LEFT)

Famous people—even when they're statues— have left- or right-handedness. Michelangelo's David holds his right hand down, not his left.

(RIGHT)

Pictographic languages such as Japanese may look just as beautiful to our Western eyes whether they're flopped or not. But don't forget that the pictographs can be read by millions of people, so do not flop them.

CROPPING

Almost always, after you have scanned an original into your computer, you will want to crop it. This is definitely something you should do early in your design, because cropping reduces the number of pixels your computer has to manipulate. In other words, a cropped picture uses up less disk space. Not only does this free up disk space for more designs, it also lets your software programs run more smoothly and faster.

When you do crop, however, be careful what you throw away. Rather than trash your original scan, save the cropped version under a different name. You're still getting rid of pixels, but if you change your mind and decide to reinstate the cropped-out portions of your art, you can. If you trash the pixels permanently, you're doomed to use the cropped version forever.

MOVING

If you do need to crop your original, rotate it, or manipulate it in some other way, do so using the original scan. Then save the changes as a new version with a new name and import the finished version into any layout you design. Don't import the original scan itself, which may have many more pixels in its bitmap than you actually use.

The computer doesn't really care what you do with the pixels, but it must still make decisions about each pixel that it has in a file. Even if the computer's decision is, "Don't use it," the computer still has to think about it. This takes time and memory, which can be particularly aggravating if you're transmitting your designs or if you're RIPing them on a high-resolution imagesetter.

(ABOVE)

This photo needed to be straightened (i.e., rotated) and flopped. After performing these operations in an image-manipulation program such as Photoshop, you should save a separate, new version before importing it into your layout program. By saving a new set of pixels, you keep the RIPing computer from wasting time rotating and flopping the pixels when it's trying to output a final, high-resolution design.

Type on Art

Overprinting or reversing out type
in the digital world is as easy as
importing graphics, keystroking your
type, adding a few layers, and poof!
You've got art. More than that, you've
got design. Through the wonders of
powerful software programs, you can
make type and graphics magically
appear on your computer screen,
move them around, show color—all
at the mere touch of a few fingers.
Who needs to worry about photo
composition when you can control all
the elements in your design at will?

The problem is, computers seem
incredibly smart but they're actually
really dumb. They just do what they're
told. So if you tell a computer to put
red type over a dark-blue portion of a
photo, it will do so. What does it care
if the design makes your readers' eyes
bounce around worse than a Volkswagen
on a washboard road?

But if you care about your readers,
you must pay attention to how your
type is arranged on your art. Here are
a few things to watch out for:

(ABOVE)

There are many ways to print type over photos: overprint, reverse, in a box knocked out, over a screened-back version of the art, big, little, or not at all. When you have a strongly patterned photo such as this one, which choice is best?

TYPE ON A PATTERNED BACKGROUND

Whether you overprint black type on a colored background or reverse it out, choose an area of color in your photo-composition that is flat and smooth, not patterned.

Studies have shown that we read text not as individual letters, but as blocks of shapes, usually two to five words at a time. If the pattern of the background interferes with the patterns made by the type—the ascenders, descenders, round shapes, angles, etc.—we are forced to look at each letter individually. This not only slows down our reading speed, but it tires out the eyes. Readers get discouraged by this and may give up on reading your message at all. If the background pattern and type actually blend with each other, readers may not be able to distinguish the shape of the letters at all. This is especially true if your type is smaller than 12-point, or if it is a font designed with fine serifs.

If you must use a photo with a strong pattern, you can improve readability by enlarging your type and using a sans serif font with thick strokes. If it is still problematic, you can knock out a box from the background photo and float your type within the box.

Another way still is to screen back the photo itself; so all the colors are much paler than in the original. You can do this by choosing a portion of the photo to screen back (in effect, creating a pale box for the type), or you can screen back the entire photo. If you use this technique, screen back the photo so that the deepest shadow has a total density of 30 percent. This may cause the lightest portions of the photo to disappear altogether, a sign that perhaps you should choose a different photo.

When you're printing black type over a black-and-white illustration, make sure there is enough contrast between the type and the art. There should be at least a 70 percent difference in tones. Here solid black type is generally readable over grays that range from 0 to 50 percent density.

But if you tried to screen back the type to print 40 percent black, you would have a problem.

OVERPRINTING TYPE ON A FLAT BACKGROUND

Even if you are careful about choosing a flat area of color to overprint type, you may still overprint something that is unreadable. You've got to consider the density of the type versus the density of the background.

Choose a place in the photo where the colors are pale enough so that readers can see the black type clearly. If the color of the background and the color of the type are the same, black type over a black-and-white illustration for example, then follow this rule of thumb: Allow at least a 70 percent difference between the density of type and the density of the background. So if you're overprinting solid black type (100 percent black), then you should not let the background get any darker than 30 percent gray.

123456 Abcdefg

123456 Abcdefg

If you're overprinting black type on a colored background, the total density of CMK (cyan, magenta, and black) should not exceed 90 percent in any combination, as long as the percentage of black stays below 30 percent. So you can safely overprint black type on a background with densities of, say, 40 percent cyan, 20 percent magenta, 30 percent black. Or you could use 60 percent cyan, 20 percent magenta and 10 percent black.

Notice that yellow has not been mentioned. That's because our eyes do not perceive yellow density very well. So generally you can use any additional percentage of yellow without affecting the readability of overprinted black type.

REVERSED-OUT TYPE

If you plan to reverse out type from a photo background and print the type in white, the background should have a total density of at least 40 percent. Without this, there won't be enough contrast between the white of your type and the white of the underlying paper. Choose an area of your photo that has enough pixels in it to provide the contrast you need.

(ABOVE LEFT)
The total density of CMYK in the water is 95 percent. Black type overprinted here is not easy to read.

(ABOVE CENTER)
Here the total density of CMYK across the butterfly ranges from 105 percent in the highlight, to 126 percent in the midtones, to 168 percent in the shadow. Black type is legible here because the density of black ink in the butterfly is less than 30 percent.

(ABOVE RIGHT)
The total density in the sky is 39 percent, making it difficult to read reversed-out type. By contrast, the total density in the water is 144 percent.

123456 Abcdefg
123456 Abcdefg

(ABOVE)

Outlining the type helps hold letter shapes whether the type is placed in a dark or a light part of the photo.

(FACING PAGE, TOP LEFT)

The colors in the sky here are very dense (215 percent of CMYK) as is the color of the type (200 percent CMYK). In addition, blue and red are on opposite sides of the color wheel. Look at the halo effect in the negative, or blank areas around each letter. Then take two aspirin and call me in the morning.

If you want to reverse type out of a photo that has lighter and darker areas in it, consider outlining the type with a hairline of black. The hairline will hold the shape of each letter in the lightest parts of the photo and won't interfere with the appearance of the reverse in the darker portions of the photo.

OVERPRINTING COLORED TYPE

Be careful about the colors you choose when you print colored type on a color photo or illustration. Some color combinations cause the eye to "bounce" from color to color because the negative space around each letterform is filled in by the background color. This creates a halo effect around each letter. The effect is worse if the colors you choose for the type are similar in density to the colors you have in the background, and those colors appear on opposite sides of the color wheel. Rich red letters on a dark blue sky are very difficult to read, for example.

If you try to output this kind of combination on a computer monitor (for instance, if you are translating a print campaign into a Web campaign), you will create a page that is almost impossible to read. That's because a computer monitor actually emits light, intensifying the halo effect. It's like shooting laser beams straight into your eyeballs. Powerful, yes, but also painful.

Sharpness

Unless you have a particular reason to use a soft-focus or out-of-focus picture, you should choose originals that have the sharpest details you can find, because the printing process degrades details. You lose information during every step of production, beginning with photo development and running all the way through scanning and final output. To ensure the sharpest detail, check out these considerations:

SIZE

The sharpness of a printed piece is affected by the size of the original. In simple terms, big printing requires big originals, if you want to hold detail.

So be careful when you decide that you don't need to use a full-frame original but want to blow up a portion of it to an enormous size.

Think of it this way: When a photo is digitized, a scanner chops it up into a given set of numbers. These numbers are called pixels. Once a photo has been scanned and turned into a set of numbers, the amount of numbers in the scan cannot be increased in any satisfactory way. But you can always throw away some numbers! For example, if you don't like the left-hand portion of a photo, you can throw out those pixels and never deal with them again. But you can't add them back in if you change your mind. Once pixels are gone, they're gone for good.

(TOP RIGHT AND CENTER)
This 35mm transparency looks fine when enlarged by 300 percent. But look at the graininess when we try to blow it up too big.

(BOTTOM)
Resampling up is a mathematical process that your computer can use to create new pixels. This is done most often when a photo has been scanned at a low resolution, losing detail. A designer may wish to increase detail by telling the computer to add pixels. The computer does this by interpolating the new pixels from the data in adjacent pixels. This, however, cannot add detail if the detail is not already there. For example, all the upsampling in the world won't restore the writing on the spools on the left side of this photo.

(ABOVE LEFT)

The amount of detail your computer can produce is related to the number of pixels it starts out with. Like butter on a knife, the computer spreads its pixels over any size area you desire. But also like butter, if you don't start with a goodly number of pixels, you won't give your readers much for their eyes to feast on. A really good photo, shot with larger-format film, should show little or no grain when enlarged.

(ABOVE CENTER)

This black-and-white photo was originally scanned from an 8-by-10-inch (20-by-25-centimeter) print. The scanning resolution was set at 300 dots per inch to keep the file size manageable. When the image size was reduced to 3 inches wide, the resolution became 700 pixels per inch. At this resolution, can you see any grain?

It is true that some software programs allow you to "resample up," meaning more pixels can be added to the file. But are these pixels good pixels? The computer resamples up by averaging adjoining numbers. In other words, it guesses how the new pixels should look from the data it already has, but it can't add anything really new.

The nature of pixels dictate why it's important not to enlarge your final output too much. Pixels living on your computer disk don't have any fixed size, they are just numbers. When you tell the computer to output its pixels onto a substrate—let's say a sheet of paper on a digital press—the computer needs to know how far you want it to spread its pixels. It could cram all the pixels into a quarter-page photo in a book, or it could spread them out over a large poster on the side of a

bus. However much the computer spreads its pixels, the amount of pixels it has to work with does not change.

It's kind of like spreading a pat of butter on bread. You can spread that butter on a cracker and get full, dense coverage. Maybe you have even more butter than you need and should have started with half a pat (i.e., you should throw some pixels away). You can also spread the same pat of butter on a foot-long baguette and hardly be able to see any butter on the bread. Maybe you should have started with more butter.

The best way to increase the number of pixels a computer has at its disposal is by scanning at an appropriately high resolution so you have plenty of pixels (but not so many that you can't run your software programs

(LEFT)

To check for sharpness, look at fine detail in areas such as curved or straight lines, hair, eyes, grass, or leaves. Do these areas look sharp or fuzzy?

(BELOW)

If you must use a fuzzy, out-of-focus photo such as this one, try sharpening it in Adobe Photoshop. Sharpening works best when the details that are out of focus exhibit broad differences in color. Look at how much better the photo on the right appears after sharpening.

efficiently; see Chapter 5). This will create the maximum number of pixels available in your scanning device.

But if you start with a scan of a small picture, say a 35mm transparency, even if you scan at a high resolution, the scanner is marching across only 35 millimeters of information. Adding more pixel-capacity is not going to add details that aren't in the film already. Enlarging a 35mm original too much causes the final output to look grainy or out of focus.

On the other hand, if you start with an 8-by-10-inch (20-by-25-centimeter) transparency, the scanner can still chop up the photo into the same small bits of numbers that it used for

the 35mm original. It just has more data to work with because the area it scans is bigger. In effect, there's more butter on the knife.

In a practical sense, if you enlarge an original transparency by more than 1,000 percent, you will start to see graininess and loss of detail.

Similarly, if your original is a piece of reflective art (as opposed to transparent art), you also need to pay attention to the size of the original. However, if you're using a photographic print, it is not an original. A photographic original is the negative from which the print was made. In most cases, the print has already been enlarged. But enlarging a photo does not add more

information to it, it just makes the picture bigger. So be careful when you select a photograph to reproduce. Check out the grain on the print itself. If you see any, it might be better to get a smaller print with less grain, if possible.

Scan the print at full size and at the highest resolution that is practical. This will give you the greatest number of pixels with the least amount of grain.

FOCUS

To check whether a picture is in focus, always use an eight-power or greater loupe or a magnifying lens. Don't rely on putting a transparency into a viewing screen of one sort or another—such systems merely take you farther away from the original.

Looking through a loupe, check areas in the photo that have fine lines or edges. Can you see everything clearly? If the main subject in the picture is a person or an animal, most photographers choose to focus their cameras on the subject's eyes, so look there too. Can you see pin-sharp detail?

If your photo is slightly out of focus and appears a bit fuzzy, you can use editing software to fix it without too much trouble. The tools that do this fall into two broad categories: One set of algorithms looks at adjacent pixels of different colors and increases the differences between them. This is called sharpening The other kind of tool looks for edges within a picture—continuous lines of pixels of one color. Then it increases the contrast between those pixels and the ones on either side of the edge. This kind of sharpening is called "Unsharp Masking."

Not even sharpening can make an out-of-focus photo look completely sharp.

Even when a photo is in focus, sometimes it's hard for the reader to see it very well if the colors and patterns of the main subject blend in with the background. Sharpening can help set the main subject apart from the background.

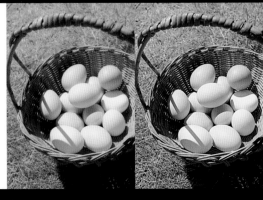

Unsharp masking can really help a fuzzy photo that has edges in it, because the program adjusts only those pixels, leaving the pixels in more graduated tones alone. So you get an increase in the effect of lines without increasing the linear look overall. You can also control the amount of contrast and the number of pixels that exist between edges before the program kicks in and does anything about it.

Using unsharp masking can produce dramatic results, but you can definitely go overboard. Too much unsharp masking makes a picture look like someone drew cartoon lines around the subjects. When such pictures are printed on a digital press, the effect can look like a poor trapping job, with colors overlapping each other to form dark boundary lines.

You should realize, too, that tricks such as sharpening or unsharp masking cannot really substitute for lack of detail in the focus. Once again, the computer can work only on the pixels that it has in its file. If details aren't in the original, you can't tell the computer to make them up.

Sometimes a photo is in perfect focus but you still can't distinguish the subject very well. This happens when the colors and shapes of a subject blend in with surrounding background. Think of an owl in a tree or a white rabbit in the snow. You can create more separation between subject and background by using unsharp masking to draw lines between the two. The lines should provide enough definition so that you can see the subject as a separate object, but not enough so that you begin to see the lines as lines.

This photo is in perfect focus – just check out the shrimp's antennae. But it can look out of focus because the depth of field is poor. You can't do much to help this, except consider using a different photo. On the other hand, sometimes poor depth of field helps the main subject of a photo stand out from the background. Here, the fuzzy background serves as a good frame of color for the shrimp. It would have been distracting if we had been able to see pin-sharp details in the background.

Here the photographer has given us a real dose of reality, with a slightly out-of-focus foreground, perfect focus in the middle, and out-of-focus background. This is just how we would view nature in real life, with the eye drawn to what is in focus and the brain disregarding the rest.

DEPTH OF FIELD

Depth of field is the apparent amount of distance from the foreground through the background within which a picture stays in focus. Depending on the film speed and exposure used to take the original photo, you can have a lot of depth of field or practically none.

Ideally, what you should look for is perfect focus in some part of the picture and out-of-focus in other parts. It is this contrast between detail and fuzziness that helps the human brain interpret the visual data our eyes see as three-dimensional. Remember, all printing is a two-dimensional trick to simulate the real world of three dimensions. So whatever mimics real life adds to the verisimilitude of print.

Try this experiment. Stare at an object about 2 feet away from you. While you focus on that object, try to look at the background behind it without taking your eyes off the object. Can you see how out of focus the objects in the background appear? Now, without moving your head, focus your eyes on the background. Can you see how the object in the foreground becomes fuzzy?

That is the effect you're trying to re-create in two-dimensional print.

Bear in mind, however, that a printed piece is viewed by readers who have never seen the original. All the readers have to look at is the printed matter that lies before them. So as you design your two-dimensional piece, try to back off from the original a bit and look at your design as though you were a reader seeing it for the first time. If there is too much foreground or background that is out of focus, the sheer color of those areas is enough to distract the reader from the main subject.

On the other hand, if nothing is out of focus, the scene looks unreal. So tied are we to this method of interpreting visual stimulus that if you composite two photos together without blurring one somewhat, people will be able to guess every time that you have com-posited an artificial piece.

(ABOVE LEFT)

The pale yellow highlight in the background adds nothing to our depth perception here. Crop out as much as possible, or color it to match the rest of the background.

(ABOVE RIGHT)

Notice how the out-of-focus background serves to draw our attention to the seeds in the center of the picture. This is how we would see them in nature, and that is why this picture looks so real.

(ABOVE)

The screen-like appearance of the subject's jacket can cause a moiré pattern when scanned as a conventional halftone. If you use a stochastic screen to scan this picture, the moiré pattern won't appear. Stochastic screens are made of tiny, randomly occurring spots that have no pattern, so they cannot conflict with any patterns that may appear in the original photo.

SCREEN LIMITATIONS

Sometimes everything about a photo is perfect but the finished piece prints with an unintended event. Maybe the smoothly curved tones you saw in the original came out as bands when the job printed. Or perhaps a closely patterned jacket on a model came out with additional patterns that weren't in the original.

These kinds of problems are the result of using a grid-type screen to create printable dots from the original. The pattern of the screen (which produces dots arranged on a grid) creates a pattern that the eye can sometimes see. So smooth tones, especially in curved metallic subjects, or finely patterned textiles are reproduced with extra screen patterns.

If this creates a problem for your design, try using a stochastic screening mode instead. (see Chapter 5) Stochastic screening uses tiny spots of ink or toner arranged in a randomized array. Since the spots are very tiny, the breakup of tones into bands is reduced. And since the spots are randomly placed on the paper, there is no screen pattern to conflict with the subject's pattern. However, not every output device supports stochastic screening, so check with your printer ahead of time.

(BELOW)
Sometime you might need to reproduce a previously printed image that has been screened as a halftone. If you apply your own halftone screen to print it again (left), the new screen angles will conflict with the old screen angles. You will get a moiré. Try using a stochastic screen (right) instead. Stochastic screens have no pattern, so they cannot conflict with halftone screen grids.

This photo is severely underexposed, but under strong light, you can see quite a bit of detail. Increasing the brightness does a lot to bring out the detail. It comes at the sacrifice of some richness in color, so you must use your judgment about how far to go.

This photo is overexposed, wiping out highlight details. You can fiddle with the brightness and contrast in your software program, which will help somewhat. But nothing will restore detail that wasn't in the original film.

Color

Color is the most important factor for good reproduction, even if the color is only gray. That's because all of the detail in print, all of the shadows, and all the highlights are expressed by pure color. Golf clubs glint in the sun because the metal heads look grayish but the reflections are white. A model touting plastic surgery looks old and wrinkled because the creases in her face are expressed as darker and lighter areas of skin tone colors. To make sure your color is giving you every last ounce of punch, check out these points:

EXPOSURE

Sometimes detail is obscured in the original because the photo is too dark (underexposed) or too light (overexposed). Photo-editing software is great for bringing out shadow detail in underexposed photos and for bringing out highlight detail in overexposed photos. By working on the brightness and contrast of a photo, you can make details appear that you never thought were there. You can lighten dark areas and darken light areas. But you cannot create new details that aren't already in the original.

If you must use an overexposed or underexposed photo, look at it under strong light on a light table. If you can see any detail in the shadow or highlight, the photo can probably be salvaged. Whether it's worth saving is another issue.

(BELOW)

When you check a photo for range of tone, look for detail in the shadows, in the highlights, and for plenty of midtones in between.

(FACING PAGE TOP LEFT)

Not every photo has to show detail throughout its range of tones. Here the dense shadows of the kelp in the foreground draw the eye into the mysterious depths of the sea. The effect would be spoiled if we could see every detail of the shadows.

I learned this the hard way when I worked on a coffee-table book about seabirds of the northern Pacific. Many of the birds in the book were rarely seen by anyone, let alone by a professional photographer with the right equipment under the right lighting conditions. In fact, several of the photos were one-of-a-kind pictures of birds never before published. These rare photos had been taken by scientists who belonged to the point-and-click school of outdoor photography. Many of the transparencies consisted of overexposed frames showing black X's with feet hanging down. One memorable underexposure pictured a black blob in a brown hole. The only way you could even tell it was something

living was that it had a small glint in a dimly perceptible eye. Everything else was just solid black.

When I saw the transparencies, I nearly had palpitations. "We need better photographs," I gasped when I could get a breath.

"There are none," said the art director. "Not a single one in the entire world. These are the best and only ones in existence."

Well, we worked with them. Whatever detail was in them, we brought out. They still looked like black X's and blobs when we printed them, but we had no choice. In this case, a bad picture was better than no picture.

RANGE OF TONE

The best photos have a full range of tones from darkest shadow to lightest highlight, with plenty of midtones in-between.

To check for range of tone, take a look at the photo first in the deep shadow areas. Ideally, there should be some detail visible in the shadows, although sometimes you may want the very deepest shadows to be completely black. This is a judgment call and depends on the kind of effect you are trying to create.

After you check the deep shadows, look at the highlights. Bright highlights should appear white enough and yet still have a little color in them to give them some shape. Sometimes you'll see very small, round highlights that are totally white. These are called specular highlights and are caused when smooth surfaces reflect white light directly back to the camera. You should generally set your scanner to blow out all pixels in these highlights, leaving the space completely blank. If you set your scanner to read some pixels in specular highlights, your resulting range of tones will be so spread out that no press will be able to print all the changes in tone from bright to dark.

(ABOVE)

The small, completely white highlights on this statue (above center) are called specular highlights. They reflect light directly back to the camera and print with no halftone dots at all. They can add a sense of reality to a photo. See how three-dimensional this statue looks compared to the statue on the right, which has no highlights at all. The statue without highlights looks flat and dull.

(ABOVE LEFT)

This is a histogram of the photo on page 84. Notice that it shows pixels on both extremes of shadow and highlight, but the majority of pixels fall in the midrange.

(ABOVE RIGHT)

This is a histogram of the photo on page 85. It lacks pixels in the deep shadows and bright highlights. All its pixels are in the midrange, creating a photo that will print looking flat.

HISTOGRAMS

If you want to check on a picture's range of tone exactly, you can ask your computer to display a histogram. Histograms are diagrams that show the mathematical distribution of pixels from dark to light in a given color channel. A well-balanced histogram should show some pixels at the extreme ends of darkest and lightest, but the majority of pixels should show up in the middle. A photo that has a poor tonal range lacks pixels on the outside extremes of a histogram.

Some photos have too big a range of tone. The darks are really dark, the highlights really light. There are plenty of midtones, but the photo gives the feeling of being stretched out over too big a spectrum. This kind of photo is too contrasty. A histogram of a contrasty photo shows how stretched out it really is. Photographic film has a bigger range of tone than printing ink or toner. In effect, ink or toner can reproduce the equivalent of only four f-stops of a camera. If a photo has a bigger range than four f-stops, you will not be able to reproduce it well; the photo simply has more tones than the press.

Changing a picture's range of tones is easy, up to a point. A picture that is heavy on the midtones but lacks deep shadows and bright highlights can be

changed by first identifying the deep-
est shadow and brightest highlights
that are on the film, and then making
them deeper in the one case, whiter
in the other. The computer will then
spread out the available pixels that
express all the tones, in effect stretch-
ing them over a wider spectrum. For
photos with minor problems, this
actually works, in the sense that a
photo looks better afterward. But for
photos with too little range in tone,
stretching out the pixels can make the
picture look odd and artificial. My
advice is, try it but save a copy of
the original. You may need it.

Compressing a picture's range of
tones is also easy. In fact, most pho-
tos should be compressed to some
extent, just to compensate for the
press's inability to reproduce as many
tones as film can. With a really con-
trasty photo, however, compressing
the tones will cause more detail to
be lost in the shadows and the high-
lights. You're left with the choice of
living with the lack of detail, or find-
ing a different photo.

(ABOVE)

*Some photos have too much range of tone.
The deep shadows are so dark you can't see
any detail. However, the brightest highlights
show no detail, either; yet there are plenty of
midtones. Such photos have too much con-
trast and may be tricky to reproduce. If you do
use a contrasty photo, make sure you have a
good design reason for your choice. Here the
strong lines and saturated colors create a
compelling image, even if the range of tones
is too great.*

Photos taken in early morning light or late afternoon can show a yellow color cast. One way to check for this is to look at colors that should be neutral gray, pure white, or neutral beige. In this photo, all three of these neutral colors have shifted to yellow.

When using contrasty photos, be prepared to spend time altering shadows and highlights. It's usually best in these cases to ignore the deepest shadows and brightest highlights and work instead on the midtones. In this photo, the model's face can and should be lightened, but everything else should probably be left alone.

COLOR CAST

Photos should have no overall color cast. You can check this by eye. Simply gaze at the original without magnifying it in any way. Can you see a color shift overall?

Sometimes a photo can show a color shift because, when the photo was shot, the ambient light itself was skewed. Photos taken in the late afternoon or early morning, for example, look too yellow or too red. Photos taken under indoor incandescent light show a similar shift to yellow and red. Photos taken under indoor fluorescent light show too much green.

Sometimes a photo's color shift is due to the way the film is made. Film manufacturers know that any given film emulsion cannot capture the full spectrum of visible light, so they make a choice about the colors that a given film ideally will portray. This can result in an overall color shift in a photo when colors are present that are outside the film's ability to "see." Most common is a color shift to the cold side of the spectrum—a photo looks greenish or bluish.

(ABOVE)

Film emulsions are somewhat limited in their ability to "see" certain portions of the visible spectrum. This can result in an overall color cast, in this case, too much blue.

(ABOVE)

The original photo (above left) has an overall blue cast. When this problem is addressed, a new problem is created: The other colors look wrong. You can spend a lot of time correcting a photo like this, as you try to compensate for a cascade of problems. Ask yourself if the photo is worth it.

You can easily alter a picture's color cast by telling the computer to look for similarly colored pixels in the midtones, shadows, or highlights. By fiddling around with these controls and checking the results on your monitor, you can create a color balance that is more pleasing. Bear in mind that the computer will change all areas that have these color tones, unless you laboriously construct layers and masks that de-select areas that you don't want to alter. That, of course, will start you down a slippery slope where making one change cascades into the necessity of making another. You can spend a long time sliding down this slope, if you're not careful.

My grandmother had a saying for situations like this: "If you see a spot on the wall, don't wash it off. Hang a picture over it. If you wash one spot, the rest of the wall will look horrible, and you'll end up washing all the walls of your house, and your ceilings too."

WRONG HUE

Sometimes a photo looks okay overall, but you wish you could tweak one color a little more. You can, either by selecting a small area and working on it in a separate layer, or by selecting one hue and changing that everywhere it occurs in the photo.

When you do this, be aware that fixing a color may mean adding more intensity to it, or reducing the intensity of the other colors. Let's say, for example, that you think a photo has too much cyan in it. The problem actually may be that it doesn't have enough yellow. Try changing both colors one at a time and see which result you like better.

It is a real art to determine exactly which adjustment will help a photo the most. Mastering this art is also enormous fun. So watch the clock.

(BELOW)
The grays in this photo are not neutral (top). Here's what happens when you take out blue (middle). Here's what happens when you add more yellow (bottom).

PASTELS

You wouldn't think that true pastels would be difficult to achieve in digital printing, but they are. On the one hand, digitally created dots are much tinier than offset printed dots, so your control of very pale colors is greater. However, digitally applied dots have a hard edge that keeps them from blending seamlessly. This is not banding, where bands of color show up in steps. The hard-dot effect is more subtle, but it is real.

In offset printing, when ink is applied to paper, it sinks into the substrate to some degree. As it soaks in, little threads of ink spread out into the paper fibers, making the dot grow in size. This dot gain has the bad effect of altering the color balance of the design, so printers go to great lengths to control it. But dot gain has a good benefit too, softening the edges of the halftone dots and making the colors blend together into more of a continuous tone effect. This can be especially helpful when you're trying to print soft colors like pastels.

(LEFT)

Subtle pastels can be very hard to reproduce with conventional halftone screens because the digital process makes hard-edged dots that are not softened on a printing press. Stochastic screening can help by giving the computer more dots to work with. You still have hard-edged dots, but at least the stochastic screen can show more subtle variations in tone.

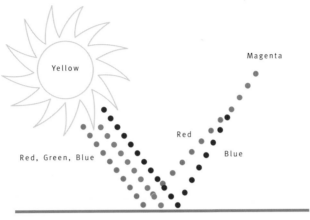

Yellow

Magenta

Red

Red, Green, Blue

Blue

Green is absorbed

Toner or waxy dyes, on the other hand, do not sink into the paper. So the dots retain their hard edges. With these forms of digital output, you don't have to contend with excessive color balance changes due to dot gain, which is good. But you also lose the softening effect of feathery dot edges.

The best way to get around this problem is to go to stochastic screening. The randomized array of dots that defines a stochastic screen mimics a softened dot because stochastic dots are much, much smaller than traditional halftone dots, and there is no discernible pattern in the colors created.

FLUORESCENTS AND OTHER BRIGHT COLORS

The gamut of colors available to printers is much less than the gamut of colors available to computer monitors. Ink and toner chemists say that this is mostly due to the fact that all printed colors in all printing processes are subtractive. What does that mean?

White light is made up of three primary colors: red, green, and blue. When white light hits ink, the pigment in the ink absorbs—or subtracts— some wavelengths of light and reflects back the wavelengths that are left. The color we see thus contains less intensity than the original beam of white light and expresses a more restricted part of the visible spectrum.

(ABOVE)

White light contains the three primary colors: red, green, and blue. When white light strikes this magenta ink film, the ink subtracts a third of the spectrum (in this case, green). The light reflected back is red and blue, which we perceive as magenta.

Most printing inks and toners are designed to subtract one-third of the spectrum of visible light. Cyan ink or toner, for example, subtracts red light and reflects green and blue light—and it appears turquoise (or cyan) to us. Magenta ink or toner subtracts green; yellow ink or toner subtracts blue.

Theoretically, if inks and toners were perfect, each of the three process colors would subtract a full third of the visible-light spectrum. In the real world, however, even the best inks and toners are imperfect and let some improper wavelengths of light "leak" back. So colors are not pure; they are contaminated by other parts of the spectrum.

What all this means is that inks and toners simply cannot duplicate all the colors of nature. Really bright greens, oranges, and purples are not in their gamut. Neither are highly saturated reds. As for bright colors that don't appear in nature—such as fluorescent yellow, pink, or turquoise—forget about it.

There is no perfect way to get around this problem, whether you're printing on digital output devices or conventional presses. Printers try, though, using various tricks. Some add a custom-colored ink to the traditional CMYK (cyan, magenta, yellow, black) inks. By chemically mixing a new color, you can achieve a wider range of hues. Some printers make extra passes through the output device, adding more ink density by just adding more ink. This can be effective for spot colors and solids especially. But printers can never entirely overcome the inherent limitations of the physical process of printing inks or toners onto paper.

(BOTH PAGES)

Ordinary process inks and toners can reproduce only a limited gamut of colors. One way to brighten up your colors is to add custom inks and toners. On these pages, we used CMYK inks to reproduce one version of the art (images on left). Then we replaced process magenta and process yellow with fluorescent substitutes (images on right). Look at the difference in vibrancy.

REFLECTIVE ART

If your original is a piece of reflective art, rather than a transparency, you might have a little extra challenge in reproducing the colors. That's because scanners "see" the artificial colors of paints, crayons, etc. as natural and try to digitize them accordingly. If the art is made from colors that do not occur in nature (such as fluorescent paints, for example), the scanner will do its best to interpret the colors; results may be mixed.

One way to improve color fidelity is to shoot a digitized version of the art using a high-end digital camera. This may give better results than shooting a color transparency of the art, simply because the digitizing process is closer to the original with a digital camera. The translation of color from one medium to another happens only once here.

When you digitize reflective art, you may notice that certain physical elements of the original may become distorted. Lumpy paint may cast unwanted shadows, for example. Or textured paper might appear as mottling that confuses the reader. Conversely, smooth-but-glossy paper might cast reflections back at the scanner's eye, introducing meaningless highlights. It's best to anticipate these problems and ask your artist, if possible, to use a smooth, matte surface for the original substrate. If that is not an option, then you should expect to spend some seat time making adjustments after the image is scanned.

Sometimes when you shoot reflective art or fabric, you get unexpected colors from the camera. This happens because the camera lens can sometimes "see" paints or dyes differently than the human eye does. This problem is called metamerism. It's a pesky problem because you never know when you're going to get it, and you can correct it only in prepress. Allow for some extra time. However, before you get started on your career to color-edit the *Mona Lisa*, you have to decide how important an exact color match really is. If the art is being reproduced in a catalog, for example, exact color matches may be crucial.

(LEFT)

When an illustration is drawn on textured paper and the art is scanned, the paper can contribute unwanted effects that you may need to correct by hand.

If the art is being used to illustrate a magazine article, perhaps it doesn't have to be as exact as you might like. After all, readers won't see the vibrant original art; they'll see only a reproduction.

This issue came up at trade magazine where the art director did not communicate her final design vision to her production manager. She just handed over a painting the size of a playing card. It was a piece showing the White Rabbit, done in beautiful oil pastels. "I want this scanned," she said.

Ordinarily the production manager scanned small pieces of art on her flatbed scanner. But usually these pieces were snapshot photos of organization members at trade shows, dressed in funny hats. This was clearly Art with a capital "a". So the production manager went to great expense to get the digital version exactly right, sending the painting to a service bureau for drum-scanning. When the scan came back, the colors were off. Everything looked dull and dirty. So the production manager sent the proof back for retouching. Two scans later, she was finally satisfied and showed the contract proof to the art director.

"Oh good," said the art director, "I've been needing that to drop into our April calendar. I picked it up at a garage sale and thought it would look really cute. I didn't really care how the colors came out, but hey, these colors are fantastic."

Just one more rabbit hole for the production manager to go down, right along with the budget.

(ABOVE)

Sometimes artist's paints or fabric dyes absorb light in unexpected ways, such as reflecting back to the camera lens a different color than our human eye sees. This phenomenon is called metamerism. Greens, for some reason, are often at fault. The only solution is to correct the colors by hand. On the left is the original scan of a Chinese embroidered picture; on the right is the color-corrected version.

Chapter 4: Color Management

The staff of a newly launched adventure travel magazine—
of which I was part—gathered around the designer's table as
she opened the package of proofs from the color separator.
We were eager to see the photos for a story about apes in
the wild that the publisher's wife had written. Several of the
photos had been taken by the publisher himself.

We all stared as the proofs were unveiled. One picture in particular drew our attention, a close-up of a gorilla squatting in a nest of green leaves. The gorilla was scowling horribly. "Aren't gorillas supposed to look warm?" asked the designer. "This one looks like his space heater just blew out, and he is not a happy camper."

We had to agree. The leaves of the nest were all very bluish. So were the plant stems. Even the gorilla's fur had a blue cast to it. If this had been live film, the poor creature would have been shivering. The two vervet monkeys on the next proof appeared even colder—the baby monkey huddled in his mother's lap actually had blue fingers.

The group turned to me. I was the production manager. I was responsible for color quality. "I'll call the separator right away," I said. "He won't get away with this!"

The color separator was surprised that we weren't happy with the color. "The photos were all perfectly exposed, no special problems. They should have been fine."

"Well, when we looked at the origi-nals on our light table, they all looked much warmer than the proofs do now," I replied.

There was a long pause. "Your light table? You mean the kind with an ordinary light bulb behind a panel of translucent plastic? Didn't you use a viewing booth?"

"What's a viewing booth?" I asked.

"I'll be right over," said the separator. When he arrived, he set up a little color-corrected projector and put our slides into it, one by one. In every case, the colors looked much bluer than I had remembered.

"That's your problem," he said. "Your light bulb is not color-corrected, so the color of the light has shifted. It makes all your slides look warmer than they really are."

What I came to think of as the "Bad Monkey Incident" took place more than twenty years ago. It taught me a valuable lesson—if you want to get good color, you have to pay attention to good color management. In the modern digital world, color manage-ment consists of two main ideas: color calibration and proofing.

Color calibration is crucial when you must reproduce a picture with the challenges presented by this one. The original photo was illuminated both with ambient light from outdoors (filtered through the door curtain) and incandescent light bulbs inside the house. Reflections from the doorway, wallpaper, and woodwork add to the mix of light sources. The net effect is to skew otherwise neutral colors to the red, yellow, and blue sides of the spectrum—simultaneously. Add in the need to reproduce good skin tones and wood tones, and you've got a potential mess. If your monitor isn't calibrated with your supplier's monitor, you could easily get totally different hues when this picture is reproduced.

Color Calibration

In simplest terms, color calibration means making sure that you see color in the same way that everyone else in the production cycle does, including your service bureau, color separator, and printer. In a way, this sounds simple. After all, color is nothing more than wavelengths of light exciting the optic nerve, which transmits the stimulus to the brain, where it is interpreted. But because we see color as both an outside stimulus and an inside interpretation, color perception really is a mysterious process.

For one thing, consider why we humans can even see color at all. Many other mammals cannot. Scientists speculate that we evolved the ability to perceive color as a way to find food. If you can see that a banana is green, you don't waste time climbing up to pick it. Instead you go for the yellow one with just a hint a brown spots sprinkled across the skin.

However, in the real world, if we were to perceive all colors in the true wavelengths that reach our eyes, we'd never pick any bananas at all. That's because a ripe banana in bright sun has a different hue than a ripe banana in shade.

A banana growing on a tree in Guatemala is a different color than that same banana sitting on a produce table in your supermarket. Yet we perceive that all the ripe bananas in all the different lighting conditions are yellow. Somehow our brains adjust the real wavelengths we see into categories of color that we recognize.

While this system may be great for finding food, it's not particularly accurate for matching color on press. You can see this for yourself by trying a little experiment. Take a square of khaki-colored cloth and view it under a 60-watt incandescent bulb. Match the color to a swatch from a Pantone® color swatch book. Then take the cloth outside in bright sun and match it again to a new color swatch. Do this again under fluorescent light. Now bring together the three color swatches and see if they are exactly the same. When I do this, I find that khaki looks more like brown in sunlight and more like green in artificial light.

(ABOVE)

When we look at objects in the real world, we don't really see the colors that are present. Rather, our brains automatically interpret the actual wavelengths of light that strike our eyes. In the real world, these bananas would all look yellow to us. But notice how many different colors are really present in this bunch. The lesson here is that we can't depend on our eyes to see color images accurately, unless we view the images under the proper lighting conditions.

(RIGHT)

A good way to check if your desktop system is accurately calibrated is to look at a scan that should have neutral colors. Gray is a good neutral to check, because it readily shows when the color balance is off. Is either half of this photo truly neutral?

(BELOW)

A good viewing booth system consists of a light table with a color-corrected bulb, a neutral-gray surround, and overhead lighting with 5,000 K bulbs, all located in a room with no windows. If possible, you should dim all other lights and wear neutral clothing yourself.

COLOR-CORRECTED ENVIRONMENTS

Because our brains interpret colors so expansively, you should always view color in a color-corrected environment when trying to match originals to proofs. The best environment is a viewing booth with a neutral-gray surround under 5,000-degree K lighting.

Viewing booths designed specifically for the graphics industry control color quality, light intensity, evenness of illumination, and surrounding conditions. They allow us to see neutral gray as truly neutral. By using neutral gray as a set point, we see all the other colors in their truest hue.

Never, ever hold a transparency up to the light bulb in your office and make color decisions about it. Whether the bulb is incandescent or fluorescent, it skews the colors of everything you're viewing. Incandescent bulbs skew the colors toward yellow. Fluorescent bulbs can skew colors toward green or even pink if the bulbs are old.

Some people have daylight-corrected bulbs in their office and think that those show colors "truly." They don't. Although many such bulbs are advertised as achieving as much as "91 percent natural daylight," you have to ask yourself, what kind of daylight?

(LEFT)

The color balance of a given photo is affected by many factors, including the ambient light present at the time the photo was shot. Take a look at the statue on the left: Each shot was taken under different lighting conditions (sunny day, cloudy day, nighttime). Notice how different the hues look in the stonework and even in the background vegetation.

Daylight in the morning and evenings is skewed heavily toward red and yellow. Daylight on rainy days can be bluish. In smoggy cities, daylight is orange. At high latitudes in the fall or spring, daylight is yellowish.

In addition to viewing color in the proper surroundings, you should also get your eyes tested as you get older. People's color vision changes over time, and you should be aware of how yours is affected.

Now that I've hit that magic age of seventeen (at least in tortoise years), I find that my color vision perceives more yellow than it used to. For me, global warming has a special meaning—the whole world is getting much more warmly colored.

MONITOR CALIBRATION

Controlling the way you view color is only the first step in running a good color-management system. The next thing you need to control is your desktop monitor. You need to make sure that your vendors' monitors show color the same way that yours does. Each of you needs to adjust, or calibrate, your monitor to the same standard.

Here, too, it's important that you view color in a consistently neutral environment. Don't put your monitor in a room painted with Federal Blue walls and expect to see very warm colors accurately on your monitor. The ambient light bouncing around off the walls is bouncing off the monitor too, affecting the colors you see. For the same reason, you should keep your monitor in a room with no sunlight. Sounds grim, but the color of sunlight changes with every passing cloud. If your room is filled with sunlight, then the colors you see are also changing rapidly throughout the day. Overhead illumination can also affect colors. If at all possible, you should consider replacing the overhead light bulbs in your office with 5,000-degree K, color-corrected bulbs.

Once you have adjusted your environment, it's time to adjust your monitor. The first thing to do is to remove any colorful wallpaper from the background of your monitor. Boring gray is what you want, all the better to see the colors of your designs accurately.

After your monitor has had a chance to warm up, you should adjust the brightness level. This is what controls the level of black that your monitor can show. Put up a solid black onto your screen and play with the brightness knob until you see a true black, but not one that is so dark that it is surrounded by a halo of gray. Now you need to calibrate the color gamut of your monitor so it meets industry standards. Monitors are surprisingly variable in the colors they can display. Different manufacturers produce monitors that might emphasize colors more to the blue or to the yellow side of the spectrum. Even individual monitors made by the same company can vary. Monitors can also change over time. You need to make sure that all the monitors throughout your production process are displaying the same colors in the same way. Theoretically if everyone in the production cycle does this, then everyone should see the same colors. This ability of digitized color to be always and ever the same is one of its most powerful appeals. Think of it: A world where, once you calibrate your monitor and set your colors, they will always look that way, whether you gaze upon them today or a year from today, whether you look at them in Peoria or your printer views them in Prague.

This almost never happens in the real world. For some reason, people seem strangely reluctant to take the time to calibrate their monitors together. Or if they do, they don't do so regularly, despite the fact that phosphors in color monitors can deteriorate over time.

Failing to match the color of all the monitors in the production process is like failing to synchronize watches before beginning a crucial mission. Even the federal government knows that everyone has to be in the same time frame: At the Social Security Administration's vast complex that constitutes the head offices in Baltimore, a security guard presses a special button once a day. All the hands of all the clocks in the building start whirling around madly. Then they all stop at the same time. "That's so nobody can claim that they were late coming to meetings because their clock was slow," explains the guard. Hard as it may be to believe, we could learn something from the government's commitment to consistency. Not only does the SSA calibrate their clocks, they do so to one standard.

Software programs exist that can calibrate monitors to a standard. But to what standard? Remember that the goal of calibration is to print a final design that expresses the colors you expect. Therefore, when you calibrate your monitor, you should always do so based on the system that your outputting service or device uses. Don't make them adjust their system to your monitor. Instead, you adjust your monitor to them.

The reason is that if you calibrate your monitor to the output device's calibration, then what you see on your monitor is pretty much what you'll get in print. Which is the point.

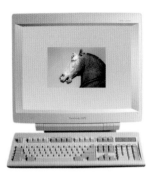

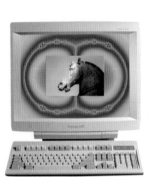

(FAR LEFT)

When viewing images on a monitor, set the background as neutral gray, not psychedelic rainbow. Take a close look at the image of the horse on these two monitors: The horse with the bright surround looks darker but really isn't.

(ABOVE)

Make sure the brightness level of your monitor is set correctly. You should be able to see a solid black square as neutral black (monitor on left) but not so dark that you begin to see a halo around the square (monitor on right).

(LEFT)

Different monitors display colors differently, even when set on the default calibration. Make sure your monitor has been calibrated properly, and that it matches the monitors of all your vendors.

(ABOVE)

Properly calibrated color systems make neutral colors look truly neutral. Wood should look in balance, not skewed to yellow, pink or blue, as here. Blacks should also look neutral, but if a calibration system is skewed to red or green, even dense blacks will take on the same color cast.

NEUTRALS

The quality of your overall color management system is revealed when printing neutral hues: grays, whites, blacks, and beiges. A system skewed even slightly toward cyan, magenta, or yellow will give these neutral hues a noticeable color cast.

This becomes an important quality issue when you print certain subjects. Skin tones, sand, gray pavement, stone, and cloudy sky are especially sensitive to color shifts away from purely neutral, as is any image with white. Images with deep shadows containing a lot of black are also surprisingly sensitive to color shifts.

The reason these neutral colors are so easily skewed is that they are created by an even balance of C, M, Y, and K dots. If one of these colors is too heavy or too light, the entire hue of the subject shifts.

So when you color-calibrate your system, don't go by just the numbers of your calibration program. Take a look at the neutral hues in your designs and make sure they are truly neutral.

(RIGHT)

Look what you can do when your color calibration is perfect. This anemone is a quiet riot of blues, pinks, yellows, and grays, and yet, because every color is perfectly balanced, we see it all as white. This is how white really looks in nature, which is why this photo looks so spectacular in print.

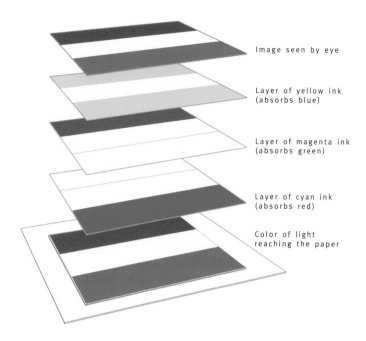

Image seen by eye

Layer of yellow ink
(absorbs blue)

Layer of magenta ink
(absorbs green)

Layer of cyan ink
(absorbs red)

Color of light
reaching the paper

(ABOVE)

We see all printing via reflected light. How does this work? Take a look at the red stripe in this Hungarian flag. White light (consisting of red, green, and blue wavelengths) first passes through a film of yellow ink (laid down on the paper). The yellow ink absorbs blue light, subtracting blue from the white light. Next the white light passes through a film of magenta ink, which absorbs green light. When the remaining light strikes the white paper under the ink, it is reflected back through the magenta and yellow ink films. The only color left of the original white light is red. So we see the top stripe as red. Similarly, on the bottom stripe, the yellow ink film subtracts blue light, and the cyan ink film subtracts red light. All that is left for the white paper to reflect is green light, so we see the bottom stripe as green.

Proofing

Unfortunately, even with all your monitors calibrated, it still may be difficult to print your designs so that they match exactly what you see on your desktop. It's a matter of physics: You can see many more colors on your computer monitor than you can print, and the colors are brighter. That's because your monitor does not show you color in the same way that paper does. We see ink on paper because the inks absorb light from a beam of white light that is shined upon it. When the inks reflect back the light to our eyes, they subtract (i.e., absorb) certain wavelengths. We see only the colors that are reflected; the other wavelengths of the color spectrum are lost in the ink.

In contrast, a computer monitor emits light through red, green, and blue phosphors, so its color spectrum is limited only by the temperature or energy of its power source. We can't see the entire spectrum of light, as we could from a brighter, stronger power source. But we can see many more colors than we can from a reflective system like ink on paper.

Thus, what you see on your monitor is not what you get on press. Your monitor shows you emitted light. The press shows you reflected light. Your monitor makes colors by adding three primary colors together. The press makes colors by subtracting three colors and by doing so imperfectly. Your monitor uses red, green, and blue. Your press uses cyan, magenta, and yellow.

When you think about all these differences, it's really a wonder that printed pieces resemble desktop designs at all. Well, okay, on some jobs they don't. But that's often because the designer didn't take the time or trouble to make an accurate proof. Making a color proof can help stabilize color communication between you and the printer because a proof communicates color in the same way that your final output does: on paper. It is the second essential tool you need to output good color.

In the analog world, color proofs have always been the standard that printers use to match color on press. Color proofs are more than just a guide. They are legally binding. Once a client approves a proof, called a contract proof, the printer is obligated to match it to the degree he promised when the client and he agreed to do business. Some printers agree to match the proof exactly; others agree just to come close; still others, the ones we call the down-and-dirty bunch, agree to produce color that only "pleasingly" resembles the proof. Because so much depends on the accuracy of the color proof, many high-end color separators maintain a proofing press on their premises. They use this press to print a couple of copies of proofs plated from the same film that the regular printer is going to use. So if the proof is okay, everybody in the production loop knows that the film is okay, and thus the plates are good and the job will match on press.

(ABOVE)

We see all color on a computer monitor as emitted light beamed directly to our eyes. How does this work? The phosphors in the monitor screen are energized with electricity and emit that energy as light. We see the red stripe of the Hungarian flag because in that section of the computer monitor, the red phosphors have been excited and emit their energy as red light. We see the green stripe because in that section of the monitor, the green phosphors have been excited. The white stripe appears as white because the red, green, and blue phosphors of the screen have all been excited. When they all emit light, the colors combine to form white.

Notice that the physics for seeing color on a monitor is completely different from the physics for seeing color on the printed page. That's why it is absolutely critical that you okay all final color by using printed color proofs.

Of course this process is extremely expensive. So years ago people looked for a cheaper way to proof color off-press. DuPont's Cromalin® proofs were one way. Separators would composite all the original negatives of a job into printing signatures, and then they would make four new negatives from the composites: one negative each for cyan, magenta, yellow, and black. Using those negatives (the same ones that would later be used to make the printing plates), they would expose a sticky, light-sensitive paper using each negative in turn. As each color was exposed, the separator would sprinkle C, M, Y, or K powdered toner onto the sticky surface and rub it on.

When these off-press proofing systems came on the market, printers didn't like them at first. They complained that the toner colors looked different from printing ink. But over time, they got used to seeing the differences, and both printers and designers were able to adjust their eyes so they could make a good comparison between the proof and the press.

Then the digital revolution hit. All of a sudden, you can send digitized files all over the world and not have to use film at all. Instead of negatives, we have numbers. The numbers are used to output the printing plates.

Since it seems ridiculous to use an analog proofing system in an otherwise all-digital printing world, designers began to push to use digital proofs. Various proofing systems came onto the market to address this need. In essence, the digital proofing systems employ the same technology as digital printers (see Chapter 1). That's because they *are* digital printers. So you can proof with ink-jet, laser, thermal-dye, and dye-sublimation systems. They all produce different quality proofs and they all do it by assembling little tiny color specks into simulated halftone dots. Printers were very uncomfortable with this idea at first. They hated the fact that a digital proof does not show the physical dots on a plate. Instead, the proof portrays abstract numbers stored in the computer and output especially for the proof. The problem is, if a page looks bad on press, the printer can't haul out his loupe and check to see if the right halftone dots are present in the proof or not. There might be dots there, all right, but the dots are generated separately by an entirely different machine: the digital platemaker. So the dots in the proof aren't the same dots as the ones on the plates.

Although conventional printers still struggle with this issue today, digital printers do not. Because digital printing is designed to generate one copy at a time, each and every time it prints, a digital press can make a proof as easily and cheaply as a real copy. In fact, you might say that a proof *is* the real copy, as long as it's made on the same paper as the final job.

Paper proofs are still important in the digital printing world because you need to verify how your design is going to look when the inks or toners are applied to paper, as compared to how the design looks on your computer monitor. But it's so easy to generate a single copy from your disk, the whole concept of proofing is different. You don't have to worry about paying for makeready on a proofing press. You don't have to try to match colors from one kind of off-press proofing technology to colors created by another kind of on-press printing technology. If you need to change your layout, you simply change your pixels and generate a new printout. You can even ask the printer to do the output on the exact paper you'll be using.

One printer who specializes in making extremely large, one-of-a-kind posters on a digital press does away with the concept of proofing altogether. Instead he insists that his clients come down to the plant and use his computers. He says he just finds it simpler to sit beside the client and make color corrections with his equipment on the spot. If a customer is fussy about a particular color, he can output it right then and there and change the color immediately by typing a new command into the computer. In the most literal sense, proofing and printing are the same thing.

(RIGHT)
Digitally printed, large-format signage like this can be proofed on the same equipment and with the same paper as the finished job. Proofing such a large piece with conventional equipment would be prohibitively expensive, but in the digital world, the final proof can be no more and no less than the final output.

Chapter 5: Resolution

When the ancient Egyptians invented hieroglyphics five thousand years ago, they never caught on to the concept of vowels. They wrote only consonants. For example, their word for "answer" was spelled "w-sh-b." But "w-sh-b" was also how scribes spelled the word "bull."

Screen resolution, for example, can mean the amount of detail on your computer monitor. But it can also mean the number of lines per inch that your printing press is laying down on paper, or the number of dots your laser printer can squeeze into an inch.

The Egyptians could appreciate that it might be a problem if you wrote home to your farm supervisor demanding an answer and he sent you bull instead. So to clarify their meaning, scribes drew a little picture at the end of a word, in this case, either a man holding his hand to his mouth or a bull walking along.

We professionals in the graphics business might do well to copy the Egyptians' practice when it comes to communicating about resolution. That's because the technology (and the jargon) for printing has overlapped that of computers. As a result, we have allowed ourselves to become very sloppy when it comes to our vocabulary.

(RIGHT)

Screen resolution can mean several things: the number of squares of red, green, or blue that your computer monitor—or screen—can display (measured as screen dots per inch); the number of screened halftone dots that a press can print (measured in lines per inch); or the number of screened ink spots a laser printer can apply (measured in dots per inch).

Understanding Terminology

Pixels sometimes refer to the squares of color on your monitor, or sometimes to the amount of data needed to print a graphic element. Dots can be halftone spots of ink on paper, or arrays of toner dots on paper.

Usually these quirks of expression are merely annoying—until your client asks you why your designs aren't coming out the way you said they would, and you realize that you, your printer, or some faceless black hole in cyberspace has messed up your resolution and your quality. It's at times like these that you might find yourself wishing you could hand out answers instead of dishing out the bull.

(BELOW)

Pixels sometimes refer to squares of red, green, and blue on your computer monitor. But technically, pixels are nothing more than a grid of zeroes and ones. The zeroes and ones tell the computer to turn off or on each pixel in its memory. That is how the computer stores information of all kinds, including images. When the computer outputs its zeroes and ones, it can do so in many formats: on paper, plastic, metal, monitor screen, audio, etc.

In the old days of printing, before the desktop revolution, sloppiness of jargon did not spoil the resolution of your finished piece. That's because the vendors determined how much resolution you needed. So you, as the customer, could throw around terms without knowing their exact meaning, leaving it to the vendors to figure it all out for you.

In an all-digital world, however, you are responsible for creating your own prepress materials. Ignorance about prepress terminology and concepts can be catastrophic.

To make your prepress art come out the way you expect, it is essential to understand the meaning of resolution. Only then can you determine exactly how much data you need to define the optimum amount of detail for a particular layout. In other words, you must answer the question: How much resolution is best?

(ABOVE)

Dots can be printed as halftone dots that are output by a printing press (above left), or as toner dots output by a laser printer (above right).

How much resolution is best?
The answer mainly depends on the resolution
of your output device.

How Much Resolution Is Best?

In digital prepress, there is no one right answer. Rather, the answer mainly depends on what resolution your output device is capable of. You can find out this information by checking with your printer, or—if your final output is an in-house device—by checking with the manufacturer.

Let's say, for example, that your digital design is going to be output on a conventional offset press. What is the maximum resolution the press can achieve? Depending on the quality of the paper, the resolution might be anywhere from 85 lines per inch to 300 lines per inch.

If you're outputting your prepress on a computer monitor, for a Web page for example, you are limited by the resolution that most monitors are capable of. You are also limited by the amount of time it takes to transmit the data to other computers. Nobody likes to hang around for too long while a computer image downloads. By trial and error, Web page designers have settled on 72 dots per inch as an industry standard because it's the default resolution of a Macintosh monitor (the default resolution for a PC monitor is usually 96 dots per inch). That means that the resolution of your scan of the original art should also be no more than 72 dots per inch.

Notice that offset presses and computer monitors describe resolution using different units of measure. Presses measure resolution as lpi, monitors as dpi. In fact, print production professionals have three main ways of discussing resolution: lines per inch (lpi), dots per inch (dpi), and numbers of pixels.

LPI

Lines per inch is a term that originally referred to the amount of resolution used when screening a continuous-tone original into a halftone print.

A continuous-tone original is a photo or an illustration, made with dyes or paints that create the image by using a continuous gradient of tones from dark to light. For example, if you load a paintbrush with watercolor paint and paint a swash of color across a paper, you'll see a continuous gradient of color gradually going from dark to light tones. A paintbrush can paint continuous tones, but a printing press cannot print them.

Printing presses can lay down ink only in very small areas at a time. If a press attempts to lay down a large amount of ink at once, it plops down on the paper in a shapeless glob.

Early in the history of printing, printers realized that to print large areas of ink—in other words, pictures—they would need to break up continuous tones into small pieces they could control on press. At first, printers used hatch marks of lines to create the illusion of tones. Lots of hatch marks together looked solid from a distance; fewer hatch marks looked pale. To etch the hatch marks, however, took a long time and had to be done by hand.

(ABOVE, LEFT)
A paintbrush can paint a continuous range of tones from dark to light. A printing press cannot.

(ABOVE, CENTER)
Engravers broke up continuous tones into hatched lines that presses could print.

(ABOVE, RIGHT)
A halftone screen really was a screen of intersecting lines, through which a camera lens converted a continuous-tone original into a series of halftone dots.

Screened halftones are created with different-size dots, all spaced evenly apart. Large dots create the illusion of dense color; small dots create the illusion of pale color. When the dots touch each other on all sides, the color prints solid.

DPI

Eventually printers began to use screens or grids placed over a camera lens to break up the continuous tones of art. When the camera lens looked at a continuous-tone picture such as a photo or painting, the grid of the screen broke up the tones of the picture into dots. The dots were all evenly spaced, but their size was determined by the density of tone. Dense tones had big dots; light tones had small dots. The dots didn't look evenly spaced because they were all different sizes. But they really were evenly spaced, as measured from the center of one dot to the center of another.

This process of creating tones using dots from a screen was called halftone screening. The results were much more satisfactory than hatching. For

one thing, the process readily lent itself to mass production—all you had to do was fit the appropriate screen over a camera lens and shoot your original art through the screen.

Printers also discovered that they could create the illusion of continuous tones better if they used finer screens to produce more dots. They measured the fineness of the screens by counting the number of lines per inch across one direction of the screen. Over time, printers came to standardize the fineness of the halftone screens they used, measured in lines per inch or lpi. The screens that were most commonly used were 85 lpi (called an 85-line screen), 100 lpi, 120 lpi, 133 lpi, 150 lpi, and 300 lpi.

85 lpi

120 lpi

150 lpi

What determined the fineness of screen was a paper's ability to hold a printed dot on the surface, without the ink soaking into the paper and spreading out. A screen with 85 lines per inch was good for printing dots on newsprint. It produced some detail, but more important, it allowed enough room for each dot to expand as it soaked into the porous newsprint paper. Finer screens—up to 300 lines per inch—could be used on paper with better ink holdout.

Designers began to forget exactly what these screen measurements represented. Instead, they developed a seat-of-the-pants way to specify the fineness of resolution they wanted. It was based on their experience with different printers and different grades of paper. As a rule of thumb, designers knew that an 85-line screen was okay for newspapers but much too coarse for magazines.

Designers settled on 133-line screens as reasonable quality for magazines because they knew that most grades of coated papers could hold dots that fine. Really fine printing with 150-line screens produced extremely high-quality detail and color and required higher-grade papers; 300-line screens pushed the limits of offset printing to the maximum.

Speaking loosely, people often substituted "dots per inch" for "lines per inch". Remember, the screens used to make halftones were grids of crossing lines. Wherever the horizontal lines crossed the vertical lines, the screen would break up a continuous halftone into dots. It was convenient to refer to screen resolution as dots per inch because when the job was printed on an offset press, the ink that was printed came out in dots.

(ABOVE)

Finer resolutions produce finer details, but only up to a point. If your printer is capable of printing only 120 lpi, finer-screened halftones will only plug up the press.

BITMAP IMAGES

When our industry began to create halftones using imagesetters and desktop systems to process art digitally, we continued to use the same terminology as before. Halftones are still "screened," even though no physical screen exists anymore. Computers instead use mathematical algorithms to break up the continuous tones into halftones. Fineness of screens is still measured as lines per inch or dots per inch. But the lines and dots from an imagesetter are completely different from physical screens.

When a computerized scanner makes a digitized halftone, it has to figure out how to turn continuous tones into dots. It does this by scanning the original art and creating cells made up of very tiny spots, with the color of each cell stored in a file on the computer. As the scanner's "eye" scans across the original picture, the computer converts each square of tones it sees into numbers. The numbers describe the color of each square. The resulting array of colored cells is called a bitmap image.

Why does the scanner need to divide the original continuous-tone picture into cells or squares? Think of it this way: A bitmap image is rather like a paint-by-number kit.

Remember those? When you bought a paint-by-number kit, you'd get a white canvas with areas outlined. (The areas could be any shape, though, not just squares.) Each area had a number printed in it corresponding to a little can of paint. You'd load up your paintbrush with the proper color and fill in the numbered area. When you were done, you'd have a picture. Usually the "resolution" of the picture was pretty coarse and would have a lot better "resolution" if it had divided the paint-by-number areas into tinier bits of color. But who would have had the patience to fill in millions of squares?

In today's world, the computer has that amount of patience. As it scans your original art, it can create thousands or millions of squares of colors.

Before the computer can do this, however, you must tell it how many little squares you want it to use (resolution). The answer is measured in dots per inch. You determine this when you set the scanner modes. For example, if you select 600 dots per inch, then the scanner divides the original into 600 little squares per inch as it moves across the original.

(ABOVE)

Scanners break up the tones of a continuous-tone original for the same reason that paint-by-number crafters paint small areas of color: You've got to apply the color using some scheme of painting small amounts that, from a distance, create the illusion of continuous tones.

LASER PRINTER

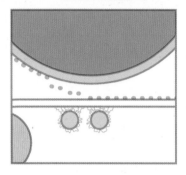

INK-JET PRINTER

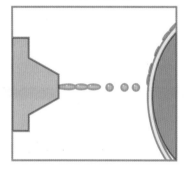

COMPUTER MONITOR

A computer doesn't care how it displays the pixels stored in its memory. It's happy to output pixels by interfacing with the software in a laser printer, which converts pixels to toner dots. Or the computer can interface with an ink-jet printer, which converts pixels to sprayed-out droplets of ink. Or the computer can direct its own monitor to display the pixels by lighting up squares or phosphors on the monitor screen.

The "dots" are not really printing dots. They are a spreadsheet of numbers arrayed in a grid or cell. Each number in the grid tells an output device either to color in a tiny portion of the grid, or to leave it blank. These tiny portions are the dots in "dpi."

These dots can be depicted or applied by various output devices. Laser printers, for example, apply little blobs of toner in a grid. Ink-jet printers spray little droplets of ink. A computer monitor turns on little phosphors that emit red, green, or blue light. All these applications are measured as dpi and all come from the same source: pixels.

(RIGHT)

Using the control bar, you can tell your computer monitor to output (or display) its pixels at different screen resolutions. The higher resolutions can display more colors and more detail. But the number of pixels displayed is the same, because pixels are pure numbers, not squares on a screen.

When you tell your computer to show you a bitmap image on your monitor, usually the computer depicts one numerical pixel by using one screen pixel. You can alter this on your monitor by clicking on the control bar and opening up the window for screen resolution (the icon looks like a little checkerboard). On my iMac, I can choose to view my monitor screen with 640x480 pixels, 800x600 pixels, or 1,024x768.

THE LIMITS OF RESOLUTION

Altering my screen resolution does not affect the real pixels at all. They're still living, inviolate, in the computer's database.

What limits the computer's ability to show resolution on any output device is the number of total pixels that were input into its file for any given image. The input can be from a scanner, a Photo CD, an E-mail image, etc. This data is expressed by the number of pixels along the height of the image and the number of pixels along the width. An image measuring 640 x 480 pixels has 640 pixels along the height and 480 pixels along the width, for a total of 307,200 pixels. All the information about the picture—the colors, the detail—is contained by these 307,200 pixels.

If you decide that you'd rather change the number of pixels in an image, you can throw data away and reduce the number of pixels you have. This may be a good idea because manipulating large numbers of pixels takes a lot of memory from the computer. Let's say you have scanned in a color picture, but you really only need black-and-white. You can throw away all the data used to create the colors, thereby shrinking the database considerably.

Unfortunately, you cannot go the other way very effectively. You cannot increase the number of pixels stored in your computer for any given image.

(However, note the discussion about resampling in Chapter 4.) If you tried to tell your computer to add pixels, it wouldn't know what to do. Put a zero here, a one there? How many zeroes? In what order? Your poor computer has no way of answering these questions. On *Star Trek*, when the crew did this to the computerized android, Commander Data, his eyes would start to flit back and forth in a Nixonian manner, and then sometimes he would topple over.

The best way to increase the number of pixels your computer has to work with is to give it more pixels in the first place when you scan the image. How many pixels should you give it?

(ABOVE AND FACING PAGE)
If you want to reduce the resolution of an image, you can always throw away pixels from a stored image, but it's difficult to add new pixels to increase resolution effectively. The computer must guess how to add the new pixels, but it can't know for sure. Sometimes you can improve an image slightly, but if you try to add too many pixels, the results look horrible. That's why it's best to scan your originals at the highest resolution you think you will need.

In the picture above, the resolution is too coarse. When the computer is told to add more pixels, it tries its best, but the image (facing page) just doesn't look right.

100%

50%

(RIGHT)

To determine the best resolution for your images, you first need to calculate the linear reduction (or enlargement) of the original. You do this by measuring one side of the original and calculating the percentage that side changes as you reduce or enlarge your scan. It doesn't matter which side of the original you choose to measure; just be sure you use only one side. Here, the original measures 3.25 inches (82 cm) wide and must be reduced to a measure of 1,625 inches (41 cm) wide, or a reduction of 50 percent.

Choosing the Right PPI

The first thing you might try is to scan at the highest possible resolution available. But you find that this leads to enormous files. For example, an 8-by-10-inch (20-by-25-centimeter) picture, scanned at 1,200 pixels per inch (ppi) contains (8 x 1200) x (10 x 1200) = 115,200,000 pixels. How big is the resulting file? If you have a 32-bit system, that's four bytes per pixel. So the raw image would be 4 x 115,200,000, or 460 MB. Such enormous images will burn up your disk space quickly and slow the output considerably. If the output is an imagesetter used to produce final film, you can spend a lot of money on this big of a file—service bureaus with expensive imagesetters often charge by the minute.

You might think that the expense is just a cost of doing business. But, in fact, a file with resolution this fine is a waste of money because most output devices can't use this much data. In effect, they throw large portions of it away.

Rather than waste money producing resolution that nobody can print, it's far better to calculate how many pixels per inch you really need for your images in the real world. There are only three numbers we need to calculate, and two of them are very easy.

ENLARGEMENT RATIO: 35mm NEGATIVE

REDUCTION RATIO: 8 x 10 INCH PHOTO

LINEAR ENLARGEMENT RATIO

The first (easy) number we need to know is the linear enlargement ratio. This is defined as the linear size of the final outputted artwork divided by the linear size of the original artwork. So if we are going to print our original 8-by-10-inch (20-by-25-centimeter) picture at a final output size of, say 4 by 5 inches (10 by 13 centimeters), the linear enlargement ratio would be: 4 inches final width divided by 8 inches original width equals one-half (0.5).

Note that we are choosing the linear measurement of the original, not the area. Note, too, that we chose to use the width measurement. We could also have chosen the length; it makes no difference.

SAMPLING RATIO

The second (easy) number we need to know is a sampling ratio. This is a "fudge factor" used to ensure that each output halftone dot is backed up by more than one bitmap pixel. Just set the sampling ratio to a value between one (for smallest feasible files at slightly lower resolution) and two (for bigger files at higher resolution). For output to a conventional offset press, use one and a half. It works. For output to a computer monitor for a Web page, use the number one. If you're in doubt, use two for the sampling ratio—you can always reduce the size later in Photoshop, or just accept a little bit of extra, wasted disk space and RIPing time.

8 X 10 ORIGINAL

Printer Resolution

The final (not so easy) number we need to know is the printed resolution. This requires some expert knowledge of the particular printing process you are using:

1. If you are using a conventional offset press, the printed resolution is determined by the press's and paper's ability to hold ink on the surface of the paper. The resolution can range from 85 to 300 lines per inch. Ask your printer what number is best, based on the equipment and paper to be used to produce your work.

2. If you are using a toner-based system, such as a laser printer, the laser printer has to draw each individual halftone dot as a bundle of many laser-printed dots. There are quite a few ways to do this, and some experimentation may be necessary for you to determine the effective resolution of your output device.

 As a rule of thumb, the effective halftone resolution of a laser printer is not much better than one-quarter of the manufacturer's quoted dots-per-inch resolution. Thus, a 600 dpi laser printer will achieve a halftone resolution roughly equivalent to a 150 lines-per-inch screen (600 divided by four equals 150).

3. If you are outputting your design to a computer monitor, the lines-per-inch resolution is the same as the manufacturer's stated pixels-per-inch resolution. In most cases this number is seventy-two or ninety-six.

FINAL OUTPUT SIZE = 4 x 5

linear reduction ratio		sampling number		resolution of output device		scanning resolution
0.5	**X**	**1.5**	**X**	**150 lpi**	**=**	**112.5 ppi**

Scanning Resolution

Once you have determined the three numbers you need, here is the magic formula to calculate how many pixels per inch you need to scan your images:

Scanner pixels per inch equals linear enlargement ratio times sampling number, times the effective resolution of the output device.

So if you're wondering how many pixels to scan that 8-by-10-inch (20-by-25-centimeter) image we first talked about, here is what you do:

1. Decide how big the final outputted image is going to be. In this case, we said 4 by 5 inches (10 by 13 centimeters). This gives a linear reduction ratio of one-half (0.5).

2. Decide on the sampling number. We're going to be outputting on a laser printer, which doesn't have very good printing quality, so a sampling number of one and a half should be more than adequate.

3. Decide the effective resolution of the output device. Our laser printer is a low-end model capable of 600 dots per inch. The effective resolution of this printer, we have learned through experimentation, is 150 lines per inch.

Therefore we need to scan our 8-by-10-inch (20-by-25-centimeter) image at a resolution of 112.5 pixels per inch (0.5 times 1.5 times 150). If we're unhappy with the detail on the resulting image, we might try raising the sampling number to two. Then we would scan at 150 pixels per inch. Anything more than that is a waste of disk space.

File Compression

Images, especially color images, are big data hogs. Not only do they require a lot of memory to store, they require quite a bit of memory just to look at them, and even more memory to manipulate them. The problem is exacerbated any time you want to send an image anywhere, whether it's over the Internet or to your ink-jet printer.

To deal with this problem, software programmers came up with the idea of compressing data. Think of it this way: Let's say you have scanned a line drawing into your computer. Wherever the image is black, the computer bits are on; wherever the image is white, the computer bits are off. Vast areas of the bitmap are nothing more than long strings of zeroes that show all the white space.

Rather than make the computer store each zero separately, why not write a little program that tells the computer, "Hey, right now you're going to show 1,082 zeroes in a row (where there is a lot of white space). Then you'll show eighteen ones (where there is a little black). Then another 582 zeroes." You can see how much shorter such a command would be than making the computer actually store 1,082 zeroes followed by eighteen ones, and another 582 zeroes.

Many programmers saw the advantage of compressing data, but they all did it in a different way. The result is that there are many compression programs on the market today. Some of the most common are TIFF (Tagged-Image File Format), BMP (used for Windows), GIF (CompuServe's Graphics Interchange Format, used mainly for pages of hypertext markup language, or

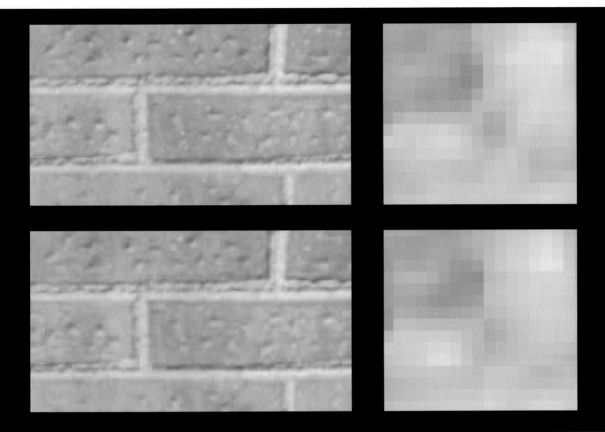

Lossy compression programs, such as JPEG, throw away some of the pixels and then restore them later when the image is decompressed. The restored pixels aren't always the same as the original ones thrown away so details in restored JPEGs can look slightly different from the original.

HTML), JPEG (Joint Photographic Experts Group, also used commonly on HTML pages), and PICT.

Some of these programs are lossless, meaning that when they compress the data, they don't throw any of it away. When you reopen the file and uncompress it, it reverts to the same bitmap it had originally. Some compression programs, notably JPEG, are lossy. That means they throw data away when they compress it. When you uncompress a JPEG file, the software recreates the data in a set way. But it doesn't duplicate the original data exactly. So JPEG images look a little different from the original.

You can save your bitmap data in many different formats. Be aware, however, that some service bureaus and printers may have trouble with certain formats. This is especially true if they are still using older imagesetters. So always, always check ahead before you compress anything. You don't want to find out that your format causes the imagesetter to crash on the day that you have to get your job printed, bound, and out the door before the last mail pickup at 3 p.m.

That would cause heads to roll just as surely today as screw-ups did in Pharoanic times three thousand years ago. Some things never change.

A BIT OF COLOR

Each screen pixel on your monitor is either on (one) or off (zero). So each pixel can show two levels of meaning. But you can't express any shades of color or intensity at that level. So computer engineers grouped pixels into collections of eight bits, or two permutations of eight zeroes and ones strung together. An eight-bit system can create 256 levels of color (two to the eighth power, or two times two times two times two times two times two times two times two). Why did engineers stop at eight bits? Because the human eye can see only about 256 levels of gray.

Now, if you make each pixel capable of showing three colors (red, green, or blue), then you increase an eight-bit system to twenty-four bits. This yields 16,777,216 colors. Bird eyes might be able to resolve more shades than that, but our eyes can't.

(RIGHT)
Sometimes vignettes that are supposed to fade gradually from dark to light do so in steps that you can actually see. This is called banding.

(BELOW)
The human eye can see approximately 256 shades of gray, ranging from solid black to white. The eye can perceive as many shades in each of the primary colors too, meaning that we can see as many as 16,777,216 colors.

Banding

When you create a design where color is supposed to gently fade off into nothingness, like General Douglas MacArthur saying goodbye to Congress, sometimes bad things happen. The general doesn't go gradually. In print, this is called banding. Instead of a smooth, continuous-looking fade, banding creates a kind of stepping-stone look in a vignette or in a design where one color blends into another.

There are four reasons why you can get banding in digital printing:

1. **Not enough bits in each pixel.** The first rule of no-band printing is: Do your initial scans with a bit depth of at least eight bits. Here's why:

In programs such as Photoshop that deal with raster images, each pixel carries several channels of information. The number of channels determines the kind of image you have. A grayscale image has only one channel (the gray level). An RGB image carries three channels (red, green, and blue). A CMYK image carries four channels (cyan, magenta, yellow, and black).

Each channel has a "bit depth," which determines the number of shades resolved in that channel. For most halftone images, a bit depth of eight is plenty. This yields 256 shades of gray (two to the eighth power), which is about as many as the human eye can see.

You are almost certain to run into banding problems if you are given files with a bit depth of less than eight pixels.

In such cases, banding is almost inevitable. Therefore, such files are not suitable for high-quality images. If you receive such a file, you can increase its bit depth in Photoshop and then use smoothing filters. But the results are unlikely to be top quality.

2. **Too much file compression.** The second rule of no-band printing is: Be careful about using lossy compression schemes. Here's why:

Lossy compression programs, such as JPEG, throw away some information to make the file size smaller. To do that, the program looks at pixels and in effect says, "Here's a tone, here's the same tone. Let's compress the data. Okay, here's another tone and another and another that we can compress in the same way. Oops, here comes a tone that's too different. Let's make a new compression tone." At that point, you might get a band not present in the original, uncompressed image.

Alternative file formats, such as GIF and TIFF, compress tones without throwing away data. The resulting files are bigger than JPEG files, but they preserve every pixel that was in the original.

Sometimes lossy compression programs can cause banding when images are decompressed (left). The solution is to use a lossless compression program (right).

(RIGHT)
The reason that designers use lossy compression programs, even though they can cause banding problems and changes in detail, is that lossless compression programs don't compress as many pixels. So the files are much bigger.

TIFF: 3.6MB

GIF: 964K

JPEG: 132K

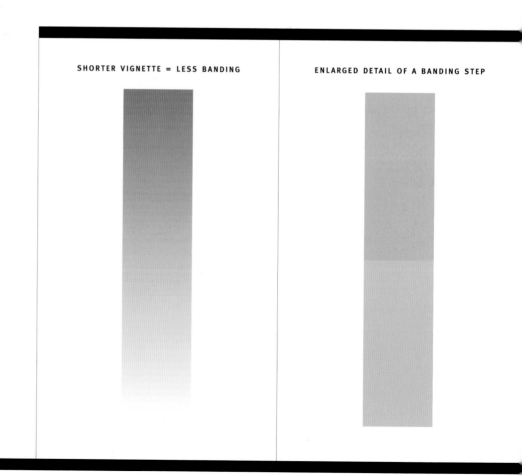

3. **Gradients spread across too great a length.** The third rule of no-band printing is: Use short blends and vignettes. Here's why:

Digital imagesetting devices create ink halftone dots by building them up out of smaller digital dots. They do this by creating a grid and placing various amounts of digital dots onto the grid to synthesize different-size halftone dots. Depending on its size, each halftone dot can be created by one digital dot on the grid (resulting in a very, very small halftone dot), two digital dots, three, all the way up to the largest number of digital dots that the imagesetter is capable of

outputting (resulting in an array of halftone dots so big and so densely spaced that the ink color is solid).

When these synthesized dots are asked to produce a continuous gradient of tones, they do not arrange themselves randomly.

All the 50 percent dots clump together in the middle of the blend, all the 40 percent dots clump next to that, all the 100 percent dots clump together on the solid end, etc. As the dots go from percentage to percentage, they do so in steps.

SHORTER VIGNETTE = LESS BANDING

ENLARGED DETAIL OF A BANDING STEP

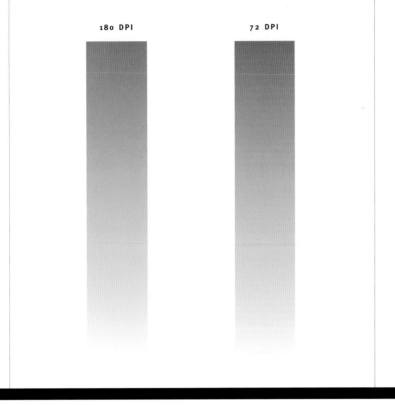

180 DPI 72 DPI

If the steps are spaced far apart because the vignette or blend is stretched across a great width, we can see the steps as bands. If the steps are packed closely together across a short distance, we can't see them.

4. **Not enough resolution.** The fourth rule of no-band printing is: Use an imagesetter and a line screen with plenty of resolution. The more dpi and lpi you have to work with, the smoother your blends and vignettes will look, simply because the steps between shades will be more finely drawn and harder to see.

(ABOVE)

Banding can be minimized if the resolution you choose is high. That's because higher resolutions use more pixels, so the steps between bands of tones are smaller and less visible.

(FACING PAGE, LEFT)

Vignettes made of halftone dots can show banding as the grayscale steps from one tone to the next. This is especially true if the vignette is stretched across a long distance. If the vignette is shorter, the banding becomes less noticeable.

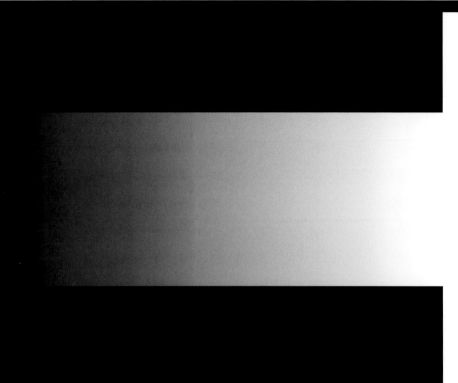

1.

calculate number of shades available

$$dpi^2 \div lpi^2 = \underline{A}$$

dpi of
monitor
or output
device

lpi of
printing
device

HOW CAN YOU TELL IF YOU'RE LIKELY TO GET BANDING?

Basically it boils down to whether you've got too few dots or too big a blend. You can calculate this for yourself.

1. Figure out the number of shades available in your blend, by acquiring two numbers: the dpi of your digital outputting device (an imagesetter, a computer monitor screen, etc.); and the lpi of your final printing device (an offset press, a laser printer, etc.). Remember that the lpi of a digital printing device is not the same as its dpi. The lpi of a digital printing device is really the effective halftone screen frequency (measured as lpi) that its digitally synthesizing toner or ink-jet heads can create. To get the effective lpi of your printing device, consult the manufacturer. Most desktop laser printers, for example, have an effective lpi of 150.

2.

measure length of vignette in points

#inches x 72pts = _B_ pts

3.

divide length of vignette
by # of shades available

B ÷ A = _C_ if _C_ > 1 banding may result

Once you have found out these two numbers, plug them into this formula:

(dpi squared) divided by (lpi squared) equals total shades available.

This formula applies to a vignette that goes all the way from 0 percent black (i.e., white) to 100 percent black (i.e., solid). If your vignette is going to shade from, say 30 percent to 70 percent black, you've got to multiply the total shades above by 40 percent (because that's all the tones you'll be using).

2. Measure the length of your vignette, in points (72 points equals an inch).

3. Divide the length of your vignette by the total shades available.

If the number you get is greater than one, you will probably see banding. Let's consider an example.

Suppose your imagesetter is capable of 1,200 dpi, and you ask it to produce a halftone vignette 5 inches (13 centimeters) long, going from solid black to white, screened at 100 lines per inch.

First, you need to figure out how many tones are available by squaring the dots per inch and dividing it by lines-per-inch squared: dpi squared is 1,200 times 1,200, or 1,440,000. Lpi squared is 100 times 100, or 10,000. 1,440,000 divided by 10,000 equals 144. You have 144 tones available.

Next, measure the length of the vignette in points: 5 inches times 72 points equals 360.

Next, divide the points (360) by the number of tones available (144), and you get 2.5. The number is greater than 1, so you will get banding.

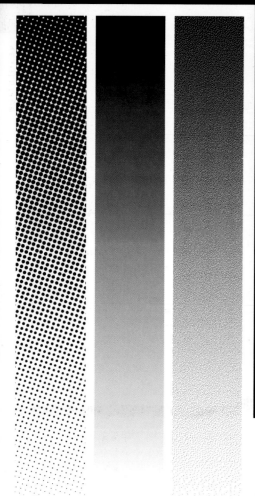

(ABOVE LEFT)

Conventional halftone screens (left) often show banding (center), while stochastic screens (right) don't. That's because halftone screens are arranged in a grid pattern, but stochastic dots are random.

(ABOVE LEFT CENTER)

Conventional halftone screens use a grid of evenly spaced dots. The dots are large in dense areas of color, and small in pale areas of color.

TO AVOID BANDING, YOU CAN DO ONE OF SEVERAL THINGS:

1. Stretch your vignette over a smaller distance. If you make the sample vignette above 2 inches instead of 5 and work the formula, you will get a final ratio of 1 instead of 2.5. So you won't see banding.

2. Use more dpi. If you use an image-setter with a resolution of 2,400 dpi, you will have 576 tones available: (2,400 times 2,400) divided by (100 times 100). When you divide the length of the vignette in points (360) by 576, you get 0.625, a number less than 1. So no banding.

3. Reduce your lpi. If you printed your halftone at a very coarse 60 lpi, you would have 400 tones available: (1,200 times 1,200) divided by (sixty times sixty). When you divide 360 points by 400 tones, you get 0.9. So no banding.

4. You can also try two general tricks: You can add noise to disguise the banding, or you can make the contrast of the blends bigger (although in our example, going from 1 to 100 percent is as big as you can make it).

5. You can use stochastic screening instead of conventional halftone screening. Stochastic screens employ randomized dots, so no banding pattern ever appears.

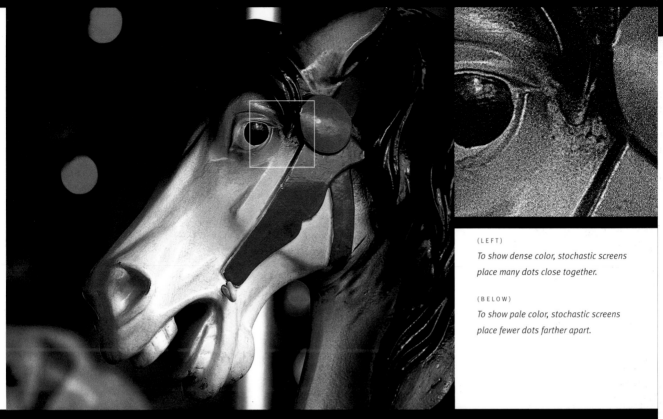

(LEFT)

To show dense color, stochastic screens place many dots close together.

(BELOW)

To show pale color, stochastic screens place fewer dots farther apart.

Stochastic Screening

Like halftone screening, stochastic screening is a method of converting continuous-tone images into dots that can be printed on a press.

The difference is that instead of chopping up an image by using a grid, stochastic imaging chops up the image by converting it into millions of really tiny dots. The dots are all the same size (unlike halftone dots, which are different sizes). But they are arranged in a randomized way so that we can see no pattern. Stochastic dots may be close to each other or farther away (unlike halftone dots, which are evenly spaced).

When many stochastic dots clump together, the color is very intense. When few stochastic dots clump together, the color is pale.

(ABOVE)

When angled halftone screens are used to reproduce a small geometric pattern, the angles of the screens can conflict with the angles of the pattern and can cause a moiré. Stochastic screens have no pattern and produce no moirés.

(ABOVE RIGHT)

Halftone screens are angled to prevent one ink printing directly on top of another.

(RIGHT)

Stochastic screens (right) can show more detail than conventional halftone screens (left).

(ABOVE)

Because conventional halftone screens are made up of dots on a grid, they butt against each other in square patterns. When you try to reproduce subjects that have a lot of smooth, curvy shapes, such as metal cars, a square grid may not create the subtle modeling effects that you need. This may be especially noticeable in digital printing, because the halftone dots do not sink into the paper, as they would on a conventional press. The grid pattern is thus not softened by dot gain. Stochastic screening might be a better choice.

(ABOVE AND LEFT)

Because stochastic screens use very tiny dots, they can print delicate shades of color with finesse (above). Halftone screens use larger printing dots that do not provide as many tonal gradations (left).

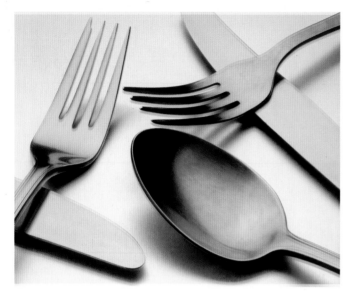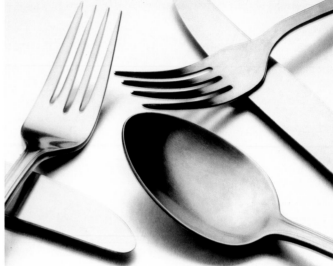

Stochastic screens are more forgiving about registration. An image that prints noticeably out of register with halftone screens (left) is not noticeably affected with stochastic screens (right).

THE ADVANTAGES OF STOCHASTIC SCREENING:

1. **More detail.** Stochastic dots are tinier than the dots used to make halftone dots, so stochastic screens can show greater detail.

2. **No screen angle conflicts.** Because stochastic screens have no grid pattern, they have no angles. Without angles, stochastic screens never show moirés.

3. **Less banding.** With smaller, randomized dots, stochastic screens do not show banding when one tone blends into another. This trait can be especially helpful when showing curved, shiny surfaces, such as those on cars, or when showing delicate midtone blends, such as skin tones. These colors look smoother and more continuous than images separated with halftone screens.

4. **More control.** Because stochastic dots are so tiny, you can control certain colors better, especially those on the pale end of the scale, such as pastels.

5. **Easier registration.** Stochastic screens are far more forgiving on press than halftone screens, when it comes to registration.

THE CHALLENGES WITH STOCHASTIC SCREENING:

1. **Harder to print.** Not every printer or output device can print stochastic screens. You need output devices that can produce the incredibly tiny dots. This is especially true for digital devices. So check ahead with your printer to make sure your job can print.

2. **Different software algorithms.** To make stochastic dots random takes powerful software. It is not a simple thing to make random dots look really random—our eyes keep insisting on finding patterns or shapes. Just go outside and look at the stars some night: The stars are distributed randomly in our sky, yet we see constellations such as the Big Dipper, Pegasus, Cassiopeia.

Since programmers knew that you wouldn't want a spoon, a horse, or a W appearing in your image, they devised software that would compensate for our desire to see patterns. Different software publishers came up with different programs. Make sure that everyone in your production flow can support your screening software.

3. **Proofing.** Even if your printer can output stochastic screens, you may not be able to proof your designs on your office laser or ink-jet printer, if the resolution they offer is too large to print stochastic dots. Ask your printer for some help with proofing.

4. **Dot gain.** If you're printing with inks, as opposed to toners, you may have to contend with excessive dot gain. That's because stochastic dots are so small that any dot gain at all is usually a significant proportion of the total size of the dot. This is an especially big problem on a conventional offset press, a small problem on a waterless press, and no problem at all with toner technology. Ask your printer how you should compensate for dot gain, if necessary.

(RIGHT)

To be random is not the same as to look random. The stars in the sky are scattered randomly, but our eyes try to see a pattern, such as the Orion constellation here. To look random, stochastic screens employ highly sophisticated mathematical programs that randomize dots in such a way that our eyes see no pattern whatsoever.

Chapter 6: Paper

A Seattle reprographics firm agreed to ink-jet an elegant invitation for a charity fund-raiser. When the designer arrived at the plant to pick up her finished work, she opened the box and saw the invitations neatly folded. "They're perfect," she said, looking at the vibrant colors. She took one out and stood it up on the counter. The edges of the invitation curled back on themselves like hair rollers. Both she and the printer stared wordlessly.

"Well, don't worry about that curl," the printer finally said. "No one will notice once they're put in the envelopes."

"They're not going in envelopes. They're standing near everyone's place setting on the tables," said the designer. "These aren't invitations to dinner. They're invitations for people to make donations. At our elegant dinner. With linen tablecloths. And crystal stemware."

"You never told me that," said the printer defensively. "I would never have laid out the job with the paper grain going that way, if I'd known. You'll have to take the invitations as is or pay for new ones."

"But they curl."

Like military spies on a clandestine mission, sometimes print buyers give out information to their printers on a need-to-know basis. We assume printers don't need to know very much about the purpose of the design; they just need to print it. So we buyers sometimes purchase paper without taking key factors into account.

When paper is formulated, it's made with certain performance standards in mind. No single paper can do everything, so mills balance one characteristic against another. If a paper has to resist tearing, for example, mills build in a lot of tear strength. But then they can't make the paper very light, because heavier weights increase tear strength. No one sends shopping bags through the mail because while they don't tear easily, they're also quite heavy.

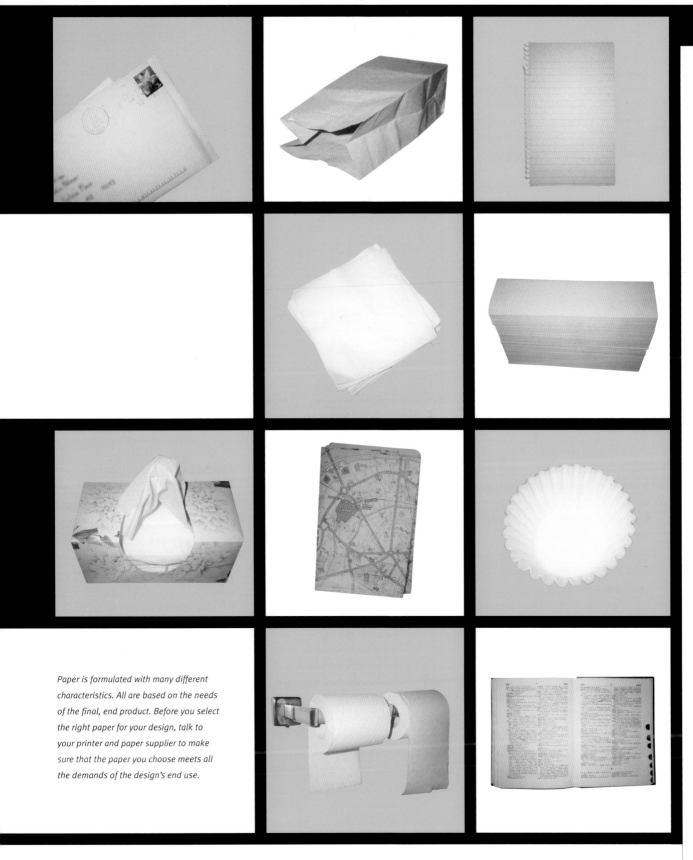

Paper is formulated with many different characteristics. All are based on the needs of the final, end product. Before you select the right paper for your design, talk to your printer and paper supplier to make sure that the paper you choose meets all the demands of the design's end use.

Cover-weight paper is usually not recommended for laser printing because it is too thick to be drawn through the printer, and the toner particles may not print properly. Here, the designer used these "disadvantages" in a creative way, creating a handmade look that resulted from a homemade desktop system.

The reason we tend not to tell the printer everything is that when many of us make paper choices, we don't base our decisions on the end use of the product. Why should the printer know what we're using the paper for when it doesn't enter our heads to select paper with that criterion in mind? We use other criteria. Designers, for example, often choose paper with their eyes. If it looks good, they buy it. Publishers, on the other hand, often buy paper with their wallets. If it's a bargain, they'll take it.

A better strategy would be to make sure that the paper you select has all the performance qualities that the job requires.

One way to do this is simply to tell your printer exactly how you're going to use the paper. The printer can decide if the paper you want will stand up to the stresses it will have to endure, whether it travels through the mail, sits on a coffee table, or ends up wrapping fish at the market.

Of course, printers are limited in the amount of paper they can stock. So if you rely solely on them to recommend paper, you will undoubtedly miss a host of other sheets that might be more interesting design-wise. If you really want design control over paper, you need to understand for yourself how to match a paper's characteristics to your needs. Here are a few things to consider:

Output Devices

The first question you must ask about your paper is: Will this work with your equipment? Different digital printing technologies have very different requirements for the papers they can accept. Toner-based technologies, for example, require very smooth finishes because the toner must be fused to the paper with heat. If a paper is too rough, the fusion doesn't work very well and the toner flakes off. Ink-jet technologies also work best on smooth surfaces because the ink droplets are small and can get distorted by heavily textured surfaces.

(ABOVE)

Knowing your output device's capabilities is key to choosing the right paper. Here, the designer knew that bristol stock for this hand-assembled sundial would be too thick to be printed conventionally. So instead, he printed his designs on vellum paper and hand-glued them to the sturdy bristol.

(RIGHT)

For this design, a truly thick feel was achieved by printing two separate sheets: A fairly thick, tactile sheet was used as the base, and a thin, translucent sheet was used as a flysheet.

(FAR RIGHT)

Papers like this one that have pieces of plant matter embedded in the pulp (here, bamboo) may or may not work in your digital press. Test a few sheets early in the design process.

36"

24"

☐ Trimmed Waste

(ABOVE)

When designing a job, consider the size of the paper sheet you'll be printing on. It's crucial, of course, that your design is small enough to fit onto the sheet, allowing enough trim around the edges to be finished properly. But it's also wise to think about how much paper will be trimmed off and discarded. Most paper is sold by weight, so the more paper you discard, the more money you waste. Ideally, your designs should fit as tightly on the sheet as is technically feasible. In the example above, if the piece were designed slightly smaller, it could be laid out vertically, two to a column. Four columns would fit on the sheet, so we could print eight copies on one sheet instead of four.

SHEET SIZE

Paper finish is not the only limitation for these technologies, sheet size can be extremely limited. Asia, Europe, and North America all use different standard sizes, and most desktop printers can accept papers no wider than A4. They can take longer sheets if you hand-feed them. Commercial printers, on the other hand, can often accept much wider and longer sheets. If your design format doesn't fit some multiple of your continent's standard size, you will be forced to accept paper spoilage: The unused portions of paper will be tossed, although you will be charged for the entire sheet by weight.

When you're considering paper sizes, remember to think about all phases of production, not just printing. I once printed a bunch of blow-in cards at a quick-print plant that were too big for my commercial printer's bindery equipment. We had to trim each card before it would fit. Not only did this add to my expenses (and my embarrassment), but the trim looked awful. The designer had used a full bleed everywhere on the card, so when we did the trim, we cut off models' heads, part of the type describing the offer, and enough of the background design to make the final card look really stupid. We were lucky to keep our company's address on the card. When all was said and done, we should have bitten the bullet and redone the card from scratch. "Scratch" meaning, we should have found out the bindery's limitation before we even designed the piece.

One major limiting factor for most digital printers is paper thickness. Paper that is either too thin or too thick usually jams. Here, this paper (a bristol stock) is so thick that no digital press could handle it. Not even an offset press could take in on. Instead, the designer used a letterpress.

(LEFT)

If you plan to use your laser printer to print a two-sided job, make sure the paper you select has been specially formulated to retain enough moisture to pass through the printer twice. Papers formulated for one-sided printing tend to crease and jam when printed on the second side. Look how mangled the top corners of this sheet became when the designer tried to print the second side.

MOISTURE CONTENT

Another factor to keep in mind is whether your printing technology requires heat to set, as most toner-based and some liquid-ink presses do. If you're printing a two-sided job on a one-sided press, you need paper that retains its body and moisture when heat is applied. Most laser printers spray a charge of static electricity onto a printing drum, which then attracts toner particles that are transferred to the paper. The toner is then fused to the paper with heat.

On two-sided jobs, the paper can pick up its own charge of static, especially if the environmental humidity is low and too much of the paper's moisture gets sucked out the first time it runs through the printer. When the paper is turned to print the second side, it will curl or crease as it goes through the printer a second time.

THICKNESS

Paper thickness can be another limiting factor when it comes to matching paper with equipment, especially if the equipment is a desktop printer. Most start to jam on anything thicker than 28-pound bond. Commercial digital presses are also limited. Many cannot take paper thicker than 80-pound or at most 100-pound stock. Ink-jet-based printers tend to have a lot more flexibility than toner-based presses. If the ink is formulated properly, ink-jet printers can print on many

substrates besides coated text paper: Transparencies, plastic film of all kinds, card stock, and uncoated papers are all possibilities, depending on the make and model of the press. Because the capabilities of a given digital technology are so variable, you should check ahead with your printer to make sure that your substrate will work for the printer you plan to use. If there is any doubt, ask the printer to run a few practice sheets through the press. There may be some extra expense for this service, but nothing compared to the expense of buying a load of paper that jams or that won't print at all.

It's important to match paper strengths to job needs. The designs on these pages required different kinds of paper strength: Mullen strength (to withstand perforations, especially folded perforations); tear strength (to withstand folding); tensile strength (to keep from stretching on a web press); and bond strength (to keep packaging from falling apart).

Strength

Paper strength is measured in two areas: internal strength and surface strength. Internal strength is built into the paper during its manufacture. It is based on the way that the fibers in the pulp bond together. Surface strength is applied later and comes either from polishing or from adding coatings.

INTERNAL STRENGTHS

1. **Tensile strength** keeps paper from stretching too much. It's an important characteristic for web presses, where the paper is on a roll that is pulled through the press. Many commercial digital presses are web presses, as are wide-format printers. If a paper has weak tensile strength, it can tear when it's pulled. It can also distort as it goes through the press, which results in poor registration, especially on the outer edges of a sheet.

2. **Tear strength** is the ability of paper to resist tearing. Papers that will be used for packaging, bagging, or wrapping should have good tear strength. Papers that are going to be folded should have enough tear strength not to tear easily along the fold line.

3. **Mullen strength** measures the resistance that paper has to bursting. If a paper is going to be punched, stapled, wire-bound, die-cut, or otherwise punctured in some way, it should have good mullen strength.

4. **Bond strength** is the strength of the bond that keeps the pulp fibers together. It's an important characteristic for web papers, which are pulled through a press. It's also important for bags and other packaging that must hold together, even when slightly wet.

Pick strength and coating strength are necessary to make sure that ink doesn't pull off surface fibers from the paper, and that heat to dry or set the inks doesn't create bubbles and blisters under the paper. These strengths are especially important when you design jobs with heavy ink coverage, as is shown here.

SURFACE STRENGTHS

1. **Pick strength** measures the ability of paper to resist ink's tendency to pull off little pieces of coating and fiber as the ink is applied or as the paper goes through the printer. A paper with poor pick strength will lose fibers as it's printed. Not only does this make the printing on it look mottled, but you have to ask, where do the fibers go? In some presses, they go onto a rolling mechanism that prints the next sheet, which interferes even more with the ink or toner.

2. **Coating strength** is the ability of paper to hang onto its coating without bubbles, blisters, or delamination. It's an important strength for any paper that is subjected to heat, as are most papers printed with toner-based technologies.

No printer expects you to know how strong a particular paper should be. It's the printer's responsibility to make sure that the paper you want can stand up to the stresses it will undergo. However, it is your responsibility to disclose fully everything you plan to do with your finished piece. Folding, punching, binding, embossing, foil-stamping, mailing, gluing, rolling, pinning, even displaying in full sunlight all affect the kind of paper you need.

You shouldn't just tell the printer all your plans, either. You should question specifically whether the paper you'll be using can do the job. We've all received magazines in the mail with covers falling off because someone failed to select a paper that had the proper mullen strength. What a shame that a designer spent time and creative energy putting together a beautiful cover only to have it fall off for such a dumb reason as failure to communicate.

LaCrosse Footwear, Inc.
Annual Report 1995

(THIS PAGE AND PAGES 158-159)

What kinds of paper strengths do you think were required for the jobs shown on this page and the following spread?

California:
In Three
Dimensions

Opacity

Opacity is to paper quality as grunge is to haute couture. If a designer outfit is supposed to look like a hobo's discard, it's great. If it really *is* a hobo's castoff, then we don't want to touch it. In the same way, papers that are designed to be translucent are considered the height of elegance. Opaque papers that exhibit show-through, however, are fit only for the bottoms of bird cages.

It's these latter papers that you have to be concerned about. Show-through is the phenomenon where ink on one side of a paper can be seen on the other side because the paper is not opaque enough. It's a particular problem when you design a job that prints with heavy ink coverage on one side and light ink coverage on the other. It's generally not an issue to worry about when you're printing on only one side of a sheet, however.

Mills determine opacity by putting a black sheet behind a particular paper and measuring how much brightness the paper loses. The measurement is calibrated as a percent, which serves

(RIGHT AND BELOW)

Opacity is mainly a function of paper thickness and lignin content. The bible paper on the right is tissue-thin and has some lignin in it. It exhibits quite a bit of show-through because of its thinness. In fact, if it weren't for lignin content in the pulp, this paper would be translucent. The newsprint paper below also has quite a bit of lignin in it, but it is much thicker than the bible paper. So it exhibits much less show-through.

as the opacity rating of the paper. Nobody ever pays any attention to this number. It's far easier just to lay a sheet down on top of a strong pattern of black-and-white and see for yourself.

To check opacity, take a blank piece of paper (not a printed sheet) and put it on top of the fish below. The amount of black-and-white pattern that you can see through the paper is about the same amount of show-through you would get if you were to print both sides of the paper.

SEVERAL FACTORS CONTRIBUTE TO MAKE A PAPER MORE OPAQUE.

If you need opacity for your design, look for papers that have these characteristics:

1. *Thicker papers are more opaque than thin papers.*

2. *Papers made from groundwood pulp are more opaque than free sheets.*

3. *Coated papers are more opaque than uncoated.*

4. *Papers with rough finishes are more opaque than papers with smooth finishes.*

5. *Colored papers, especially dark-colored papers, are more opaque than white sheets.*

(BELOW)

To get an idea about the amount of show-through a paper might exhibit, lay an unprint-ed sample sheet over this fish print (or any print that shows a strong black-and-white pat-tern). The degree to which you can see the fish print through the sample sheet is the degree to which the paper will exhibit show-through.

Paper manufacturers bleach white paper to make it white, but different mills use different chemicals and different amounts of bleaches. The resulting papers are white, but look at how different "white" papers appear. When you select white paper, it helps to compare your choices using unprinted sample sheets. If you look at only one sample, you won't even notice whether the white paper is blue-white, creamy white, or just plain dull.

Some paper mills add dyes to their paper pulps to make colored papers. These papers can be very effective in designs, but you must be careful when you print custom inks on them. The paper color can alter the way we see the ink color. If you are very picky about selecting a specific, custom color from an ink swatchbook, ask your printer to put samples of your ink choice on the paper you're planning to use (above right, bottom) so there are no surprises.

Color

Mills add dyes and bleaches to paper to give it color. Even white paper has a color, or at least a color cast. Some white sheets are blue-white, some a warmer yellow-white.

When you choose paper color, always look at both printed samples and plain sheets. Use the plain sheets to compare different hues. Use the printed samples to see how ink will look on the paper. Make sure the printed samples you see are printed with the same printing process and the same inks or toners that you plan to use.

Most digital printer companies are glad to throw a few sample sheets onto their press at the end of someone else's run. Since digital presses are designed to print each page as a separate entity, the printer spends little additional effort doing this for you.

You may run into difficulty if you're requesting a test run with custom inks instead of the normal CMYK. If your printer is reluctant to put a custom ink into the printer head, ask to see an ink drawdown on your paper. The printer will take a glob of ink and smear it across the paper so you can see how it will look.

The reason it's important to check this before you buy paper is that some inks (though usually not toners) can be transparent, at least to some degree. They create color by letting light through to strike the paper underneath, then they reflect the light back. But they don't reflect all the light back. Some of the wavelengths of light are absorbed by the dyes in the paper. This skews the ink colors, depending on the paper that lies underneath.

(ABOVE LEFT)

Depending on the design, sometimes it doesn't matter how paper color affects ink color. In this design, each recipient received a postcard printed on one of the four different-colored sheets of paper. The exact color of the type was not critical.

(ABOVE RIGHT)

However, in this design, ink color was vital, as each ink and each paper color were supposed to match. It was a difficult job to pull off, but the results were worth the headache.

Even black ink changes color on different colored stock. In some versions here, the black ink looks almost green, in other cases, gray. The ribbon and design, not the color, create the identity.

If ink color matters, try two-colored duplex paper. Here the designer folded the paper and put the critical ink color on the paper's white side.

One quick-printer found this out the hard way when she was asked to ink-jet a purple University of Washington "W" onto some gold paper—purple and gold are the school's colors. The W came out brown instead of purple because the gold paper absorbed too much blue light. I came in on the tail end of the discussion between her and the client.

"No one's going to know the point of my design," said the irate customer. "What the hell does a brown W on yellow paper mean in this town?"

The printer tried to explain the physics of light to the man, but he was a football fan. Physics was not his forte. All he wanted was a purple W.

PERCEIVED COLOR

Even if the inks or toners you use are opaque enough to prevent the paper color from altering the color balance of your work, you should still ask to see a printed sample. Often the paper color surrounding an ink color can affect our perceptions. Take a look at the cat illustrations below to see how this works.

(ABOVE)

The color of paper can affect how we see the color of ink, even if there is no physical or chemical interaction between the two. Toner inks are opaque and so are not affected by the colored paper under them. However, our eyes can still perceive that ink colors vary, just from the effects of the surrounding colored paper. Do the three cats above look the same color to you? They are, you know.

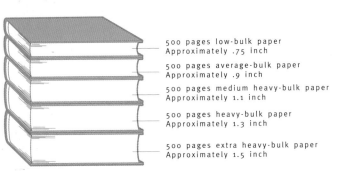

500 pages low-bulk paper
Approximately .75 inch

500 pages average-bulk paper
Approximately .9 inch

500 pages medium heavy-bulk paper
Approximately 1.1 inch

500 pages heavy-bulk paper
Approximately 1.3 inch

500 pages extra heavy-bulk paper
Approximately 1.5 inch

(ABOVE)

Papers can be made to bulk up more or less thickly. Five hundred sheets of a low-bulk paper, such as newsprint, are not nearly as bulky as five hundred sheets of cover stock. You should pay attention to this factor when you consider how people perceive value. Most people think that higher-bulk papers convey a higher sense of quality.

(ABOVE RIGHT)

The thickness of paper can also affect how it can be finished in the bindery. Thick papers, for example, do not fold well. You can see here how the ink along the edges is cracked and the corners have frayed.

Caliper

The thickness of paper is calipered in points by measuring a single sheet of paper. Note that one caliper point is .001 inches (.03 millimeters). Don't confuse it with a typeface point, which is 1/72 inches (0.6 millimeters). A caliper point measures thickness; a typeface point measures height.

Some very thick papers, such as bristol, are measured in ply rather than points. A ply is not really a measure, however; it's one layer of paper, laminated to another layer of paper. Most board papers are made in this way, with multiple layers of paper laminated to each other, just like plywood. A six-ply bristol board, for example, has six layers of paper laminated together.

Since the caliper of any one layer of paper might vary widely, knowing the ply of a board doesn't tell you anything about its real thickness. Ask for its caliper in points to find out how thick it is.

Paper caliper can have a huge impact on digital printing. For one thing, some papers might be too thick to go through a particular digital press or printer. Make sure you check this out early in the design process.

LETTER-SIZE MAIL DIMENSIONAL STANDARDS TEMPLATE — UNITED STATES POSTAL SERVICE®

USE THIS TEMPLATE TO CHECK FOR MINIMUM SIZE,
PROPER HEIGHT TO LENGTH RATIO AND THICKNESS.

STANDARD SIZES (Only for First-Class Mail weighing one ounce or less):

THE TIP OF THE UPPER RIGHT CORNER OF THE MAILPIECE MUST TOUCH THIS SHADED AREA TO BE MAILED AT REGULAR POSTAGE.

A SURCHARGE WILL BE ADDED TO NON-STANDARD SIZE MAIL.

MAXIMUM POSTCARD DIMENSIONS - 4 1/4" BY 6"

Minimum Size

1/4 inch Maximum Thickness

MINIMUM PIECE DIMENSIONS —

3 1/2" by 5" and at least .007 inches thick

To be mailable, piece edges must touch or extend beyond dotted lines.

6 1/8 inches
Maximum Height of LETTER-SIZE Mail

Pieces .25 inch thick or less not meeting any one of these requirements are NONMAILABLE. (Pieces such as keys and identification devices are not subject to the minimum standards except for the thickness requirement.)

Check the thickness and height standards by sliding the piece through the 1/4-inch slot lengthwise. If piece does not pass through, CHARGE REGULAR POSTAGE PLUS SURCHARGE.

Nonstandard First-Class Mail Size Limits. A piece of First-Class Mail weighing 1 ounce or less is non-standard if it exceeds any of the following size limits:
a. Its length exceeds 11-1/2 inches.
b. Its height exceeds 6-1/8 inches.
c. Its thickness exceeds 1/4 inch.
d. Its aspect ratio (length divided by height) does not fall between 1 to 1.3 and 1 to 2.5, inclusive.

TO USE TEMPLATE, PLACE LOWER LEFT CORNER OF PIECE HERE.

6 1/8 inches · 4 1/4 inches · 3 1/2 inches · Minimum Size

5 inches
6 inches
11 1/2 inches

Notice 3A/AUG 1998

Caliper can also affect folding. Depending on how thick a sheet is and also on the kind of coating it may have, you might need to score a sheet before you fold. If you don't score thick paper, the paper will crack on the outside of the fold. If printing happens to fall on this line, it will flake off. Usually you don't need to think about scoring any paper thinner than 8 points, but this does vary, so ask.

If you plan to mail your piece, check caliper. Now that the United States Postal Service is so fully automated—and now that it rewards mailers who cooperate with their requirements—you need to make sure that anything you mail is thick enough to be processed by the mail center. For most jobs, paper must be at least 7 points thick. But your design can't be too thick or it will jam the USPS machinery. The Post Office has a handy little plastic ruler with a slot cut in it that you can pass your mail piece through. If it goes through easily, you're okay. But just to be sure, you might consider taking your design to the nearest USPS Business Center or post office and asking them to okay your specs. They can check that your design has the proper proportions and correct barcodes too. Believe me, nothing is worse than having the postal clerk refuse to take your mailing, or getting it all back a few days later with a note that you need to add more postage.

(ABOVE)

Paper thickness is also a big factor for direct mailing. The Post Office has stringent requirements about how thick a paper can be and still qualify for certain postage rates. To check whether your design qualifies for the best rates, slip a dummy of your design through the slot of a postal measuring device such as this one. Your piece should pass through the slot easily. If it doesn't, you might have to pay additional postage.

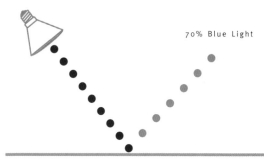

Blue Light

85% Blue Light

#1 White Paper

Blue Light

70% Blue Light

#5 White Paper

Grade

Paper manufacturers must be the most conservative people on earth. They never throw anything away. One of the things they have hung onto the hardest is the language they use to categorize different kinds and qualities of paper. The sheets they make are still graded based on the kind of job each paper was originally designed to handle. It may sound painfully obvious, but book papers were used to make books, newsprint for newspapers, cover stock for covers. Since the different uses of papers never overlapped in the old days, there was no need to standardize.

None of us confine ourselves to using paper the same way our forebears did, however. Nowadays, we use paper for whatever job a design calls for, never mind what the sheet itself is called. Thus, while the most common kind of printing paper is uncoated book, it is now used for books, brochures, newsletters, announcements, and other collateral material. Coated book, another common paper, is used for magazines, catalogs, brochures, calendars and posters. Cover stock is still used for covers, but it's also used for heavy posters, business cards, postcards and POP displays.

Of course, this being the paper industry, there are independent-minded mills out there who use their very own terminology to distinguish grades.

Some of these mills, for example, produce text paper, which might mean bond or uncoated book. Some make publication paper, which is really coated book. Some mills get fancy and say writing papers, not bond. Others prefer to be more down-to-earth. It's business paper, not bond.

The actual grading of each category of paper is also a happy leftover of bygone days. Bond paper, for example, is graded by its pulp content and weight. The highest quality bond is made from 100 percent cotton; five hundred sheets of it weigh 28 pounds (13 kilograms).

Coated offset paper (i.e., coated book) is graded by the amount of blue light it reflects:

#1 sheet (highest quality) reflects 85% or more blue light

#2 reflects 82-84%

#3 reflects 78-82%

#4 reflects 74-78%

#5 reflects 70-74%

The whole issue of paper grade is almost moot because of this confusion and because technically, a grade of paper is determined by a very narrow criterion. In the case of coated offset paper, it's the reflected blue light. Period. However, over the years, customers have come to expect other quality characteristics to go along with various grades. A #1 offset paper, for example, should be very, very smooth. It should not be made in the ultralight weights. It should have great ink hold-out and plenty of opacity. The paper mills do respond to these customer

expectations, so you can generally find higher overall quality in the higher grades of paper. But you can't necessarily count on it.

The best way to use paper grades as a selection tool is kind of like the judges who use a first cut at a Miss Universe beauty pageant. In the first cut, you can eliminate all the papers that just aren't going to make it at all. After that, you can compare a small number of sheets to each other and check out all the paper characteristics you need.

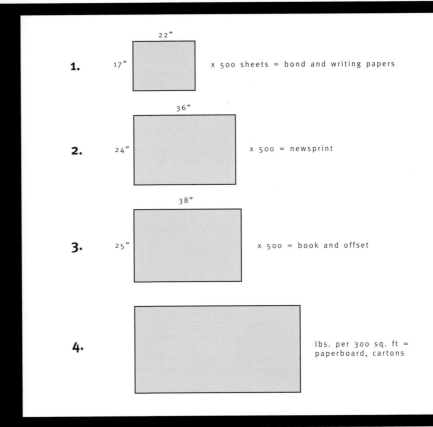

1. 22" × 17" × 500 sheets = bond and writing papers

2. 36" × 24" × 500 = newsprint

3. 38" × 25" × 500 = book and offset

4. lbs. per 300 sq. ft = paperboard, cartons

(ABOVE)

Basis weight is measured as the weight of five hundred sheets of a given paper. Five hundred sheets of 60-pound paper weigh 60 pounds, for example. However, for historical reasons, the size of the sheets being measured can vary, depending on what kind of paper is being weighed.

Basis Weight

Basis weight is another holdover from the past. Paper mills determine the basis weight of a given paper by weighing five hundred sheets (one ream) of it. Sounds simple, until you realize that each category of paper uses different size sheets! Mills originally did this because their scales were not very accurate and could not weigh lighter-weight sheets very well. So the mills cut the lightweight papers into bigger sheets that they could weigh more precisely. Now we're stuck with these formulas:

1. 17 x 22 x 500 sheets = bond and writing papers

2. 24 x 36 x 500 sheets = newsprint

3. 25 x 38 x 500 sheets = book and offset

4. lbs. per 300 sq. ft. = paperboard, cartons

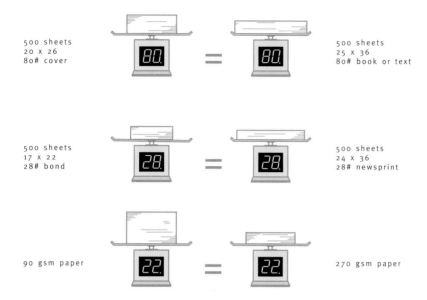

500 sheets
20 x 26
80# cover

=

500 sheets
25 x 36
80# book or text

500 sheets
17 x 22
28# bond

=

500 sheets
24 x 36
28# newsprint

90 gsm paper

=

270 gsm paper

These different sizes don't mean that you have to buy paper cut to that size. You can usually buy these papers in many different sizes. It just means that when a mill wants to figure out a paper's basis weight, it uses a different size sheet for each standardized category.

Sometimes it might pay for you to buy an equivalent sheet of paper in another category than your original design idea. If so, here are the equivalent weights:

BOND EQUIVALENTS:

- 16# bond ≈ 40# book

- 20# bond ≈ 50# book

- 24# bond ≈ 60# book

- 28# bond ≈ 70# book

COVER EQUIVALENTS:

- 50# cover ≈ 90# book

- 55# cover ≈ 100# book

- 60# cover ≈ 120# book

(ABOVE)

To determine the basis weight of paper, mills weigh 500 sheets of a given stock. But the size of sheets being weighed varies, depending on what kind of paper is measured (see the diagram on page 170). So 80-pound cover paper and 80-pound book paper both weigh the same, but the basis-sizes of the sheets is different. This makes it difficult to compare the weights of different kinds of paper. Outside of North America, basis weight is measured in grams per square meter (or grammage). So comparing the weight of one kind of paper to another is much easier.

WHEN PAPER IS BAD

ALTHOUGH BAD PAPER IS RARE IN
THE DIGITAL PRINTING WORLD,
OCCASIONALLY YOU MIGHT GET A BAD
BATCH. HERE ARE YOUR OPTIONS FOR
HANDLING THE PROBLEM:

- REJECT THE JOB. *Rejecting a roll or ream of paper might be necessary if the quality is so bad that you just can't print acceptably on it. If you do reject the job, The printer may be able to supply you with more of the same sheet from a different batch. Most printers carry enough paper in their inventory to cover emergencies, and most press runs for digital print jobs are short.*

 If you have special-ordered the paper, the printer may not have enough of your sheet to print the entire job. In that case, you might have to accept a substitute paper, a house sheet that the printer keeps constantly replenished in inventory.

 Before you agree to use the printer's house sheet, you need to ask yourself whether it matches your original paper selection. If not, would the substitute paper be different enough to bother your readers, or—more likely—your advertisers?

- REJECT THE HOUSE PAPER. *If you reject bad paper and the printer's substitute, your job will undoubtedly be delayed. You need to find out the exact length of the delay because it may involve more than mere delivery of new paper. Your printer may be so heavily scheduled that your job will be bumped far into the future.*

 Ask for a written guarantee of a new schedule from the mill and from the printer. Then ask yourself if you can stand the delay. Be sure to consider readers' expectations, distribution schedules, and promises to advertisers. Special offers may have to be altered, ads may have time-dependent information, editorial may need updating—the list of repercussions can cascade as quickly as a mudslide. This is why most print buyers accept any kind of substitute paper rather than delay.

- PAY FOR WHAT YOU GET. *If you accept the job as is, you will have to pay for it. Accepting the job means that either you sign for receipt of delivery, or you allow copies of your job to be sent directly from the printer. Most direct mail is bagged right off the bindery line, so you may not discover bad paper until you get your office copies. If this happens to you, don't expect the printer to charge you zero. After all, as faulty as the job was, you did get some use out of the product.*

- NEGOTIATE. *The size of a makegood or fee reduction that your printer may offer will depend on how harmed you were and how important your business is to the printer. Harm may be difficult to quantify. Did you lose advertisers' contracts? Did you have to give makegoods to advertisers? Did subscribers cancel? These are all straightforward consequences that you can attach a cash value to. Grayer areas might involve whether you believe you lost potential benefits (more advertisers, more sales, etc.), or even some of your reputation. Work it out.*

- PAY FOR YOUR OWN PAPER. *If you supplied the paper to your printer, then you must try to get redress from the paper mill. You'll need accurate evidence about the problem. Ask your printer to supply a detailed report. Resolving the dispute could take a very long time, and the outcome might not be to your liking. Mills have a habit of not paying too much attention to anyone other than their best customers. In the meantime, you must pay the printer for the printing and for any substitute paper supplied.*

All paper is made from pulp mixed with water. When the pulp is wet, some manufacturers press shapes into it, creating an embossed design. Watermarks are one such shape, created by pressing shallow dies into the wet pulp. But other shapes can be pressed in too, such as the leaf shown here.

Pulp Content

When Chinese court official Ts'ai Lan discovered how to make paper centuries ago, he used tree bark, hemp, and rag fibers. Later papermakers in China found that mulberry and bamboo made excellent paper, too. In fact, almost any fiber that bonds together when it's wet can be used to make paper.

Most publication papers in the U.S. are made from wood fiber because it's so cheap. The fiber is pulped and used in either of two forms: groundwood papers and free sheets. In both cases, the wood is first ground up into chips, usually at a separate pulping factory. For groundwood papers,

the chips are further pulped and washed, making a slurry of wood fiber and water. This is usually bleached white, and then dried. The dried pulp is shipped to the mills that actually make the paper. There it is remixed with water and beaten and refined. This is the point where the additives are put in: dyes, starches, brighteners, etc. This is also the point where recycled pulp is usually added.

This slurry, called "furnish," is then poured or sprayed out onto a vast wire mesh, the Fourdrinier paper machine. As the wet slurry flows along the mesh, water is squeezed out with rollers and flows out through the mesh. The rollers polish the paper as they press on it, but they only polish

one side. The mesh side picks up the pattern of the mesh. Eventually the paper is pulled through polishing rollers at the end, which polish both sides of the paper. But the mesh (or wire side) never becomes as smooth as the top (or felt) side. Its relative roughness causes it to accept ink differently than the felt side, creating a somewhat mottled effect that makes the ink colors look grayish.

Groundwood paper contains a lot of lignin, which is a brownish, organic compound in trees that "glues" the cell fibers together. Lignin gives groundwood paper a lot of strength and opacity, but it also makes groundwood sheets less bright and white.

Paper can be made from groundwood pulp (left) that retains its lignin (a substance that gives strength to the tree's cell walls). Or paper can be made from lignin-free pulp that has had the lignin "cooked" out (above). Groundwood paper is browner and duller than free sheets, but it's also much stronger. Free sheets, on the other hand, accept ink better than groundwood and have better overall printability.

Free sheets have all the lignin chemically "cooked" out of them in the pulping stage. They are lignin-free. Such papers are whiter and brighter than groundwood sheets, but they're also somewhat weaker and less opaque. Free sheets are often coated with a mixture of clay and other chemicals to make them smoother and brighter. Depending on the thickness of the coating, its chemical composition and its method of application, these coated papers can reflect almost all the light shined upon them.

Once the paper reaches the end of the Fourdrinier machine, it is rolled up into huge logs called reels. Each log can weigh as much as 28 tons (29 metric tons) and contain 46 miles (74 kilometers) of paper. These logs are cut into smaller reels for web printing. The smaller reels can later be unrolled onto a machine, a sheeter, that cuts them into individual sheets for sheetfed presses.

All paper is essentially made this way, although boutique papers are made with less automation and on a smaller scale. Special sheets might even be made with hand-presses and might contain all kinds of added materials: rose petals, leaves, metallic fibers, seeds. These things actually tend to weaken the paper bond, so they are unsuited to most kinds of commercial printing. But for one-of-a-kind jobs, they can be very beautiful. If you do use boutique papers, be sure to test them on your equipment before you roll out your design on them. Many specialty pulps are suitable for toner-based or ink-jet digital printers, but many are not. Generally speaking, ink-jet printers are more accepting of unusual papers, laser printers less so, and commercial digital presses hardly at all.

HOW PAPER IS MADE

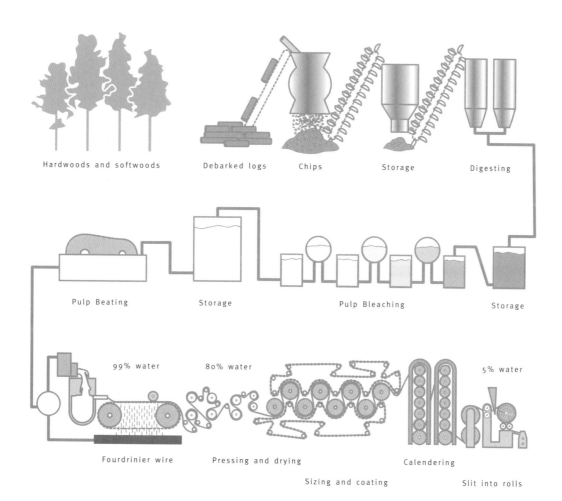

Hardwoods and softwoods

Debarked logs

Chips

Storage

Digesting

Pulp Beating

Storage

Pulp Bleaching

Storage

99% water

80% water

5% water

Fourdrinier wire

Pressing and drying

Calendering

Sizing and coating

Slit into rolls

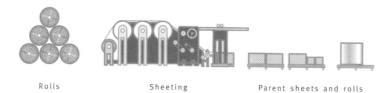

Rolls

Sheeting

Parent sheets and rolls

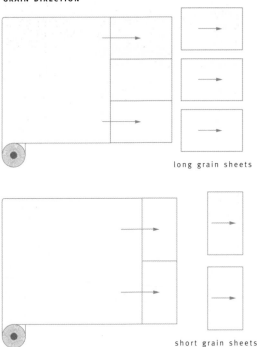

long grain sheets

short grain sheets

Grain

When wet pulp is sprayed out over a Fourdrinier wire, the pulp fibers begin to align themselves in the direction that the wire is moving. This creates a grain in the paper. When the finished paper is rolled up into logs at the end, the grain flows in the same direction as the way the paper is rolled: parallel to the outer edges of the log.

However, when the paper log is cut into smaller rolls, which in turn eventually get cut into sheets (for sheet-fed presses) or individual pages, the mill can cut the log into short rolls or long rolls. The grain is then called either short grain or long grain. Then the short grain or long grain sheets can be run through the press or your printer in such a way that the pages print with the grain running from top to bottom of the page or side to side of the page.

Why should this matter? Because paper prints with better registration when it's run grain-long. It folds more smoothly when folded with the grain but more strongly when folded against the grain. With heavier paper stock, a fold against the grain may need to be scored first so you get a crack-free fold that is also strong. Book pages that have the grain running parallel to the spine lie flat. The pages don't curl or become wavy, and they turn easily.

Mills tell you the grain direction of the paper by listing the grain-long measurement last. If a sheet measures 11 by 17 inches (28 by 43 centimeters), the grain runs parallel to the 17-inch (43-centimeter) side. Some mills underline the grain-long measurement, just so you know. A sheet that is called "22 x <u>17</u> inches" has a grain parallel to the 17-inch side.

If you don't know the grain of your paper, you can find out by tearing a sheet in each direction, top to bottom and then side to side. Paper tears more smoothly and easily with the grain. Tears made against the grain tear much more roughly—not in a straight line at all. Just try it with any sheet of stamps: Depending on the layout, you'll find that you can tear off a stamp easily in one direction. But in the other direction . . . ah, that's when you tear off pieces of the next stamp by accident, or rip your stamp in two, then try to glue the pieces back onto the envelope because darned if the Post Office is going to rip you off. Thank goodness for those self-adhesive stamps with die-cut edges that you simply peel off, unless they get stuck to the paper and you need a knife to tear them off, and . . . but that's another story.

(ABOVE)

If you can't determine for certain which way the grain runs on a sheet, try tearing it by hand. The paper tears easily and fairly straight with the grain; it tears unevenly against the grain.

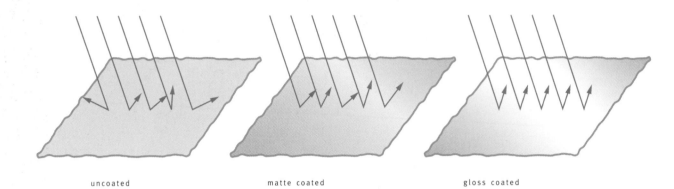

<div align="center">uncoated matte coated gloss coated</div>

(ABOVE)

The smoothness of a paper's finish affects how much light the paper can reflect back to our eyes. Uncoated papers (left) have an uneven surface that scatters light in random directions, carrying information unseen away from our eyes. Such papers do not hold detail well and make colors look grayish. Matte-coated papers (center) are smoother and do a better job of reflecting light, but gloss-coated papers (right) are the smoothest of all and reflect light most perfectly. That's why images printed on glossy paper show fine detail and saturated colors.

Finish

Finish describes the way a paper is surfaced. Generally paper can be made with either a rough or a smooth finish.

Most digital printers work best with smooth finishes. That's because toner or ink-jet droplets are really small and they can get lost in the crevices of rough paper. In the case of toner, this might prevent good fusion of the toner to the paper. In the case of ink-jet, you might lose detail in your artwork as the ink droplets disappear into the texture.

Images tend to be brighter on smooth paper because smooth paper reflects light back evenly, in parallel wavelengths. Rough paper scatters light in all directions. The light that is scattered away from our eyes carries information with it. Think of printing on corrugated paper. You might not see one part of an image at all, if the curvature of the corrugation scatters light in a direction completely away from your eyes. That being said, most rough finished papers are not this rough so the information you lose is related more to intensity: Colors look less bright on rough textured paper. This is not necessarily a bad thing; it is a factor that you should incorporate into your design from the beginning.

One way to compensate for the tendency of rough finishes to scatter light is to lay on a coat of something that smoothes out the texture in the areas you are going to overprint. Foil stamping has this effect, as do various kinds of undercoats that are then overprinted later with your design.

Finishes can sometimes be too smooth for digital technology. If the paper feeding mechanism depends on friction to carry a sheet through the printer, a really slick paper surface can jam up the works. In addition, paper that has been smoothed with a coating can present ink-drying or toner-fusion problems. Not every coated paper works with this technology. Check with the mill or try experimenting before you buy.

GLOSS

Gloss is the amount of shininess a paper has, as measured by the amount of light it reflects back. Gloss can be applied merely by polishing a paper during manufacture. Papers made this way are called calendered or supercalendered.

For more gloss, mills add coatings to the paper. Some of these are shinier than others. The shiniest is cast coating, followed by: ultragloss, gloss-coated, dull-coated (also called velvet or suede), and matte.

The reason why printers like glossy paper is that it makes colors look brighter. This is partly caused by the fact that coatings seal the surface of paper and make it smoother. But colors also look brighter because shiny papers simply reflect more light. The more light you see, the more intense the colors appear.

(ABOVE)

You can print bright colors and fine detail on rough-finished paper, if you first print a layer of opaque white ink to smooth out the surface, or if you overprint foil stamping, as shown here.

COMMON FINISHES

Mills use their own terminology to describe their finishes, so you should really check paper samples. but generally, the most common finishes are:

ANTIQUE
Slightly rough surface to simulate old-fashioned paper. It is halfway between the rougher vellum and smoother eggshell finishes.

CALENDER
Created during manufacture as the paper is smoothed between rollers. This finish is smoother than uncoated paper but not as smooth as coated paper.

CANVAS
Embossed onto dry paper to simulate a canvas weave.

CAST-COATED
Coating applied to paper and polished against a hot, smooth drum while the coating is still wet. This finish is the glossiest of all.

COCKLE
Slightly pebbly.

DULL
On coated paper, a coating applied to make the paper look very flat, not shiny at all. It is smoother than matte finish.

EGGSHELL
Pebbly to resemble an egg. This finish is smoother than antique.

FELT
Soft pattern that looks woven.

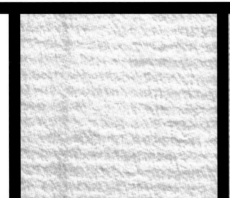

LAID
Grid pattern of parallel lines.

LINEN
Lightly embossed to resemble linen cloth.

MATTE
On coated paper, a coating applied to make the paper look flat, instead of shiny. It is a slightly rougher finish than dull-coated paper.

PARCHMENT
Hard-surface finish that looks almost brittle.

SATIN
Smooth finish with slightly embossed look to resemble satin. Also used as an alternate name for dull finish on coated stock.

SUEDE
Another term for dull finish.

SUPERCALENDER
Smoother than calender finish; created by pulling paper through alternating chrome and fiber rollers.

VELLUM
Fairly rough to simulate animal hides.

WOVE
Smooth finish just hinting at cloth-like appearance.

WHEN YOU LASER-PRINT IN-HOUSE

Laser printers work the same way that xerographic copiers work: First a print drum is given an electrostatic charge and a light source burns away the charge from nonprinting areas. Toner is attracted to the still-charged areas on the drum, which then transfers the toner to the paper. Then the toner is fused onto the paper by heat. Furthermore, printers and copiers feed individual sheets through the printer using surface friction.

These facts have implications when it comes to paper choices. You need to look for papers that have:

1. BALANCE BETWEEN SMOOTHNESS AND TOOTHINESS. *To feed properly, paper should have enough toothiness (rough surface) to provide the proper amount of friction for the feeding mechanism to grab each sheet separately. But to print properly, paper should have a smooth enough surface so the toner is applied evenly and, more important, so the tiny little toner particles achieve good adhesion when they're fused to the paper. Too rough a surface will prevent good fusion, and the toner will flake off.*

Papers made specifically for copiers and laser printers achieve a nice balance between smoothness and toothiness. You're usually safe when you select them, although the cast-coated, ultra-smooth papers will jam from time to time because they're so slick.

If you want to use papers not made for copiers and laser printers, you should always experiment first to see if they go through without jamming or flaking. Some will; some won't.

2. BALANCE BETWEEN HIGH AND LOW MOISTURE CONTENT. *High-speed printers and copiers that produce more than ninety pages a minute are finicky about the moisture content of paper. If the paper is too dry, static builds up on the surface and jams the equipment. But if the paper is too moist, the toner won't adhere.*

Papers made for copiers and laser printers always start out with the right moisture content, but paper moisture can vary, depending on the surrounding environment. You should always keep your printer and copier in an environment that controls humidity. Ordinary air-conditioning usually does the job adequately. It also helps if you keep the paper wrapped until you're ready to use it.

When printing on both sides of the paper, make sure you buy a sheet that is specially formulated to withstand the rigors of going through your equipment twice. Copiers and laser printers use heat to fuse toner. The first time you pass a paper through, the heat evaporates some of the moisture content in the paper fibers. You need enough moisture content left in the paper to make it through the process again.

Alternative Papers

Not all commercial papers are made from wood pulp. Some of the most intriguing papers on the market today are made from alternate fibers that would be well worth looking into.

A word of caution before you start salivating over these delicious papers: Because alternative papers are so specialized, supplies can be limited. Sometimes a mill stops making a particular paper altogether for awhile because demand is low or raw materials are short. Sometimes the paper comes back onto the market again; sometimes the mill just moves on. Some mills are completely committed to making a particular kind of paper— kenaf, for instance—so supplies are fairly reliable. But many of the alternative mills are small. When they decide to produce paper from a different fiber, they may go out of production for awhile with other fibers. Finally, some of the alternative papers are prone to market forces based more on fashion than fiber. People just get tired of them, and they disappear.

Make absolutely sure the paper you want is available in the quantity you need, when you need it. You might have to special-order the paper, in which case you must allow enough lead time for delivery. You might also consider stocking up ahead of time so you know you'll have enough. Be careful, too, about committing a major campaign to these papers. If you use an alternative sheet to establish a client's identity, what do you do when the paper disappears? Having said all that, alternative papers are worth all the hassle. They are gorgeous. Here are some of the most interesting ones available now:

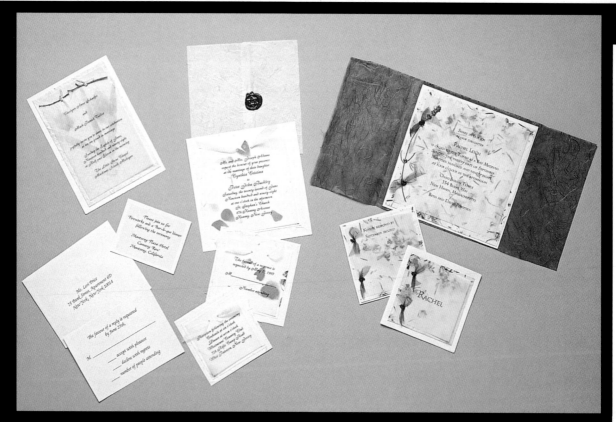

KENAF

A marrow-like plant related to the hibiscus, kenaf was originally grown in Africa but is now grown in the United States, too. It produces a warm, creamy paper that feels soft, almost floppy to the touch, like the finest bond papers. Pure kenaf paper is made without bleach. Although it contains very little lignin, it is very opaque. With a brightness reading of seventy-two, it's equivalent to the brightness of a #5 coated paper, so ink appears fairly bright on the surface. However, the creamy color makes the paper appear much less bright than a white sheet. Colors printed on kenaf appear warmer than on white paper, and ink looks softer. This can be an advantage on digital presses, which produce a very hard-edged printing dot. In addition, kenaf takes foil-stamping well, so you can get a beautiful contrast between the shininess of foil and the dull matte of the paper.

Kenaf is most often blended with other fibers, including cotton, recycled paper pulp, and hemp. Kenaf and kenaf-blends are ideal for books and collateral that strive for an old-fashioned feel, like the feeling you get when you curl up in front of a warm fire.

HEMP

Although it is banned in the United States because it is a member of the marijuana family, hemp can legally be imported from Canada. It makes a paper that is very durable and tightly bonded. The tight bonds keep ink high on the surface for maximum brightness, however, this can create ink-drying problems. Experiment ahead of time if you're planning to use ink-jet technology. Because of its drying problems, hemp is usually mixed with other fibers, including cotton, kenaf, and wood pulp. With mixed pulps you get all the ink holdout of hemp but without the drying problems. Hemp papers are slightly crisp to the touch but with a cloth-like feel that makes for an intriguing combination.

(ABOVE TOP)
Designs made from kenaf, recycled paper, and hemp. Most hemp pulp is mixed with other pulps because hemp alone forms such a tight bond that ink pools almost entirely on the surface, a bit like plastic.

(ABOVE BOTTOM)
Green Field's Hemp paper.

Crane's Crest Moonstone Grey Wove and Crane's Crest Natural White Wove are both papers made from cotton.

The designer chose 100 percent cotton paper for this restaurant postcard to link the restaurant's food image to its commitment to the environment. As a bonus, the look of the paper added to the warmth of the image.

Twinrocker Double X Flax.

Paper made from agripulp (in this case, Arbokem's wheat-stalk paper) prints very like the paper made from wood pulp. Of all the alternative fibers, it is the most predictable on press.

Agripulp papers include Banana Fiber, Favini Seaweed, Domtar Weeds/Hemp/Sugarcane, and Twinrocker Heartland Cornhusks.

COTTON

Some of the finest bond papers in the world are made from cotton or cotton blends. In the past, these papers used to be made from cotton rags. Nowadays they are made from linter, an otherwise unused portion of the cotton ball. Cotton papers can also be made from recycled cotton fiber, including denim. Usually when denim is the base fiber, the papers are unbleached, allowing the familiar denim-blue color to dominate. Cotton papers can also be made from organically grown cotton, a more expensive source of supply but very correct politically for audiences who care about such issues. Cotton papers are exceptionally strong, because cotton fibers are longer than wood fibers. These papers feel soft and toothy and carry an unmistakable association with quality and excellence, especially for stationery.

One of the more intriguing cotton papers is made by Green Field from cotton that is naturally colored pale green or pale brown. The papers made from these plants keep their natural color and have no additional dyes. They look subtly different from anything else on the market. Unfortunately they can be hard to obtain at times.

fields of reams

FLAX

Linen comes from flax, and linen has long been used to make the finest writing paper in the world. In fact, many wood-pulp sheets today are given a finish to resemble flax paper. Like cotton papers, flax papers are very strong and rather toothy, in an elegant way. Also like cotton papers, they feel a little bit like cloth, though somewhat stiffer than the floppy feel you get with cotton papers.

AGRIPULP

As rural land becomes more valuable throughout the world, companies try to make every possible use of the crops that are grown. One of the more innovative ideas is to make paper out of the waste left behind when crops are harvested. Wheat stalks, rice straw, sugar cane stems, and even banana plant stems have been used as fibers for paper pulp. Usually the fibers are blended with more traditional fibers, especially recycled paper, so that the resulting papers behave more predictably on press. In fact, of all the alternate-fiber papers, agripulp fiber acts most like ordinary wood pulp paper in terms of overall runnability. In some cases, you can hardly tell the difference, especially with wheat straw fiber. However, different fibers can create surprises.

Bagasse, for example, is a very short-fiber, so the papers are thicker and stiffer but also weaker than wood pulp paper. It's best to run tests with these papers and to plan ahead, too. They're not always available in the sizes or quantities you need.

Eventually, even the nicest of brochures is bound to ask for the opportunity. Thank you for considering us for your next golf course project. From the offices of Forrest Richardson and Arthur Jack Snyder, golf course architects.

(ABOVE LEFT)

Crane's Denim Blue, Green Field's Seeds, and Crane's Old Money papers.

(ABOVE RIGHT)

Four Corners' Golf Paper includes grass clippings from golf courses. The flecks of grass in the paper add visual interest to the design. To avoid dealing with flecks in the four-color art, the designer scanned the color images onto T-shirt transfers, hot-pressed them onto muslin fabric, and glued them into place.

(FACING PAGE)

All the papers in these designs were made from recycled paper, but the papers were made in various grades and colors. Recycled paper is now available in almost as many varieties as virgin paper.

RECYCLED

These papers are so common in the market now that they can hardly be called alternative fibers. However, there are vast differences among these papers, based largely on whether the pulp content contains post-consumer waste. Post-consumer waste is the only kind that actually keeps used paper out of landfills. It comes from paper products that have been used and discarded by consumers. This used paper is collected and trucked to a special kind of paper mill, where it is chopped up and de-inked. The de-inking can be a very tricky process because of the many different kinds of inks used today. De-inking also involves the removal of glues, coatings, varnishes, and laminates. These products, called "stickies," all need to be washed out of the recycled p before new paper can be made.

The other kind of recycled paper is made from "mill broke," scraps of paper left over from the manufactur process. Mill broke has been recycle for decades. It's easy to reuse beca it has never been printed or finishe in any way. Technically, paper made from mill broke is recycled because the broke is thrown back into the m But broke never reaches the consur in its original form; it never leaves mill at all. So it doesn't really keep paper out of the waste stream.

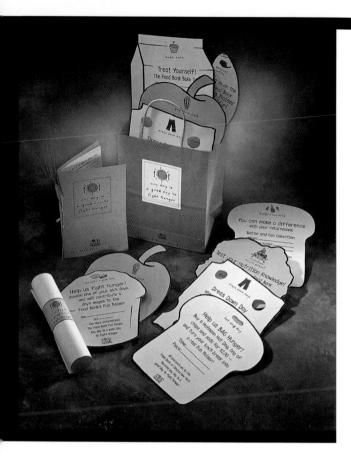

If recycling to you means keeping paper out of landfills, then be sure to check the post-consumer waste content of the paper you buy. You might be surprised at how low the percentage is in most recycled papers. The reason for the low percentage is that recycled paper pulp has shorter fibers than virgin pulp. Short fibers means weak paper. So almost all recycled sheets contain a significant amount of virgin pulp, just as a practical matter.

WHAT-THE-HECK-IS-THAT PULP?

Because paper can be made from any fiber that bonds when wet, some companies have come up with really creative pulps: grass clippings, old money, junk mail, seeds you can plant, sea grass that would otherwise clog the canals of Venice, beer labels and hops, denim jeans, coffee plants, and banana stems. Many of these papers work extremely well in laser printers and ink-jet printers. They generally aren't available in rolls however, so commercial digital web presses are out of luck.

The charm of these papers is that the pulp contains visible flecks that provide texture and color. With the right design, they can be stunning. But be aware that the flecks can occur anywhere on the sheet, including some areas where you'd rather not have them appear. For example, you wouldn't want your runway model to look more like Long John Silver just because an inconvenient fleck covered up her eye and a few too many teeth in her smile.

Chapter 7: Workflow

There's a scene in the movie *Top Gun* in which the intrepid hero (played by Tom Cruise) straps himself into a fighter jet, announces to the world that "I feel the need . . . for speed!" and, with no more than about three seconds of preflight preparation, he zooms off into the sky at supersonic velocity.

If only digital workflow were this easy! Your client may envision digital printing jobs whirring out the door every 20 seconds, but experienced designers know that without careful planning and preflight checks, a digital printing job can all-too-swiftly resemble a smoking pile of wreckage at the end of the runway.

The key to success is to design a workflow that makes sense. To do this you should consider two aspects of workflow:

1. In-house control of versions

2. Electronic compilation of files for printing

Versions

Years ago, when designers still sent out manuscripts to a typesetter to be typeset, my staff and I were working on an adventure-travel guidebook. The book listed more than 2,000 trips that people could take to exotic locations. Many trips went to places that we had never heard of before. We bought the best atlases we could find and hired a staff just to check place names.

Spelling all the geographic names was a major challenge for our typesetter, too. He had to take our original, correct manuscript and keystroke it into his software (no desktop publishing in those days!).

You know how some words just seem to baffle you? No matter how hard you try, you always spell them wrong. For our typesetter, Ougadougou was his Waterloo. Ougadougou is the capital city of Upper Volta. It's not really that exotic, but it's certainly not a name that you'd ever want to see spelled wrong in your book. But on the first proofs, our typesetter had consistently spelled it Ougagadougou. Just saying that name out loud had us rolling in the aisles. When our eyes stopped streaming, we sent back the proofs with the corrected name supplied.

When the second proofs came back, all was well. So we directed him to send the reprographic-paper layouts to our printer in Indiana to be plated. When the blueline proofs came back from the printer, somehow Ougagadougou had returned. My boss caught the error and came steaming into my office.

"Now, I know I had that fixed," I said, puzzled. I hadn't bothered to reread the bluelines word for word because we were in the computer age, after all. Once a correction has been made, it doesn't change. But inexplicably, Ougadougou had changed. I sat down and read the blues from cover to cover. Many of the corrections I remembered making were now missing. I called the typesetter.

"I did make those corrections," he said.

"Then what happened?" I asked. He refused to speculate. I asked the printer to send back all our original layouts. When they arrived, I saw that the typesetter had not output clean copies of the corrections. Instead, he had typeset individual words and glued them on top of our repro paper with wax. In the heat of summer in Indiana, the wax had melted and many of the corrected words had simply slid off.

I bring up this story because I'm often reminded of it when I deal with modern-day versioning issues. Unless you're a one-person design shop working in complete isolation from the real world, you will be challenged by the possibility that someone will change your work—either your text, your layout or your graphics—and you won't realize it. That is, until the worst, most embarrassing moment, of course, which usually is after the job has been printed and mailed.

The temptation not to check everything word for word or pixel for pixel in late stages of production will be overwhelming. After all, you live in the digital world, where type and pixels reside as numeric abstractions on a sacrosanct disk, invulnerable from wind, weather, or wacky typesetters. Right. If you believe that, then have I got a trip planned for you.

The reality is, whenever anyone makes a change in your digital designs, it can create a cascade effect that can reflow text and alter line breaks, create false color readings, freeze up embedded commands, and otherwise prove to be disastrous.

Original ad

YOU'RE OUT
IN FRONT.
THAT MEANS
YOU WON'T GET
LEFT BEHIND.

A NEW FORCE IS REVOLUTIONIZING THE WAY YOUR CUSTOMERS AND THE INTERNET INTERACT.
THE BENEFITS ARE IMMEDIATE.

ARE YOU READY TO CHARGE AHEAD?

YOU ARE WHEN YOU INVEST IN LOCAL CACHE PRODUCTS MADE BY THE COMPANIES
YOU SEE HERE. BECAUSE THESE CACHES HAVE BEEN TESTED TO WORK WITH
CENTRAL CACHE SERVICES FROM MIRROR IMAGE. SERVICES THAT SUBSTANTIALLY
ENHANCE YOUR CACHE PERFORMANCE, NO MATTER THE SIZE OF YOUR CUSTOMER
BASE OR THE SCOPE OF YOUR NETWORK.

IMAGINE WHERE THAT LEAVES YOUR COMPETITORS.

mirror image
Double your cache performance.

*1999 Mirror Image Internet, Inc. | London / +44-171-712-1515 | Stockholm / +46-8-506-255-00 | Boston / +1-800-353-2923 | www.mirror-image.com

Sometimes these changes can be obvious: The ad director makes the tiniest, smallest, most insignificant alteration on an ad when he proofs the "final" copy. The art director wants to tune up the skin tones in that model's face "just a tad." The copywriter realizes she has an extra hour that she didn't expect and wants to take advantage by rewriting one paragraph — it won't change the line breaks, she promises.

These in-house alterations are challenging enough. Even more challenging, however, are editorial changes that outside vendors may have to make to your designs. Perhaps you need to call in a spelling error that you just found, or your client just called to let you know that a price change has to be made in the ad copy. Sometimes when the printing vendor opens your file and makes the change, mysterious things can happen. Text can reflow completely, despite the fact that your printer is using the same font. Fonts can change. Colors can alter. Systems can crash.

Updated with wrong version of photos

Text edit reflowing body text

Text box brought to front

Controlling Changes

You need to control both kinds of changes, but you must do it with two different strategies.

IN HOUSE

Within your own environment, you need to set up a version control system that helps you keep track of who's changing what and when. Software programs exist that can manage your sites without a lot of nagging and herding by you. Such applications should provide:

- A secure system that lets different people check in and check out files and that records when they do so.

- A method to lock down files currently in use to prevent simultaneous modifications by others on the network.

- A way to lock out files so that only particular people can open them and change them, but anyone can look at them.

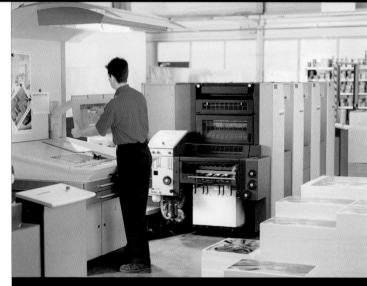

OUT OF HOUSE

To address outsourcing version changes, you need to pursue two rules.

- You and your vendors must share the same software and the same versions of that software. Don't make assumptions here; check explicitly ahead of time.

- You need to set up a way to view proofs, even when the changes are really and truly the last possible moment. Realistically, this may not be possible, but be aware that without proofs, you run the risk of creating a new problem when you attempt to solve the old one.

Compilation of Files

Consider how many applications must come together for an imagesetter or a digital printer to output a fairly simple design. You might employ:

- An object-oriented illustration program, such as Adobe Illustrator.

- An editing program for bitmapped color separations, such as Adobe Photoshop.

- A layout program, such as QuarkXPress or Adobe PageMaker.

- Fonts from various sources.

- Imported graphics in a variety of formats, such as EPS, TIFF, GIF, JPEG, etc.

- A trapping program, such as Adobe InProduction.

- A validation or preflight program such as Enfocus PitStop.

- A workflow automation program, such as Callas PDF Toolbox.

- A compression tool, such as TIFF or JPEG.

To print on any digital printing device, all these different applications must come together to produce one document that can be read by your output device.

In the past, the language that brought all these elements together and communicated them to the output device was PostScript. PostScript language converts many different digital schemes into one

scheme that arranges data into lines of dots, called rasters. Before anything can be printed, it must be rasterized (RIPed).

PostScript is still universally used to RIP graphics applications. But PostScript is limited. It cannot accept all software programs. When a RIPing device receives PostScript instructions that it doesn't recognize, it halts or crashes.

Service bureaus and printers try to accommodate the almost infinite number of software programs in the marketplace by buying and installing the most common applications. Many attempt to satisfy customers by buying the same software that the cus-

tomers like, so that they can support the designs that customers submit. But service bureaus and printers can't buy everything. Now and then, a customer embeds a file or graphic that simply won't RIP. This usually happens at the end stage of production, when there is no time left in the schedule. Customers become very unhappy if their designs fail at this point.

To solve this problem, vendors urged programmers to come up with some kind of standardizing, over-arching software. Adobe PDF (Portable Document Format) is the answer that is coming to dominate digital printing more and more. PDF is a language that is platform- and media-independent.

You don't need to separate text files, fonts, image files, or vector illustrations. PDF can incorporate everything into one file. Furthermore, PDF can compress data, making it easy to send extremely large files across the Internet without tying up your equipment for eons. Best of all, you can design your own workflow system. Here's how:

(ABOVE)

A big advantage of PDF-based workflow systems is that you can E-mail complicated designs to distant clients quickly and reliably. PDF is platform- and application-independent, so almost any desktop system can download and read PDF files. In the above design, for example, the designer employed complex features, including color photos, illustrations, overprinted and reversed-out type, and vignettes. He was able to E-mail the whole thing to his client in another state. The client could output a proof, make revisions, and send back the design in mere hours.

To Build Your Own Confidence, Build Your Own Workflow

When you're learning to fly an airplane, they don't start you out on a jumbo jet (too expensive) or a jet fighter (too fast). No, they start you out on something like a Piper Cub— an airplane so simple that all the parts are visible, so slow that a new pilot has plenty of time to look around and figure out how it all works, and so inexpensive that that you can afford to own one yourself.

Recent developments have made it possible to get started in digital printing workflow the same way, using PDF as the core technology. At this point, so many different vendors support PDF that it is now practical to build a complete digital workflow environment on your own personal computer, inexpensively, in a completely do-it-yourself manner.

In fact, not only is it possible to construct a do-it-yourself digital workflow environment, doing so is by far the best way to acquire an in-depth understanding of how digital workflow works.

Your first step toward digital production is to convert the PostScript file output from your layout program (typically a program like PageMaker or QuarkXPress) into a PDF file. Among the higher-end products are Adobe

Acrobat and Agfa Apogee Create, while at the low end there is the shareware product Ghostscript. Even at this very first step, however, it is entirely possible to "crash and burn." You have to keep in mind all the things we talked about in previous chapters. For example, did you remember to embed all the fonts you need into the PDF document? Do you know whether the fonts are Type 1, TrueType, or some even more modern format, and does your RIP engine care? Are all the bitmap graphics in the document of sufficiently high resolution? Was the trapping handled in the layout program, or are you going to handle it yourself later on in the digital print cycle?

Many of these problems can be detected by verification software, which essentially performs a preflight check on the PDF file. Many such verification packages are available on the market.

It used to be the case that PDF files could not be readily altered, but the modern software programs have changed this: It is now perfectly possible to change fonts, add words, tweak the position of graphics elements, and alter the color balance of individual graphic elements within Acrobat. Major changes, however, require a return to the starting layout program most of the time.

(ABOVE)

Preflight applications such as this one are essential for good workflow. They can flag potential RIPing problems that would cause your job to crash. They can also remind you to send all the necessary files to your printer. You might think this last point is a no-brainer, but a recent survey among service bureaus showed that the most common problem is that clients don't include all the font files needed to RIP their designs.

> Variable-data printing is likely to play a very important role in any twenty-first century career in print production.

You can be reasonably assured that a PDF file that passes the verification stage will RIP without crashing, but this does not mean that the results are guaranteed to be good. Innumerable layout problems like poor kerning, insufficient bleeds, bad color balance, insufficient pixel resolution, and banding can occur, and may require you to return to the beginning to fix.

Most of the verification software programs do not attempt to deal with the next stages of digital production: trapping, imposition, and separation. Typically these are handled by separate applications. This is a rapidly evolving area in which new software products appear on a monthly basis— your best bets for keeping up-to-date

in these areas are to check with your printer ahead of time to see what you might need to do in-house and what may be performed by the printer on the printer's workstation.

But if you become reasonably conversant with a PDF program such as Adobe Acrobat, a validation program like Enfocus PitStop, a separation and trapping tool like Adobe InProduction, and an imposition and workflow automation tool like Latana CrackerJack, you should be capable of RIPing onto ink-jet, dye-sublimation, liquid toner, and dry toner presses, in four or more colors.

Congratulations! You have achieved the digital equivalent of flying a Piper Cub . . . now it's time to begin upgrading your skills.

Reach Out to Clients Through Variable-Data Printing

If you are lucky, it will not be until after you have finished your own do-it-yourself digital workflow system that one of your managers, in a highly excited state, will approach you waving a trade journal article about a hot new marketing tool called "variable-data printing which allows you to individualize every single message that you print."

"I've got a great idea!" he or she will say. "Let's start customizing all our print jobs for our individual customers! Here's a Zip disk with our customer database. Can you have something printed by next week? Oh yeah, and we want to put it on the Web too!"

Picture the new way to do business...

EMPLOYEE IDENTIFICATION

EXP
Jan/01

5764400932

Suzanne Gonzales
Building Services, Inc.

Introducing the
E id Vendor Registration Program

w w w . e i d o n l i n e . c o m
877.675.6943

Changing the face of vendor relations...

EMPLOYEE IDENTIFICATION

EXP
Jan/01

5764400932

Robert Chang
Building Services, Inc.

Introducing the
E id Vendor Registration Program

w w w . e i d o n l i n e . c o m
877.675.6943

VENDOR REGISTRATION

Check out what we can do for you

- ✓ Reduce inventory shrinkage
- ✓ Protect against theft (office equipment, warehouse, supplies, etc.)
- ✓ Provide a safer work environment
- ✓ Reduce civil liability exposure
- ✓ Promote vendor compliance

Introducing the
E id Vendor Registration Program

w w w . e i d o n l i n e . c o m
877.675.6943

This may sound like a nightmare—and it can be. Unless, that is, you have anticipated that this day will come, and have prepared for it. Because the plain fact is, variable-data printing is likely to play a very important role in any twenty-first century career in print production.

The main challenge you are going to face is this: Companies that know a lot about business and database management (such as IBM and Xerox) are generally not too strong at high-end printing. And conversely, companies that know a lot about high-end digital printing (such as Agfa, Indigo, Heidelberg, and Xeikon) are generally not too strong at business database management. But all these companies, and dozens more, are scrambling furiously to enter the market for high-quality, variable-data digital printing.

The paradoxical result is that the overall business of high-quality variable-data printing is going to be a big success, but most of the individual products will not survive. A shakeout is inevitable.

As a designer, you can save yourself a lot of grief by being proactive in this area. Identify a product in your client's portfolio that would clearly benefit from variable-data printing: Such products can be as varied as billing statements, business proposals, catalogs, direct mail, and posters. Then contact the vendors of your favorite layout programs: You can be completely confident that most of them now offer a variable-data interface.

(ABOVE)

Using variable-data printing, the designer of this job was able to provide a service to his client that was impossible prior to the invention of on-demand digital printing. With variable-data printing, an entire press run of brochures can be printed, and each brochure can be completely different from the one before.

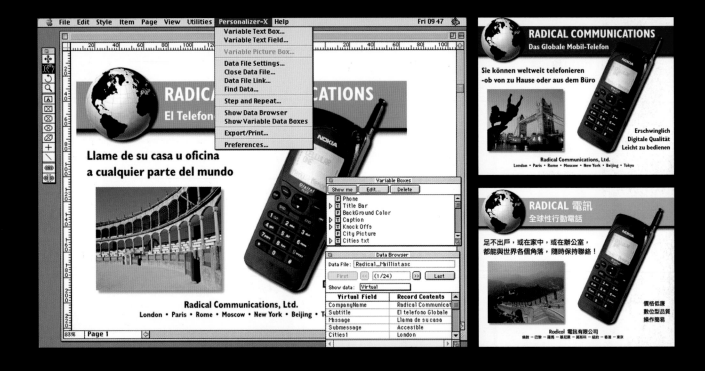

Many digital presses divide data into two parts: the elements that stay the same on every copy (for example, the color art in the designs here), and the elements that vary with each copy (here, text in different languages). Doing this speeds up the printing process.

Ordinarily, it would be difficult to reprint a short-run color design like this one every time a retailer adds a new outlet. But digital printers make short-run, on-demand color cost-effective.

Now work out the kind of variable-data assignment you would like to receive from your client, as a do-able increment on your existing digital workflow system. Concentrate mainly on a smooth and reliable production flow; don't worry too much about the marketing or artistic aspects (which will be taken care of later). How will you interface to the database? Once you have a good idea of the kind of variable-data job you would be prepared to tackle as a reasonable first job, approach your client and say, "Look, this is the kind of variable-data printing job we are presently set up to do. Let's give it a try and see how it works." In this way, you can reliably arrange to fly a Piper Cub for your first variable-data mission. Your chances of surviving the mission and enjoying the trip will be correspondingly greater, and you will look like a hero to your clients.

There are some not-so-obvious considerations that enter into variable-data printing. A key issue is that a digital press that prints a page every 3 seconds cannot be efficiently driven by software that takes 20 seconds to RIP each page.

ACTION SPORTS
M E D I A

UNIVERSITY OF WASHINGTON
Seattle, WA/Pac-10

WASHINGTON STATE UNIVERSITY
Pullman, WA/Pac-10

KANSAS STATE UNIVERSITY
Manhattan, KS/Big 12

UNIVERSITY OF IOWA
Iowa City, IA/Big Ten

PURDUE UNIVERSITY
West Lafayette, IN/Big Ten

UNIVERSITY OF KENTUCKY
Lexington, KY/SEC

VANDERBILT UNIVERSITY
Nashville, TN/SEC

OREGON STATE UNIVERSITY
Corvallis, OR/Pac-10

UNIVERSITY OF TENNESSEE
Knoxville, TN/SEC

UNIVERSITY OF SOUTH CAROLINA
Columbus, SC/SEC

UNIVERSITY OF TEXAS
Austin, TX/Big 12

TEXAS A & M
College Station, TX/Big 12

OKLAHOMA STATE UNIVERSITY
Stillwater, OK/Big 12

Ole Miss
UNIVERSITY OF MISSISSIPPI
Oxford, MS/SEC

UNIVERSITY OF ALABAMA
Tuscaloosa, AL/SEC

MISSISSIPPI STATE UNIVERSITY
Starkville, MS/SEC

When PostScript was originally written, this problem was not anticipated. It was thought that a RIPing engine, such as an imagesetter, would be given one job to do, and it could chunk away at it for an appreciable amount of time. Eventually it would spew out film that would go on to be made into printing plates that would then be used to print many, many copies. The paradigm was RIP once, print many.

Variable-data digital printing requires a different paradigm: RIP and print, RIP and print, RIP and print really, really fast. That's because, with variable-data digital printing, the RIPed file is essentially the final printed piece.

Different digital printers have come up with different ways to speed up the RIP so that their printers don't sit around waiting while the RIPing device thinks about what to output. Commonly, these vendors try to segregate elements of your design that do stay the same from one copy to the next. These elements are RIPed once. Then little sidecar RIPs can process the design elements that are different and plug them into the final output. Because the amount of data used to create the differences is smaller, the process goes faster.

Unfortunately, it will be awhile before new standards emerge in this area, and in the meantime, the vendors all tout their own (proprietary) solution. There is no perfect solution to this, except to encourage your vendors to embrace open standards as they emerge.

Another not-so-obvious consideration is that your client may be very unwilling to let the company's proprietary customer database travel off-site to a commercial printer. They worry about this because, in principle, it would be easy to extract the company's database, especially now that text in PDF can be saved to rich text format (RTF).

This fear can lead to ludicrous situations in which large-capacity Xeikon presses suddenly appear in-house, with a corresponding decrease in your business (if you are an independent design firm) or an increase in your responsibilities (if you work for one of these corporations and they snag you into this before you can run away). This is where a proactive relationship with your client and/or management and marketing can pay big dividends.

(ABOVE)

One of the most important reasons to maintain rigorous protocols in your workflow process is that when a last-minute digital printing job comes in the door (above left), you will have the systems in place to handle it as well as the other jobs already in the pipeline (above right)—without causing you or your staff to burn out.

Maintain Situational Awareness

Lastly, to create a sensible digital workflow, you should know what every pilot knows: how vital it is to maintain situational awareness. Situational awareness is knowledge of where the airplane is, what direction it is headed, and what is likely to happen next. Without good situational awareness, nasty crashes are almost inevitable.

Digital print production is like that too. You can maintain your own situational awareness if you:

1. Control and master all the details of your own digital workflow.

2. Get serious about keeping up-to-date on developments.

3. Be proactive in dealing with your clients and/or your management: Let them know what you can and cannot do with exciting new resources before they get too creative.

4. Be progressive yet incremental in the jobs you tackle. Don't tackle new technologies unless and until your present digital workflow environment is calm, stable, and productive—at least, within reason.

TRAPPING

Trapping is a way to butt two or more colors against each other so that white space doesn't show between them when they're printed. As the paper goes through the printer, minor variations in registration can occur. The printing device can put one color down in one area, but then the paper can shift slightly and mis-register when the printer puts the second color down on the paper.

To avoid this problem, designers must overlap the two colors. The question is: Which colors overlap and which underlie? You have two choices:

- You can spread (enlarge) the lighter color into the darker color.

- You can choke (reduce) the lighter color into the darker color.

You use a spread trap when the background color is darker than the image it surrounds; use the choke trap when the background color is lighter than the image it surrounds.

You can set traps in many different software applications and at different stages in the design process: when you create a graphic; edit the graphic; or layout the pages. Most of these software applications have tried to automate trapping for you; several have default traps built in.

The problem is that different output devices have different trapping requirements. Before you set any traps, you must find out what the overlap requirements are (especially the amount of overlap) for the particular output device you will be using. Then set traps accordingly.

Some printing devices are extremely finicky and idiosyncratic. Your printing house should be able to tell you ahead of time all the information you need to set proper traps. Or your printer might just tell you not to set any traps at all. If the printing device is extremely idiosyncratic (as all flexographic presses are, for example), the printer may prefer to set all the traps once your job is in the production pipeline.

If you do set your own traps, you should make them during late stages of design. It's usually not a good idea to set traps in your individual illustrations or graphics because, under certain circumstances, if you have to resize your art, the traps don't convert to the new size.

Chapter 8:
Binding and Finishing

One of the most gratifying things about a new technology is the thought that you can help people you were never able to help before. Take midlist book authors, for example. In their dreams, they are the next frontlist Stephen King, signing thousands of books for hordes of eager readers at each whistlestop on the promotion circuit. In reality, however, midlist books often wind up on the remainder tables at Barnes & Noble. Then they go out of print.

It's not the lack of royalty checks that hurts so much, although that is painful. It's the sense that one's unique artistic interpretation of the world is no longer around to speak to readers.

Luckily the Author's Guild has recently sponsored a partnership with an on-demand book publisher who promises to print one book at a time for a reasonable price. As one midlist author thrilled, "Each time an order is placed, a single copy of the book is printed. The result: one book per happy reader, and the end of dusty remainders."

More than 600 midlist authors have signed up to join the digital print revolution. What makes this revolution possible is not just the digital printing devices that can cheaply image one copy at a time. It's also bindery and finishing machines that can efficiently trim, fold, staple, or glue one copy at a time.

Many of these machines are linked directly to the printing device, so all the finishing happens in one fell swoop.

In other cases, trimming, folding, and binding machines are offline operations, sometimes so far offline that they happen in a different location and with a different company altogether. Either way, the goal of finishing and binding a digitally printed piece is speed: You need enough speed in the bindery to keep up with the speed of the printer. Without it, your job will stall in bottlenecks. If that happens, then on-demand printing might take on a whole new meaning, as your clients demand to know where their printing is.

The best way for you to stay on the sunny side of your clients is to remember this simple rule: Always start at the finish and work backwards. Before you design anything, you need to discuss finishing with

your printer. Most particularly, you need to know two pieces of critical information:

- What finishing options are available?

- What are the design specifications?

This is important even if you're printing only a single-page design, such as a poster. The poster may require no folding or binding, but it will require trimming if you want your image to bleed off the sides.

That's because in all printing, mechanical limitations prevent a printer from covering a sheet completely with a printed image. The printers need a certain amount of blank paper to grab onto to feed through the printing units. This is not a problem if you plan to keep white margins in your finished design, of course. But you still need to know the dimensions that your printing device can image.

Similarly, folding and binding equipment may require some extra paper to grab onto. The extra paper is trimmed off during processing but is absolutely necessary to plan for in the design stages. You don't want to fill a sheet with your design, only to find out later that you haven't allowed enough blank space for the equipment to function.

Another reason to check finishing specs before you design anything is that, as you fold and gather paper, parts of the image may become lost in the folds and trims. Images that used to line up may no longer do so. Binding methods, even simple staples in the upper left corner of a school book report, can obscure images.

(ABOVE LEFT)

Simple trimming and folding jobs might be able to run in-line on an all-in-one printing/ finishing system such as this one. More complicated jobs might require off-line finishing, adding to the lead-time.

(ABOVE RIGHT)

Even simple finishing jobs, such as a one-page poster that needs no folding or stapling may require off-line trimming. Check with your printer to make sure your design allows enough trim space.

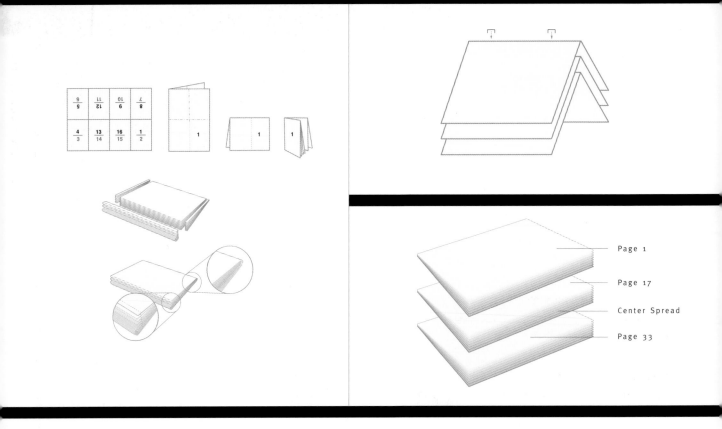

If your job needs folding and trimming, you should ask your printer for a folding dummy before you start designing anything. The folding dummy shows trim lines, bleed lines, imposition, and center lines. If your job is to be saddle-stitched, you should also ask your printer to indicate how much creep (the forward movement of two-page spreads during folding) will occur.

Saddle-stitched binding nests one folded signature on top of another on the bindery line. The signatures are then stapled along the folded center line.

Perfect binding stacks one folded signature on top of another. The bound edges are then glued or stitched to a cover.

Another technical issue can arise too: The imposition or arrangement of your pages on a press sheet can affect the image size. Any time you print multiple pages on a single printing sheet, this issue can arise. Different styles of imposition result in different image area dimensions.

Because the specifications for each job can vary widely, your best strategy is to ask your printer for a folding dummy (also called a folding layout). The dummy should be lined out with trim marks, bleed marks, fold lines, and center lines.

It should also show the layout of all the pages in imposition order, if your design is a multiple-page job. If your design needs die-cuts or drilling, then the folding dummy should show those, too.

Here are some parameters to consider, as you think about the kind of folding dummy you may need.

Binding Methods

There are two basic ways to bind pages together. Saddle-stitching folds a page or signature in two and drapes the folded piece over a V-shaped saddle, nesting one piece on top of another and fastening them all together along the center fold line.

Perfect binding stacks one page or one signature on top of another and fastens them together along the side in various ways.

All saddle-stitching works essentially the same way, no matter how many signatures are involved. At the start of the bindery line, a folded signature drops onto a V-shaped saddle, with half the pages draped on one side and half draped on the other side. The line conveys the signature to the next station, where the next signature is dropped on top of it. The signatures are carried down the line until all the signatures have been assembled. Then a stitcher staples them together on the center fold, using two, three, or more wire staples. Then the assembled booklet is trimmed on three sides.

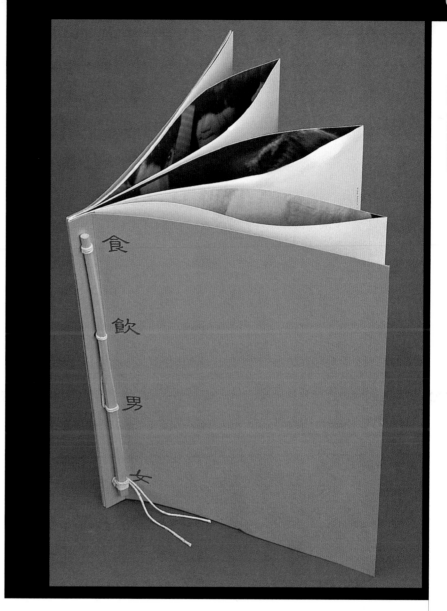

By contrast, perfect binding can be done in many different ways, although all involve a similar approach. A folded signature is fed folded and unopened into the first station of the bindery line. The line carries it to the next station, where another folded signature is dropped on top, making a stack. After all the signatures have been stacked, one on top of another, they are bound together and trimmed.

Different methods do this differently, but essentially what happens is that the signatures are bound together by glue, sewn together with thread, or stitched with staples. At some point, the spine side is roughened or milled off and the cover is attached, sometimes with glue, sometimes with stitching. Eventually the three sides of the book are trimmed to final size.

The method of binding can have a large impact on how much image area you have to work with, and how much image gets lost in the gutter or trimmed off. It can also affect how flat the pages lie when the book is open, and how durably the spine can resist weakening with use. Here is a rundown of the most common forms of perfect binding:

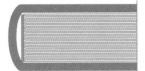

Perfect Binding (closed)

Perfect Binding (open)

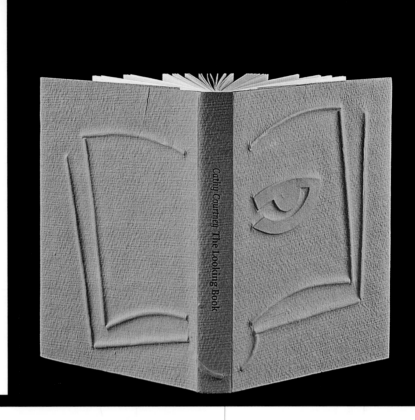

Cathy Courtney: The Looking Book

PERFECT-BINDING

The signatures are assembled by stacking one on top of another on a bindery line. The signatures are not draped or opened, as with saddle-stitched jobs. The spine edges of the signatures are milled off and glue is applied. The cover is wrapped on and pressed against the glue, then the three remaining sides are trimmed.

The book does not lie flat when opened. In fact, if the book is opened too widely, the glue on the spine can crack, causing the binding to fail.

SIDE-STITCHING

The signatures are assembled by stacking one on top of another on a bindery line, which then runs them through a side-stitcher. The stitcher staples the signatures together by shooting two or three staples through all the signatures along the spine side, inset a fraction of an inch.

The edges of the signatures on the spine side are then milled off and roughened, and glue is applied. A cover is wrapped on and pressed against the glue. Then the other three sides of the book are trimmed to size. The pages do not lie flat when the book is opened, but the binding is very durable.

Side-Stitching (closed)

Side-Stitching (open)

Channel Binding (open)

Channel Binding (closed)

Channel Binding (open)

CHANNEL BINDING

The signatures are assembled in a stack and trimmed. Then they're put into a cover, like a case. A metal channel on the cover is compressed, gripping the pages inside.

The metal channels are available in different colors. The pages do not lie flat when opened.

Case-Binding Assembly

1

3

2

4

5

CASE-BINDING

Case-binding is done in two stages. In one stage the case (outer cover) is manufactured. In a separate stage, the body of the book is assembled. Then the two parts are glued together.

1. The case is made by cutting thick paperboard or other rigid material into three pieces: one for the front cover; one for the back cover; and one for the spine. A book covering is cut out of cloth or leather big enough so that it can overlap the three pieces of the case. The case pieces are glued onto the covering, leaving enough room between the three pieces so that the book can be folded. The lapping pieces of the cover are folded over and glued on the inside.

2. The body of the book is assembled much like any other kind of perfect binding. Endpapers may be glued to the first and last pages of the book at this point. Endpapers can be decorative and are often made of heavier stock than the body stock.

3. Then the assembled signatures may be glued together along the spine, or they may be sewn together in different ways.

4. A strip of gauze is glued to the spine, so that the gauze extends outward on each side of the spine.

5. Paste is applied and the book is glued inside the case. Books made in this way "float" inside the hard case. This helps them open flatter than they otherwise would. The spine is also more durable than if the spine was glued directly to the case itself.

Lay-flat Binding (open)

Lay-flat Binding (open)

LAY-FLAT BINDING

This binding method attempts to blend the strength and durability of case binding with the cost-effectiveness of machine perfect-binding. The inside of the book is assembled as with any perfect binding method. The pages are trimmed, and a flexible adhesive is applied to a strip of reinforced crepe lining, which is wrapped over the spine and extends around a portion of the first and last book pages. This is what binds the book pages together; it is also what holds the cover onto the book. The softback cover is glued to the sides of the front and back pages of the book, so the book "floats" between the covers.

The key to this process is the glue, a special kind of cold glue called polyurethane reactive (PUR) that stays flexible throughout its life. The book lies flat when opened.

ADVANTAGES AND DISADVANTAGES OF BINDING METHODS

PERFECT-BINDING

1. *Can bind single sheets or cards*

2. *Can print text or graphics on the spine*

3. *Many different binding styles and materials available*

4. *Signatures don't creep*

5. *Direction of paper grain is crucial—the grain must run parallel to the binding edge*

6. *A certain portion of the image area may be lost in the gutter*

7. *Must have an overall thickness of at least 1/8 inch*

8. *Expensive*

SADDLE-STITCHING

1. *Must bind folded signatures, so the minimum page count of a signature is four pages*

2. *Has no spine, so cannot print text or graphics here*

3. *One style of binding available; can vary the number of staples used*

4. *Signatures creep, meaning that as one signature is nested on top of another, it must be slightly larger than the one below it for the trimmed edges to line up evenly*

5. *Direction of paper grain doesn't matter for most papers, so you can use grain-long or grain-short papers*

6. *No portion of the image area is lost in the gutter*

7. *Cannot be thicker than approximately 1/2 inch (13 millimeters), and at that size, the binding is weak*

8. *Relatively cheap*

Comb-binding (open)

Tape Binding (open)

Comb-binding (closed)

Tape Binding (closed)

Comb-binding (front)

PLASTIC COMB-BINDING

This kind of binding is very similar to wire spiral-binding, except that the binding material is plastic and is usually much wider than wire.

The signatures and cover are assembled like wire spiral-bound books, and holes are drilled. The holes can have many different shapes: square, rectangle, circle, or oval. The plastic binding can be of many different colors. It is fairly durable but not as strong as wire binding. The book lies flat when opened.

TAPE BINDING

All the signatures and cover are assembled and trimmed. Then a strip of flexible cloth tape that contains glue is applied on the edges of the spine side and heated. The glue melts and spreads, gluing the stack of signatures together.

The tape is available in several different colors. The book lies flat when opened.

Screw and Post Binding (open)

Screw and Post Binding (front)

Screw and Post Binding (closed)

SCREW AND POST BINDING

This is a form of side-stitch binding in which the signatures are fastened together with posts held on by screws instead of staples. The signatures are assembled in a stack and trimmed on all sides. Holes are drilled along the spine side. Posts already attached to the cover are threaded through the holes, and a screw head is screwed on to hold everything in place. The process is slow because it must be done by hand.

The book does not lie flat when opened, but the screws can be unscrewed to accommodate more pages at will.

Single Wire Spiral-Binding (front)

WIRE SPIRAL-BINDING

The signatures are assembled by stacking one on top of another. A cover is wrapped on and the pages may be trimmed at this point along all four sides. Holes are then drilled through all the pages. The holes may be square or round. Then wire is threaded through the holes. The wire can be threaded singly or doubly, in different spiral patterns.

Most wire is silver, but you can get colored wire too. The book lies flat when opened. Unlike other forms of perfect binding, which use glue to stick the pages together, spiral-bound books can be printed with bleeds out to the edges of all four sides. However, while you can bleed an image out to the spine edge, it will be punched with holes and partly obscured by the wire.

Wire Spiral-Binding (open)

Wire Spiral-Binding (closed)

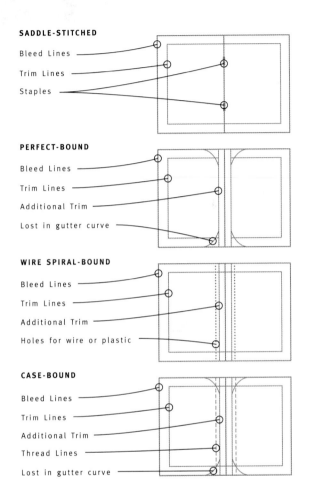

SADDLE-STITCHED

Bleed Lines

Trim Lines

Staples

PERFECT-BOUND

Bleed Lines

Trim Lines

Additional Trim

Lost in gutter curve

WIRE SPIRAL-BOUND

Bleed Lines

Trim Lines

Additional Trim

Holes for wire or plastic

CASE-BOUND

Bleed Lines

Trim Lines

Additional Trim

Thread Lines

Lost in gutter curve

Lost in the Gutter

Depending on the binding method you choose, a certain amount of your design is going to be compromised in the middle. With some methods, actual holes are drilled in the gutter area, or staples are punched through the center fold of gutter. With other methods, the image is not actually mutilated, but because the pages don't open fully, portions of the design can curve into the gutter and be lost from view.

As you design your job, you should keep bindery limitations in mind and adjust your designs accordingly. You may want to back the image away from the gutter altogether. Or you may decide to choose a binding method that minimizes the loss of image. At the very least, you need to know specifically how much image will be affected by the bindery. Ask your printer for a ruled-up folding dummy in page-reading order. Open the dummy in a natural way, not pulling the pages apart more than a reader would, and see for yourself.

You may want to laminate your printed piece after it has been produced, especially if the inks you use are water-based (as most ink-jet printers' inks are). Laminates protect ink and paper from scuffing, flaking, running, and fading. They are usually available offline and can be made from many different kinds of plastics. You should choose one that is somewhat porous, if possible. It will allow the paper to adjust to changes in atmospheric humidity, preventing paper curl. Also pay attention to how thick the laminate is. Thicker plastic protects better but may overwhelm the design, giving it the feel of a driver's license. You can also decide between a glossy or a dull laminate. Choose the one that enhances your design best, as you would with a glossy or matte varnish.

If you need to laminate a large piece of printing, such as a poster or a banner, then consult with the printer. Some laminating machines can crease large-format paper, creating unsightly lines and folds in the finished piece. You may need to print a backup copy or two, in case things go wrong. Ask about the spoilage rate and get a recommendation as to how many extra copies would be reasonable.

This happened to me on a job I was doing for a political candidate. Her campaign staff had ink-jet-printed the voting records of hundreds of precincts onto a giant map of the city. They wanted to laminate the map so that they could assign door-belling volunteers to the best areas.

The printer fed in the first map, and the machine creased it badly. "Not to worry," I said. "I've come prepared." I hauled out another copy and halfway through, the machine stopped. It had run out of plastic. The printer had to back the map out with only half of it coated.

"You'll have to be satisfied with that," he said. "I can't put the map through the machine again."

I looked at my two crashed and burned designs and heaved a sigh. What to do? Two copies were all I had made. Should I give my client the creased map or the half-laminated one? Neither choice was calculated to make me look like I had a clue about what I was doing. I looked more closely at the creased map. By some chance, the creases all seemed to run through precincts that wouldn't vote for my client if she was running for dog-catcher. So that's the map I gave her. I'm not sure she ever noticed, but I sure did, every time I walked into her headquarters. Three weeks later, she lost the election.

Folding Preflight

If you've ever tried making a Japanese crane out of origami paper, you know how frustrating folding can be. The paper curves in some directions and won't lie flat. Creases may not be straight. The folds weaken the paper fibers, so if you're not careful, your crane's beak will flop down like a piece of overcooked spaghetti. I know mine always did.

In the same way, folding your digitally printed jobs can be frustrating too. Your printer may not have the proper folding equipment. Paper may tear or crumple as it goes through the machine. The paper can wave and curve, without lying flat.

To avoid these mood-breaking moments at the end of the production line, you need to check with your printer early in your design process to make sure of three things:

1. **Will your paper work in the machines?** Paper needs to be the right thickness and weight to be folded. Papers that are too light-weight may not go through a machine without tearing. Papers that are too heavy and thick may not go through the machine at all, or if they do, they may need to be scored first to give a clean fold. Scoring is an off-line process that you'll need to pay for separately.

Papers also need to have the right finish to withstand folding. The finish of some highly glossy papers will crack along fold lines, creating unsightly blemishes. You also need to consider the grain of the paper as you fold it. Folds that parallel the paper grain are preferred by most designers because the folded paper lies flat afterward. This is particularly important if you're printing multiple-page designs that will be perfect bound. The first fold should always be parallel to the grain.

(ABOVE)

Signatures can be folded either with the grain (top left) or against the grain (bottom left). Most signatures are folded with the grain because paper that is folded this way lies flat; paper folded against the grain can curl, although the folds are stronger and less apt to tear.

(ABOVE)

Whenever you have a complex folding job
like this one, you should get a folding dummy
(facing page) from your printer and make sure
that your art works properly with the folds.

Sometimes, however, you may want to fold perpendicular to the grain. Folds may not lie as flat, but they are stronger. Talk to your printer to get the best recommendation.

2. **Will your designs work in the machines?** When a job is folded, the accuracy of the fold does not match the accuracy of print registration. Registration that may be accurate to within a thousandth of an inch in print may decline to an accuracy of 1/8 inch in folding. If your design calls for a perfect match across fold lines, you may be disappointed. I've seen this many times with four-color envelopes, where the design of the flap is supposed to match the design on the body of the envelope. One memorable mailing for the local zoo

showed an elephant whose trunk was sticking out of his ear.

Misalignment is even more problematic with page designs that are folded more than one time. Each time the page folds, it may lose 1/8 inch accuracy, compounding the problem with each fold.

As you design your folds, you should also be careful about tracking the sequence of copy from one panel to the next. What may be an obvious sequence to you may not be to your reader, who has not been living with the design night and day, as you have. If the text sequence is not obvious, your message may be lost. One way to mitigate this problem is to make each panel of your piece become a stand-alone panel.

3. **Can your printer fold your design in the way you want?** There are many ways to fold a printed sheet, especially when you use more than one fold. Combination folds can be parallel to each other, or they can be perpendicular to each other. Folds can nest into each other or stack on top of each other. Paper can be folded symmetrically or asymmetrically. The possibilities are almost endless, and folding machines are not standardized. You should check with your bindery.

Having said that, there are a few folds that are fairly common:

SIMPLE FOLD

One fold, made either with the grain or against the grain, along the short dimension of the paper or along the long dimension.

SHORT FOLD

A simple fold that is not folded symmetrically—one side is longer than the other.

BARREL FOLD

Two simple folds in which the outer edges of the page are folded in toward each other. Depending on where you make the folds, the edges can meet in the middle or overlap each other.

OVERLAPPING BARREL FOLD

A barrel fold in which the paper is folded asymmetrically, so one panel overlaps another.

COMPLEX BARREL ROLL (ROLLING FOLD)

A barrel fold with more than two simple folds. You can start on one side of the page, fold short, fold over short again, and fold over short again, as many times as you want.

GATEFOLD

A class of barrel fold that has an additional fold in the center of the paper. Depending on where the folds are, the gates can be the same size or different sizes.

ACCORDION FOLD
A multiple fold where the first fold bends in and the next fold bends out.

MULTIPLE ACCORDION FOLD
An accordion fold with more than two folds, each fold bending in and out successively.

FRENCH FOLD
A multiple fold in which the paper is first folded in one direction, then folded perpendicular to the first fold. Sixteen-page signatures on offset presses are usually folded in this way.

COMBINATION FOLDS
Multiple folds that combine features of simple folds. For example, you can combine a French fold with an accordion fold. Maps are often folded in this way.

PARALLEL FOLD
A combination fold that combines a barrel fold with an accordion fold.

COMBINATION FRENCH AND OVERLAPPING BARREL FOLD
Complex folds like this one are sometimes used for large-format brochures. Be careful when designing such folds; it is not always clear how a reader should track each page. You should consider designing each page so it can be read independently.

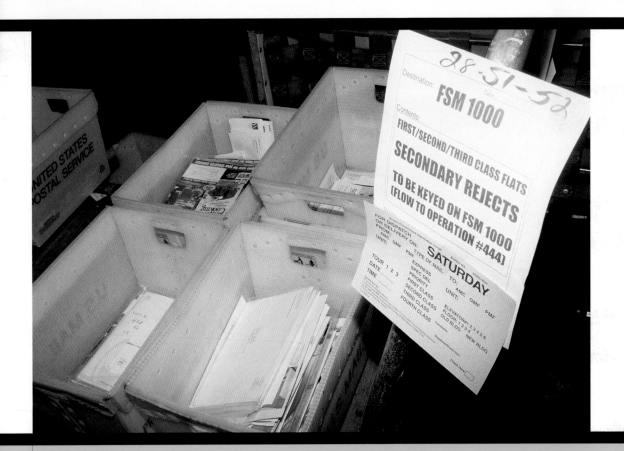

THE MAILING ISSUES YOU SHOULD ADDRESS ARE:

- WIDTH AND HEIGHT OF YOUR FINISHED DESIGN—*not only the absolute dimensions but their proportions*

- THICKNESS OF YOUR FINISHED DESIGN

- BINDING METHOD—*not much of an issue for first-class mail but important for all other mail classes*

- CONTENT—*there are certain savings for book rate and certain costs for mail that contains advertising*

- QUANTITY—*different classes have different minimum quantity requirements*

- INKS—*some inks will goof up the USPS automatic scanners, especially fluorescent inks and some metallics*

- PAPER GLOSSINESS AND FINISH

- PAPER TEXTURE OR PRINTED PATTERNS THAT MAY CONFUSE THE SCANNER

- CONTRAST NEEDED BETWEEN THE PRINTED DESIGN AND THE PRINTED ADDRESS—*especially if you're overprinting the address onto a colored background*

- WINDOW SIZE AND PLACEMENT

- WINDOW COVERINGS—*if any*

- BARCODES—*including size, location, and inking*

- ADDRESS LOCATION

- ADDRESS SORTING REQUIREMENTS

- PERMITS

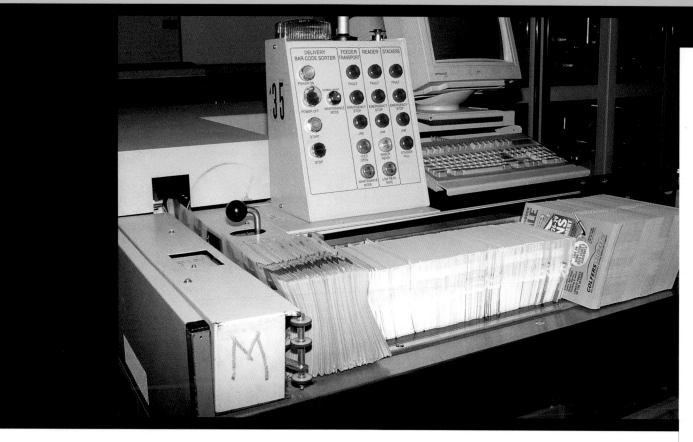

Pleasing Mr./Ms. Postal Delivery Person

If you plan to mail your piece, you should check with the United States Postal Service before you begin designing anything. This is especially true if you print in larger quantities and hope to benefit from the USPS discount program.

The USPS discount program operates on one simple principle: The more automated your job, the cheaper your postage. The savings can be substantial if you use barcodes and if you presort and prestamp your mail. But the specifications can be daunting.

Few things will send your stomach crashing through the floor faster than a postal service worker who opens your sack of mail and finds that your design is too wide or too fat, or that you used the wrong inks or the wrong contrast on the labels. The USPS may dump you easy or they may dump you hard, but dump you they will.

Fortunately the USPS is perfectly happy to help you ahead of time by providing the right specs. They will even go over a folding dummy with you and help you make corrections before you print. You can access this service at any USPS Business Center around the country. To find a USPS Business Center near you, call 1-800-238-3150.

(ABOVE)

The Post Office rewards mailers who design jobs that fit the system's automated equipment. Here stacks of mailers in three different sizes all qualify for automated sorting — and lower postage fees.

(FACING PAGE LEFT)

Designs that don't fit the postal service's equipment are thrown into the reject bin, to be returned to sender for expensive remakes or expensive additional postage. Don't let this happen to you.

Art & Photography Credits

page	9
studio	Disario Photography
photographer	George Disario
contact	978-463-3372
copyright	© 2001

page	11
studio	Invisible Imports
photographer	Randy Collyer
contact	www.invisibleimports.com
copyright	© 2001

page	13
photographer	Zoe Campagna
contact	212-768-6027
copyright	© 2001

page	13
design firm	Parachute Design
designer	Bob Upton
paper	Cougar Opaque Smooth

page	19
artist	John Sidles
contact	sidles@u.washington.edu
copyright	© 2000

page	26
design firm	Peter King + Co.
designer	Garet McIntyre
contact	www.peterkingandcompany.com
photographer	Aaron Washington
contact	617-710-9094

page	35
photographer	Dennis Swanson
contact	www.studio101west.com
copyright	© 1999

page	44
design firm	Miriello Grafico
designer	Michelle Aranda
paper	Chipboard (cover); Gilbert Esse (interior)

page	51
designer	Maury Sharp
courtesy	Seattle Academy
contact	csidles@mail.isomedia.com
copyright	© 2000

page	52
artist	John Hegnauer

page	62
photographer	Kevin Morrill
contact	www.workbook.com/portfolios/morrill
copyright	© 2001

page	63
photographer	Zoe Campagna
contact	212-768-6027
copyright	© 2001

page	64
photographer	Marie Mueller
contact	csidles@mail.isomedia.com
copyright	© 2001

page	65
photographer	Marie Mueller
contact	csidles@mail.isomedia.com
copyright	© 2001

page	66
photographer	Kathy Baxter
contact	csidles@mail.isomedia.com
copyright	© 2001

page	67
photographer	Marie Mueller
contact	csidles@mail.isomedia.com
copyright	© 2001

page	68
courtesy	Nathan Hale High School
contact	csidles@mail.isomedia.com
copyright	© 1998

page	69
photographer	Constance Sidles
contact	csidles@mail.isomedia.com
copyright	© 2001

page 70
artist Jo Sherwood
contact 505-983-6916
copyright © 2001

page 71
courtesy Rob Phillips
contact csidles@mail.isomedia.com
copyright © 2001

page 71
photographer Keitaro Yoshioka
contact 617-542-0096
copyright © 2001

page 71
courtesy Rob Phillips
contact csidles@mail.isomedia.com
copyright © 2001

page 73
photographer Kevin Morrill
contact www.workbook.com/portfolios/morrill
copyright © 2001

page 73
photographer Kathy Baxter
contact csidles@mail.isomedia.com
copyright © 2001

page 74
courtesy William Booker
contact 425-827-4862
copyright © 2001

page 74
photographer Keitaro Yoshioka
contact 617-542-0096
copyright © 2001

page 77
photographer Constance Sidles
contact csidles@mail.isomedia.com
copyright © 2001

page 78
studio Invisible Imports
photographer Joan Richardson
contact www.invisibleimports.com
copyright © 2001

page 78
photographer Kevin Morrill
contact www.workbook.com/portfolios/morrill
copyright © 2001

page 80
photographer Kathy Baxter
contact csidles@mail.isomedia.com
copyright © 2001

page 83
photographer David Katz
contact dmkatz@earthlink.net
copyright © 2001

page 83
photographer Marie Mueller
contact csidles@mail.isomedia.com
copyright © 2001

page 85
studio Invisible Imports
photographer Joan Richardson
contact www.invisibleimports.com
copyright © 2001

page 85
photographer Marie Mueller
contact csidles@mail.isomedia.com
copyright © 2001

page 85
photographer Marie Mueller
contact csidles@mail.isomedia.com
copyright © 2001

page 87
photographer Zoe Campagna
contact 212-768-6027
copyright © 2001

page 88
photographer Constance Sidles
contact csidles@mail.isomedia.com
copyright © 2001

page 89
photographer Constance Sidles
contact csidles@mail.isomedia.com
copyright © 2001

page 90
photographer Todd Fairchild
contact www.peterkingandcompany.com
copyright © 2001

page 91
photographer Alex Sidles
contact csidles@mail.isomedia.com
copyright © 2001

page 92
artist Jane A. Gildow

page 94
photographer Todd Fairchild
contact www.peterkingandcompany.com
copyright © 2001

page 95
artist Nathan Bulmer
contact 206-236-6120
copyright © 2001

page 96
artist Nathan Sidles
contact csidles@mail.isomedia.com
copyright © 2001

page 97
photographer Kathy Baxter
contact csidles@mail.isomedia.com

page 106
photographer Keitaro Yoshioka
contact 617-542-0096
copyright © 2001

page 107
studio Invisible Imports
photographer Joan Richardson
contact www.invisibleimports.com
copyright © 2001

page 111
design firm Peter King + Co.
designer Ann Conneman
contact www.peterkingandcompany.com
photographer Aaron Washington
contact 617-710-9094

page 117
artist John Cameron
contact 617-338-9487

page 120
photographer Kevin Morrill
contact www.workbook.com/portfolios/morrill
copyright © 2001

page 132
artist Nathan Bulmer
contact 206-236-6120
copyright © 2001

page 136
photographer Zoe Campagna
contact 212-768-6027
copyright © 2001

page 137
studio Disario Photography
photographer George Disario
contact 978-463-3372
copyright © 2001

page 142
studio Disario Photography
photographer George Disario
contact 978-463-3372
copyright © 2001

page 143
studio Disario Photography
photographer George Disario
contact 978-463-3372
copyright © 2001

page 144
photographer Keitaro Yoshioka
contact 617-542-0096
copyright © 2001

page 145
photographer Todd Fairchild
contact www.peterkingandcompany.com
copyright © 2001

page 146
photographer Keitaro Yoshioka
contact 617-542-0096
copyright © 2001

page 150
design firm Lionel Ferreira
designer Lionel Ferreira
paper French Construction;
French Durotone

page 151
design firm Sagmeister, Inc.
designers Stefan Sagmeister & Veronica Oh
contact 212-647-1789
paper Chipboard

page 151
design firm Bob's Haus
designer Bob Dahlquist
paper Simpson Teton (base); Millers Falls
EZ Erase typing paper (flysheet)

page 151
design firm Michael Bartalos
paper Handmade

page 153
design firm Mires Design, Inc.
designers John Ball & Miguel Perez
paper Handmade (folder); Rising
Drawing Bristol, 4-ply vellum (card)

page 153
courtesy Seattle Academy
contact csidles@mail.isomedia.com
copyright © 2001

page 154
design firm Miriello Grafico
designer Ron Miriello
paper Gilbert Esse

page 154
designer Babsi Daum
paper Various

page 155
design firm Visual Dialogue
paper Monadnock Revue; Astrolite

page 155
design firm Matsumoto, Inc.
designer Takaaki Matsumoto
paper Carolina board lined with
white corrugated

page 156
design firm Louey/Rubino Design Group
designer Robert Louey
paper Hopper Cardigan

page 157
artist Anna Wolf
paper Sundance Felt

page 157
design firm Costello Communications
designer James Costello
paper Hopper Protera

page 157
design firm Arts & Letters, ltd.
designer Craig Dennis
paper Neenah Environment;
Appleton Currency

page 157
design firm Arts & Letters, Ltd.
designer Craig Dennis
paper Neenah Environment;
Appleton Currency

page 158
design firm Cahan & Associates
designer Bill Cahan
paper Riegel Jersery Leatherette

page 158
design firm Mires Design
designer Deborah Horn
paper Champion Carnival

page 158
design firm Parachute Design
designer Heather Cooley
paper Strathmore American; ProTac
Pressure Sensitive; Curtis Corduroy

page 159
design firm Ashley Booth Design
designers Helene Skjelten & Ashley Booth
paper Multiart Silk

page 159
design firm Mires Design
designer Deborah Horn
paper Champion Carnival

page 159
design firm Matsumoto, Inc.
designer Takaaki Matsumoto
paper Van Nouveau

page 160
design firm Jeanette Hodge Design
paper Newsprint

page 160
design firm Sagmeister, Inc.
designers Stefan Sagmeister & Mike Chan
contact 212-647-1789
paper Lightweight bible paper

page 161
artist Nathan Sidles
contact csidles@mail.isomedia.com
copyright © 2001

page 162
design firm Vrontikis Design Office
designer Kim Sage
contact 310-446-5446
paper Fox River Confetti

page 163
design firm Wages Design
designer Ted Fabella
paper Champion Benefit

page 163
designer Sigi Ramoser
paper Anders Reflex Hochtransparent

page 164
design firm Spielman Design
designer Amanda Bedard
paper Fox River Confetti; Frida Flack
(card with no ribbon)

page 164
design firm Spielman Design
designer Amanda Bedard
paper Strathmore Writing Natural

page 166
design firm Visual Asylum
paper Potlach McCoy Gloss

page 169
design firm Peter Felder Grafikdesign
paper Zöchling Black (box);
Chromocard (cards)

page 173
design firm Pressley Jacobs Design
designer Amy Warner McCarter
paper Alpha Cellulose (cover);

page 174
design firm Pangborn Design, Ltd.
designer Dominic Panghorn
paper Corrugated cardboard

page 179
design firm Vaughn Wedeen Creative
designer Steve Wedeen & Pamela Farrington
paper Kraft chipboard (cover);
Vintage Velvet (interior)

page 184
design firm Cross Colours Ink
designer Joanina Pastoll
paper Various Mondi products

page 184
design firm Hornall Anderson Design Works
paper Strathmore Beau Brilliant (cards);
Tai Chiri (outer wrap); Gmund Boch
(sticker); Gliclear (envelope)

page 185
design firm Woodson Creative
designer Laurel Shippert
paper Various

page 185
illustrator Michael Bartalos
paper Various

page 185
design firm blackcoffee design
designers Mark Gallagher, Laura Savard
paper Chipboard

page 186
design firm Sixth Street Press
paper KP Products Vision Paper

page 187
design firm Vrontikis Design Office
contact 310-446-5446
paper Crane's Old Money; Kenaf;
Eco Paper Hemp

page 188
design firm Jeanette Hodge Design
paper Cotton handmade

page 190
design firm Richardson or Richardson
designers Forrest Richardson & Debi Mees
paper Four Corners Golf Paper

page 191
design firm Mark Russell Associates
paper Various recycled stocks

page 200
design firm Jeff Fisher LogoMotives
designer Jeff Fisher
contact www.jfisherlogomotives.com
copyright © 2000

page 203
design firm Jeff Fisher LogoMotives
designer Jeff Fisher
contact www.jfisherlogomotives.com
copyright © 2000

page 205
design firm Jeff Fisher LogoMotives
designer Jeff Fisher
contact www.jfisherlogomotives.com
copyright © 2000

page 206
design firm Cahan & Associates
designer Bob Dinetz
paper Warren Patina

page 206
design firm Troller Associates Graphic Design
designer Fred Troller
paper Beckett RSVP

page 211
design firm @KA
designer Albert Kueh

page 212
design firm Thomas Manss & Company
designer David Law
paper Various

page 213
design firm Cahan & Associates
designer Kevin Roberson
paper Cougar Vellum (cover)

page 217
design firm Gee + Chung Design
designers Earl Gee & Fani Chung
paper Simpson Starwhite Vicksburg

page 218
design firm Bailey Lauerman & Associates
paper French Construction

page 221
design firm @KA
designer Albert Kueh
paper Ivorex

page 222
design firm Vrontikis Design Office
contact 310-446-5446
paper Fox River Confetti

Accordion fold In binding, a series of parallel folds where the first fold bends in and the next one bends out.

Agripulp In paper-making, a pulp made from agricultural waste such as wheat straw, rice straw, hops stems, banana stems, etc.

Ambient light Light surrounding an area or object. Outdoor ambient light is all the light from the sun. Indoor ambient light is all the light supplied by light bulbs and/or incoming sunlight from windows, as well as reflected light bouncing off walls and objects.

Analog proofing system A system that makes proofs through analog (or physical) processes, as opposed to a digital proofing system that makes proofs through digital (or electronic) processes.

Banding An undesired phenomenon in which visible bands mark the borders where one tone graduates into another tone.

Barrel fold In binding, two or more simple folds in which the outer edges of the pages are folded in toward each other.

Baseline In typesetting, an imaginary, horizontal reference line along which all letters in an alphabet, all typefaces, and point sizes align.

Basic size The standardized dimensions of a given sheet of paper for the purpose of measuring the sheet's basis weight. Basic sizes for different kinds of paper differ.

Basis weight The weight of one ream (500 sheets) of paper, cut in the basic size for that particular grade.

Bézier curve A smooth, mathematical curve whose shape is determined by control points; much used in object-oriented graphics programs (such as Adobe Illustrator) to draw smooth curves.

Bible paper A kind of paper stock, made originally for bibles and dictionaries. It is very lightweight (usually well under 20-pound stock) and rather opaque for its weight.

Bit In computers, the smallest unit of information defining one of two conditions: on or off.

Bitmapped A gray-scale or color image stored as a collection of pixels, with minimal or no data compression.

BMP A format for storing bitmapped images in compressed form, conceptually similar to JPEG, PICT, GIF, TIFF, etc. and mostly used with Windows.

Bond strength The ability of paper fibers to hold together.

Bootlegged font A digital type font copied (often illegally) from a previously programmed type font. Bootlegged fonts typically do not contain the mathematical programming that ensures smooth curves and sharp edges, so when the type is scaled up or down, it may show jaggedness or blurriness.

Brightness In paper, the amount of blue light a given sheet reflects. This term is used to grade different paper stocks.

Broke In paper manufacturing, the paper that is spoiled during the manufacturing process, usually returned to the pulping process to be made back into virgin paper.

Byte In computers, the standard unit of measure for files equal to eight bits (see **bit**); a megabyte equals 1,048,576 bits.

Calendered A paper finish that has been applied mechanically by smoothing and pressing the paper between rollers during the manufacturing process (see **Supercalendered**).

Caliper A measure of the thickness of paper, expressed in points.

Case binding A form of perfect binding in which the outer cover is first manufactured. The pages are then assembled, trimmed, bound, and attached inside the case.

Cast coating A high-gloss paper finish made by applying a wet coating to the paper and then pressing the paper against a hot metal drum that is highly polished. Cast-coated papers have the glossiest finish of any paper.

Channel binding A form of perfect binding in which pages are assembled and trimmed, then placed inside a cover or case, which has a metal channel that is compressed to hold the pages.

CMYK (cyan, magenta, yellow, and black) the four inks used to reproduce full-color (i.e., four-color) printing.

Coating strength In paper, the ability of coating to resist delaminating or blistering.

Color calibrate To fix, check, or correct the gradations of color on a color monitor.

Color cast In photography or printing, an overall tinge or shade. A picture with a pink cast has an overall tinge of pink.

Continuous tone Artwork that contains a continuous gradient of tones from dark to light. Continuous tones cannot be printed by a press; the tones must be broken up into small dots (halftones).

Contract proof A proof that has been signed by the print buyer and designated as the official proof to be matched by the printer on press.

Contrast In photography and printing, the amount of gradation between tones, especially between highlights and shadows.

Conventional printing press A printing press that applies ink to a substrate by using a physical printing plate. Such presses may be offset, gravure, flexographic, letterpress, etc.

Cromalin proof An off-press proofing system (trademarked by DuPont) that involves laminating successive layers of CMYK toner onto a light-sensitive, sticky substrate with the use of color toners.

Cropping Cutting out portions of unwanted artwork in a layout.

Depth-of-field In photography, the zone of acceptably sharp detail in the background and foreground of a subject.

Digital sheet-fed press A printing press that applies ink or toner onto a substrate via digitized commands rather than with printing plates. The substrate is fed into the press one sheet at a time.

Digital web press A printing press that applies ink or toner onto a substrate via digitized commands rather than with printing plates. The substrate is fed into the press continuously from a roll; individual pages are created at the end of the line when a blade cuts the pages off the roll.

Direct-to-plate In printing, the process whereby digital layouts are transmitted electronically to a platemaking apparatus, without the intervening process of making film negatives first.

Dot gain In printing, the physical gain in size of halftone dots, caused by ink sinking into the substrate and spreading out.

Dot-matrix A digital printer that "types" small dots to make patterns that form characters.

Dye-sublimation A form of digital printing in which a computer-controlled scan-head heats special dyes to such high temperatures that they transform directly from a solid to a gaseous state. The vaporized dye is then transferred to the substrate.

F-stop In photography, a measure of the size of the lens opening, or aperture, on a camera. The larger the number, the smaller the opening. Each f-stop doubles the amount of light reaching the film.

Felt side The top side of paper made on a Fourdrinier wire. When finished or coated, it is smoother than the reverse side (see **Wire side**) and accepts ink better.

File compression Any of a large number of software protocols for storing a file at a reduced storage size; most commonly used in desktop publishing to reduce the size of image files (see **Lossless compression** and **Lossy compression**).

Finish In paper, the surface characteristics of a sheet. In the bindery, a general term covering trimming, folding, binding, off-line varnishing, etc.

Flax A slender plant whose stems can be spun into fiber to make linen or paper.

Flexography In printing, a process that prints by using raised images on a flexible printing plate made from rubber or soft plastic.

Font In typesetting, a complete set of all the characters (upper- and lowercase letters, numerals, punctuation marks, superscripts, subscripts, small caps, etc.) that make up one typeface.

Free sheet Paper made by cooking wood chips to break down chemicals and remove lignin.

French fold In binding, a multiple fold in which the paper is folded first in one direction and then folded again perpendicular to the first fold.

Furnish In paper manufacture, the mixture of pulp, water, dyes, clays, and chemicals poured out onto a Fourdrinier wire. As the water is removed the furnish bonds into paper. Also called **slurry**.

Gatefold In binding, a multiple fold that combines a barrel fold with a simple fold down the center line of the paper.

GIF (graphic interchange format) a lossless (or more recently, lossy) format for storing bitmapped images in compressed form, conceptually similar to JPEG, PICT, BMP, TIFF, etc. GIF supports animation but does not support a full range of colors.

Gloss A paper's ability to reflect light.

Grade A general term categorizing different qualities of paper. Grade can mean a category of paper, a class, a rating, a finish, or even a brand.

Grain The direction in which the paper fibers line up.

Grain long A sheet of paper whose fibers are aligned parallel to the long side of the sheet.

Grain short A sheet of paper whose fibers are aligned parallel to the short side of the sheet.

Grammage In paper, the basis weight as expressed in grams per square meter.

Gravure In printing, a process that prints by using cylinders that contain cells to hold the ink, which is transferred to the substrate.

Groundwood Paper stock that is made by mechanically grinding up wood into chips.

Halftone The reproduction of an image through the process of shooting an original, continuous-tone image through a grid (screen) that breaks up the continuous tones into discrete dots of differing sizes. Also a term for artwork that has been screened in this way.

Hatching The reproduction of continuous tones through the drawing or etching of fine dots and/or crossed or parallel lines.

Hemp A plant whose fibers are commonly used to make rope, cloth, and paper.

Highlight The brightest or lightest part of a photograph.

Hints In digital typography, mathematical algorithms used to turn pixels on and off in such a way as to make typeset characters look smoother and more crisp.

Histogram In digital prepress, a graph that displays the tonal range of a given image.

House sheet Paper stock always kept in inventory on a printer's floor.

HTML (hypertext markup language) one of many markup languages used to create digital graphics and text. HTML is especially useful in Web design, but it is gradually being supplanted by WYSIWYG languages.

Imposition The layout of individual pages of a multipage design on a press sheet so that, when the sheet is folded after printing, the pages are in correct, sequential order.

Ink holdout A characteristic of the surface of a paper sheet that keeps ink from sinking into the paper fibers. Papers with good ink holdout keep ink on the surface, so colors look more saturated and details are finer.

Ink-jet printing A digital printing process that applies ink to a substrate by spraying tiny droplets of ink through computer-controlled nozzles.

JPEG (Joint Photographic Experts Group) a lossy format for storing bitmapped images in compressed form, conceptually similar to BMP, PICT, GIF, TIFF, etc. JPEG best supports continuous tone images.

Kenaf A plant related to hibiscus whose fibers can be used to make paper.

Kerning The reduction of space between letters so that the letters appear closer together than they normally would.

Kerning pairs Two letters that have been moved closer together than they would normally be, to make those letters appear optically spaced as evenly as non-kerned pairs. Most digital type fonts are programmed with a certain number of kerned pairs of letters.

Laser printing A printing process that employs a laser beam to charge a drum, which in turn attracts toner particles that are transferred to paper and set by heat.

Lay-flat binding A form of perfect binding in which the pages are assembled and trimmed. Then a strip of reinforced crepe is glued onto the spine and a portion of the first and last pages with flexible glue. A case (or cover) is then glued onto the first and last pages, so the pages "float" within the case.

Leading In typography, the space between lines of type; also called line spacing.

Letterpress In printing, a process that prints by using raised images on flat plates. The raised images are inked, and then paper is pressed against them.

Ligature In typography, two or more letters designed to print together as one unit so that one letter does not interfere with the other.

Lignin The substance in trees that gives strength to wood cells. If left in paper, lignin adds strength and opacity but lessens brightness.

Lithography In printing, a process that prints by using flat plates that employ water to repel ink from nonimage areas.

Lossless A data compression scheme that reduces the amount of data needed to store an image but without any loss of data. When a lossless image is uncompressed, it contains exactly the same data as the original.

Lossy A data compression scheme that reduces the amount of data needed to store an image by throwing away some pixels of information. When a lossy image is uncompressed, it may be slightly different from the original.

Loupe A magnifying lens held close to the eye to examine printing. The most common loupes are eight-power, which enlarge images by a factor of eight.

Makeready The process by which printing plates are hung on a conventional press and inked to the proper density and color balance.

Markup language In computer programming, a language that requires the user to keystroke lines of commands to produce text and graphics. The user cannot see the design until the commands are output, in contrast to WYSIWYG languages, which display text and graphics directly on a monitor.

Metamerism A phenomenon in which colors perceived by the human eye appear different when viewed by an artificial lens, such as a camera lens.

Midtone In printing and photography, the range of tones in the middle between highlights and shadows.

Moiré An unwanted pattern of printing dots caused by halftone screen angles that conflict with each other, creating a discernible pattern of squares. This often occurs when previously screened halftones are screened again, or when screened halftones are used to reproduce patterns that already have a screen or grid pattern in them (such as houndstooth checks)

Mullen strength The ability of paper to resist bursting.

Offset printing In printing, a process that prints by using flat plates (deployed either flat or wrapped around a cylinder) to pick up ink from an ink fountain (or trough) and transfer it to a rubber blanket. The blanket then presses against the substrate to print the image.

One-sided press A press that can print only one side of a substrate at once (as opposed to a perfecting press, which can print both sides of the substrate at the same time)

Opacity The ability of paper to keep printing on one side from showing through on the other side.

Orphan A widow carried to the top of the next column or page of type.

Overexposed A photograph that has been exposed to too much light. Overexposed photos look washed out and lack a full range of tones, especially deep shadow tones.

Paper spoilage The amount of paper discarded during the printing process because it has been spoiled by a number of factors: poor registration, printing flaws, folding flaws, poor color balance, bad paper, etc.

PDF (portable document format) a file format created by Adobe that allows users to view and print documents independent of the applications used to create the files.

Perfect binding A form of binding multiple pages together in which signatures are stacked directly, one on top of another, the spine edges are milled off, and a cover is attached, usually by glue.

Perfecting press A press that can print both sides of the substrate at the same time.

Pica A unit of measurement used by printers and designers, equivalent to approximately 1/6 inch (4 mm).

Pick strength The ability of a paper surface to resist fraying into little fragments when sticky ink is applied.

PICT A format for storing bitmapped images in compressed form, conceptually similar to JPEG, BMP, GIF, TIFF, etc.

Pixel Digitized bits (see bit) of data collected into a bitmap and stored by a computer, used to form images on any kind of output device, including computer monitors.

Ply In paper, one of several sheets laminated together to form extremely thick, heavy board-papers. Six-ply board means that six sheets of paper were laminated together to make one board.

Point In typesetting, a measure of type size. One point equals 1/72 inch (0.35 mm). In paper, a measure of the thickness of paper. One point equals .001 inch (0.25 mm).

Proof In printing, a representation of what your job is supposed to look like on press.

Pulp Fibers that are separated mechanically or chemically, then dried into thick sheets. Mixed with water and other chemicals, it becomes furnish to make paper.

Pulp content The nature of fiber used to make pulp. Pulp content can include any fibers that bond together when wet, including wood, bamboo, cotton, rice, mulberry, kenaf, hemp, flax, and used paper.

PUR (polyurethane reactive) a special kind of cold glue that always stays flexible, making it a good choice for lay-flat binding.

Rasterized image An image that has been converted into a bitmap for every pixel in that image.

Registration The process of placing two or more overprinted images in such a way that the images align exactly over each other.

Resolution The degree that a device can record or reproduce sharpness of detail.

RGB (red, green, and blue) the three primary components of white light.

RIP (raster image processor) hardware and/or software that converts all files to bitmapped images that can be output on an imagesetter at very high resolution, thereby producing film or data files that can be printed on a commercial press.

Saddle-stitching A kind of binding method in which signatures are nested on top of each other along a "saddle" bindery line and stitched together with staples.

Scan-head printing A form of digital printing in which a printing head controlled by a computer is driven (or "scanned") across a substrate in order to apply ink. The two main forms of modern scan-head printing are ink-jet and dye-sublimation.

Scale To reduce or enlarge an image according to a fixed ratio or proportion.

Scoring The process in which paper is compressed along a straight line to break the fibers and allow the sheet to be folded without cracking.

Selective binding A process that allows distinct copies of a publication to be assembled with different signatures. The process is controlled by a computer, which directs the bindery line to drop the correct signatures into place. It is often combined with ink-jet printing, also controlled by a computer, which may print a unique message onto each copy of the publication.

Separation The process of breaking a full-color image into four colors (cyan, magenta, yellow, and black) that can be printed together to simulate full-color.

Serif type Letters whose ends terminate in circles and cross-strokes.

Shadow In photography or printing, the darkest part of an image.

Sheet-fed press A printing press that uses a stack of pre-cut sheets of paper.

Short fold In binding, a simple fold that is folded asymmetrically so that one side is longer than the other.

Short-run color A printing job printed in color in a small quantity. The term is relative and depends on the capability of the printing press and the economics of the process. Short-run for a gravure press might be any quantity less than 100,000. Short-run for an offset press might be any quantity less than 5,000. For digital presses, short-run can refer to a quantity as small as one copy.

Show-through In printing, the amount of printing on the reverse side of a sheet that is visible on the front of the sheet under normal viewing conditions.

Signature In printing, a sheet folded at least once and usually more than once, to form individual pages or panels in a publication.

Simple fold In binding, a single fold.

Slurry See **furnish**.

Specular highlight In photography or printing, a highlight that reflects a light source directly. When printed, specular highlights have no dots at all.

Stochastic screen In digital prepress, a method of breaking up continuous-tone images into printable dots. The dots are extremely small and randomly arranged, in contrast to halftone screens. Dark tones are represented by many dots; light tones by few.

Subscript In typesetting, a character set smaller and slightly below the baseline of type; used most commonly in chemical and mathematical equations and in footnotes.

Substrate In printing, any printing surface that accepts ink. The most common substrate is paper, but substrates can also be plastic, metal, wood, fabric, glass, etc.

Supercalendered A paper finish that has been applied mechanically by smoothing the paper over chrome and fiber rollers during manufacture. The finish is smoother than ordinary calendering but less smooth than coatings.

Superscript In typesetting, a character set smaller and slightly above the x-height of type; used most commonly in chemical and mathematical equations and in footnotes.

Tear strength The ability of paper to resist tearing.

Tensile strength The ability of paper to resist stretching without bursting.

Thermal-wax printing A form of digital printing in which dots of waxy dye are heated to melting point and transferred to the substrate.

TIFF (tagged image file format) a lossless format for storing bitmapped images in compressed form, conceptually similar to JPEG, PICT, GIF, BMP, etc. TIFF best supports continuous tone images.

Tooth A descriptive term referring to the rough surface of a paper finish.

Trapping In printing, the process whereby one ink is printed over another. In prepress, the process whereby one color is lapped over another so that when printed, no white space shows between the two overlapped colors.

Typeface The design of one particular style of type. Originally typeface meant the printing surface of a letter of type.

Underexposed A photograph that has been exposed to too little light. Underexposed photos look dark and lack a full range of tones, especially in highlight areas. The deep shadow tones may lack detail as well.

Unsharp masking In digital prepress, an algorithm that increases the contrast at the edges of objects. You can control the amount of unsharp masking you use, as well as the level at which the computer will apply the mask or not (the threshold), and the number of pixels surrounding each edge that will be affected (the radius).

Variable-data printing A form of digital printing in which each printed piece is different from the one before. The difference might be as simple as an address label or as complex as an entire design.

Vector curve A mathematical description of smooth curves, also called Bézier curve.

Viewing booth A booth constructed in such a way that color art (both originals and reproductions) can be seen under totally neutral light. Viewing booths are painted with neutral-gray walls and are illuminated with color-corrected lights at 5,000 K.

Visible spectrum White light diffracted by a prism into bands of visible color arranged by their respective wavelengths, ranging from violet to indigo, blue, green, yellow, orange, and red.

Web press A printing press that uses paper from a continuous roll (a web). The paper is threaded through the press units and is cut and folded into signatures at the end of the line.

Widow In typesetting, the last line of type in a paragraph that is less than one-third the width of the line above.

Wire side The side of paper lying against the Fourdrinier wire during manufacture. The wire side of paper is less smooth than the felt side and accepts ink differently.

WYSIWYG (what you see is what you get) describing a computer monitor's ability to display layouts more or less as they would appear when output by a printer. WYSIWYG is pronounced WHIZZ-ee-wig.

X-height In typesetting, the height of the lower-case letter x.

About the Author

Constance Sidles is a production consultant and business writer with twenty-five years of experience in print production. She has been a production editor for several publications and for eighteen years has operated her own production consultancy that specializes in production planning, color printing, and troubleshooting for commercial clients and publications. Additionally, Sidles has written more than 450 feature articles and has won two Maggie awards for best nonfiction feature article. She presently writes regular columns for *HOW* Magazine and is the author of *Great Production by Design* (North Light Books), *Printing: Building Great Graphic Design Through Printing Techniques*, and *Pre-Press: Building Innovative Design Through Creative Pre-Press Techniques* (both by Rockport Publishers).

Trademarks

Trademarked names are used throughout this book. We are using the names only to describe, inform, and advise you about various aspects of computer and printing products and to the benefit of the trademark owner, with no intention of infringement of the trademark.

Products included in this book are identified for information only and the author and publisher assume no responsibility for their efficacy or performance. While every attempt has been made to ensure that the details described in this book are accurate, the author and publisher assume no responsibility for any errors which may exist, or for any loss of data which may occur as a result of such errors.